THE MONSTER BOOK OF MORE
MANGA

THE MONSTER BOOK OF MORE
MANGA

Edited by Ikari Studio

COLLINS DESIGN

An Imprint of HarperCollinsPublishers

MONSTER BOOK OF MORE MANGA
Copyright © 2007 by COLLINS DESIGN and maomao publications

First Edition:
Published by maomao publications in 2007
C/ Tallers, 22 bis, 3º1ª
08001 Barcelona, Spain
Tel.: +34 934 815 722
Fax: +34 933 174 208
mao@maomaopublications.com
www.maomaopublications.com

English language edition first published in 2007 by:
Collins Design
An Imprint of HarperCollins Publishers
10 East 53rd Street
New York, NY 10022
Tel.: (212) 207-7000
Fax: (212) 207-7654
collinsdesign@harpercollins.com
www.harpercollins.com

Distributed throughout the world by:
HarperCollins Publishers
10 East 53rd Street
New York, NY 10022
Fax: (212) 207-7654

Publisher:
Paco Asensio

Editorial Coordination:
Cristian Campos

Illustrations and texts:
Ikari Studio (Daniel Vendrell, Iban Coello, Joaquín Celis, Santi Casas)

Translation:
Christine Schroeter
Enric Ruiz-Gelices
Verónica Fajardo
Felipe Vallejo

Art Direction:
Mireia Casanovas Soley

Layout:
Zahira Rodríguez Mediavilla

Library of Congress Control Number: 2006940284
ISBN-13: 978-0-06115169-9
ISBN-10: 0-06-115169-6

Printed in Spain

First Printing, 2007

CONTENTS

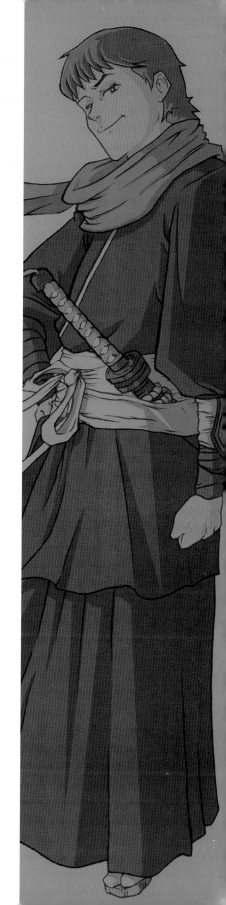

INTRODUCTION

What has happened with Manga? Well, what has happened is that Manga has been introduced at every level; Manga is everywhere. What for many started as a passing fashion is now acknowledged worldwide as the most important trend in comics.

In the 1990s, the real Manga invasion started in international markets. Generations of children all over the world suddenly discovered that most of the cartoons that had stolen their hearts were known as Anime in their country of origin. Most of them came from comic strips called Manga. This art form from the country of the rising sun started to attract fans from all over. The audience wanted more, much more. Producing more series and more characters was no longer enough. As time passed, Manga culture was exported to the world, like hundreds of influences from the Japanese culture before it. These days, Manga is Japan's most representative artistic and iconographic culture. Its philosophy, its graphic vocabulary, and its characters are now the modern archetypes of classic Manga stories.

But its influence has been strongest without a doubt not in cinema and animation, but in the artistic fields of narrative and comics. During the last few years, hundreds of draftsmen and scriptwriters have emerged, who, unashamed of their influences, are proud of being among the new wave of authors influenced by Manga.

At a certain point, it became necessary to create a teaching tool so that artists could create their own Manga aesthetics, and this handbook aims to fulfill that need. Manga is not an immutable being. Therefore, it is affected by the evolution of genres and styles, and in this book we want to demonstrate these facts.

We have prepared this book by looking into the past to recover topics and genres that seemed forgotten but that every fan knows. We thought that we should resurrect these for this edition. But we also look to the future, seeking the most novel aesthetic and color treatments, and we make every attempt to reveal their secrets. Overall though, we remain 100 percent focused on the present in order to offer you the best information and advice possible.

This time, we have created an array of exercises in which, from the first glance to final art, you can see how an illustration evolves until it is ready to be printed. You can find several detailed exercises organized by genre and type.

In this book, we will enter the world of Tokusatsu and Sentai, filled with transformations, powerful heroes and robots, and gigantic monsters. Tokusatsu is the TV genre of action series and Japanese superheroes. This genre has a broad tradition and has passed the test of time because it is still popular today. In the first Tokusatsu series, effects were produced by drawings, supported by camera effects, firecrackers, cable tricks, and massive loads of imagination and good will. Now the computer has replaced many of these tricks and has taken the genre to the next stage. Tokusatsu is represented mainly by Ultraman, Kamen Rider, and the Super Sentai series, the Power Rangers being the best known of the genre thanks to Saban's adaptations.

We will also review the martial arts genre, one of the broadest and with most influential in the world. A genre that floods Mangas, Anime, and of course, video games, this has given Manga easy entrée to the West. It has transformed some sagas, such as Street Fighter, into authentic, well-loved classics. We will use feminine beauty as a unifying thread in the review of our heroines. And we will learn how to transform heroines into stars.

We will also take a ride down the dark side, getting a good look at the evil and antagonistic characters that make our heroes' lives so difficult. We will learn how to draw enormous, lurid villains for our most incredible stories.

Little by little and step by step, we will take you hand in hand from the simplest exercises to the most complicated illustrations. We will see different styles and finishes for illustrations and show you how to produce the most professional finishing.

And finally, like the proverbial icing of this cake, there is a new section for all of those who want more than a few nice drawings. This time, you can enjoy very detailed step-by-step descriptions in which we reveal all of our secrets so you can really take control of the colors you'll use. Now you will have at your fingertips all of our tricks, illustrated in great detail.

There is all of this, and much more, in this amazing book.

Come with us once more on an incredible and gigantic trip through the Manga drawing universe, and learn how to draw Manga like a pro.

PETS

PHOENIX

The Phoenix is a mythological creature that has become a popular icon; the bird of fire is supposed to come back to life from its ashes eternally, thus representing continual rebirth and immortality.

To draw a Phoenix, imagine a sort of pheasant with a long tail of beautiful feathers, which will be colored in warm and very saturated tones to make them resemble flames. In this case, the figure is less stylized than usual because we have chosen to do a more amusing version of the creature by drawing a super-deformed Phoenix. We will draw a chubby bird, with a thick, strong neck; a head that is chunky and round; and a pair of enormous eyes.

1. Shape

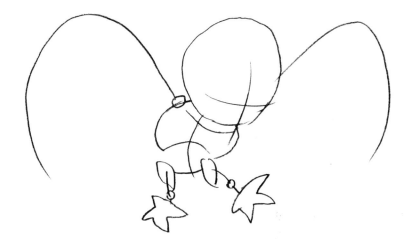

Sketch the bird with wings outstretched, legs spread, and head bent forward to indicate that the bird is landing.

2. Volume

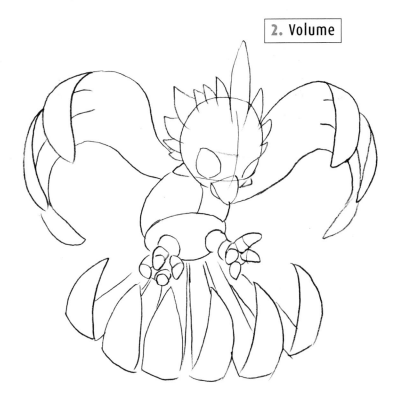

Draw in more detail. This is a very simple figure, so just draw the basic shape of the feathers on the tail and on the wings.

Source of light

Show that a soft light models the profile of the plumage and projects the Phoenix's shadow on the ground.

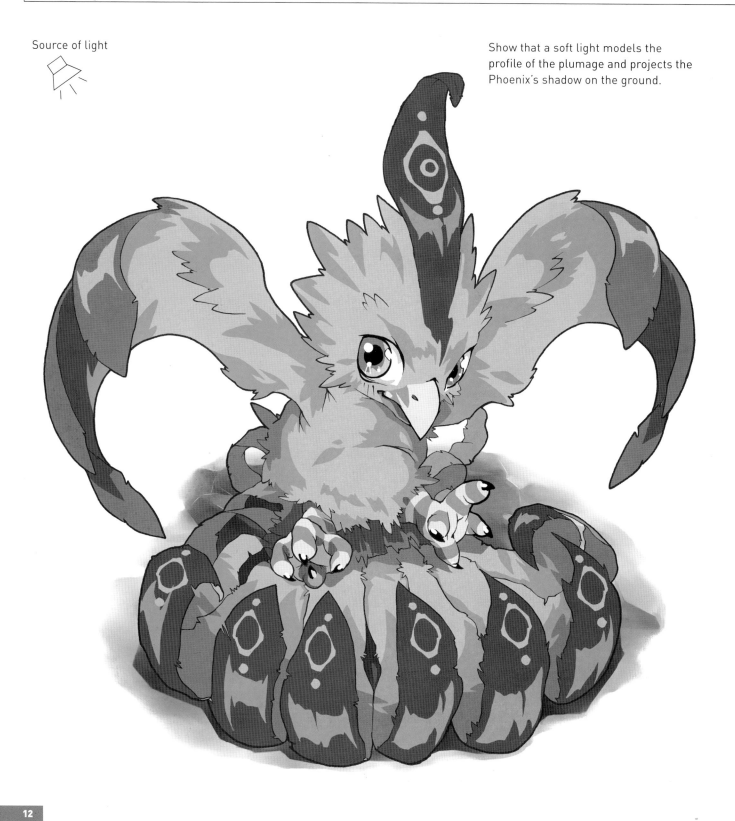

4. Color

The colors here create an incandescent atmosphere with intense shades of reds, oranges, and yellows. Graduate the intensity of the colors to represent the texture of the plumage. Green-colored eyes stand out from the firelike plumage.

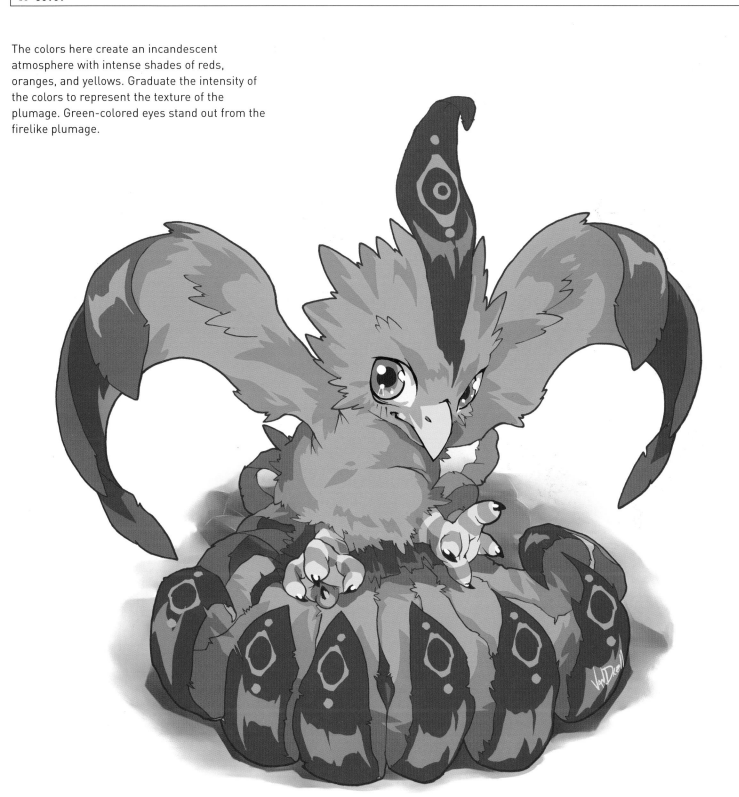

PETS

This project depicts a scene with a cheerful, carefree atmosphere to show the joy that a monster pet can bring to a girl's life. The monster pets should resemble friendly-looking teddy bears, with chubby bodies, thick fur and gentle eyes.

We want to show the ideal pet, so it would not work to create little monsters with aggressive-looking components. That is why we avoid showing claws, teeth, or spikes on these animals. But yes, they are still monsters; they just have a teddy bear look. So we can draw them as lively characters, even with a mischievous look indicating that they are up to some prank.

1. Shape

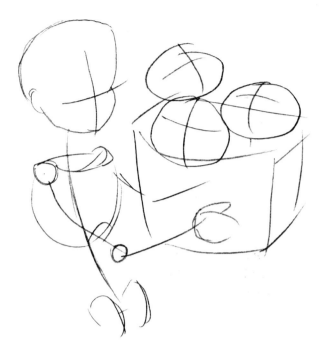

For now, do not draw the clothing. Begin by drawing the girl as if she were naked, concentrating on the pose—in this case, holding a box.

2. Volume

Draw the shape of the front shoulder and arm so it looks as if she is holding the box with both hands. By putting the hand on one side of the box, it is understood that her other hand is in the same place on the other side.

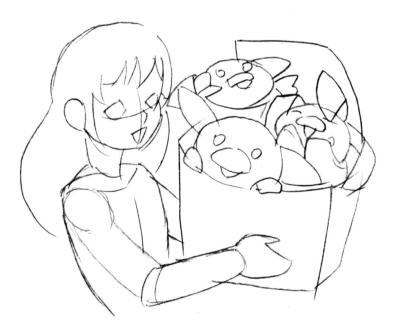

3. Clothes

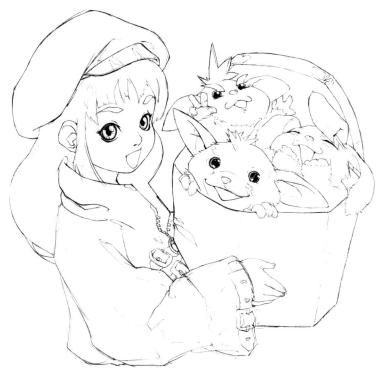

Now clothe the figure in bulky garments. The extravagant newsboy-style cap creates large folds as it falls down by its own weight.

4. Lighting

Source of light

Add shine to the coat to make it look like a raincoat. Draw in shadows beneath the folds of her cap to give it more volume.

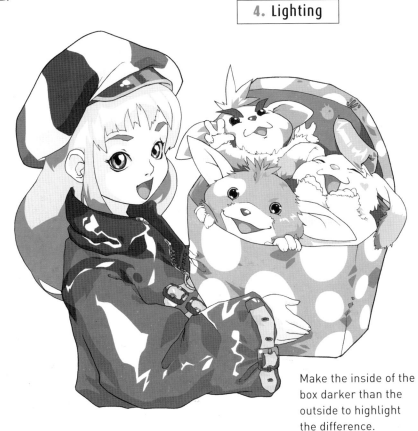

Make the inside of the box darker than the outside to highlight the difference.

5. Color

Use bright colors to give the picture a feeling of happiness. Amplify this with a background patterned in pastel-colored circles.

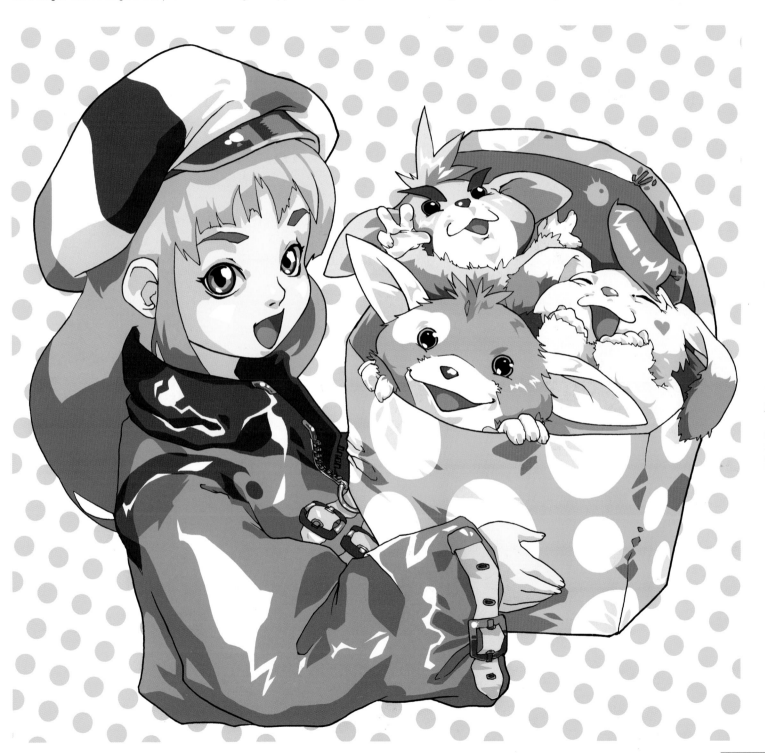

MONSTER TRAINER

There is a genre of stories that is becoming increasingly popular amongst teenagers—one of cute monsters that compete with each other and use strange powers to win each combat, powers that are generally associated with nature or with the monsters'environment. As a matter of fact, the search for different kinds of creatures is part of the plot of these stories since the protagonists are not just the monsters but also the boys and girls who look after them and teach them how to make best use of their powers: the monster trainers. The relationship between trainer and monster is usually a very close one, so close that it more closely resembles a friendship than an owner-monster relationship.

1. Shape

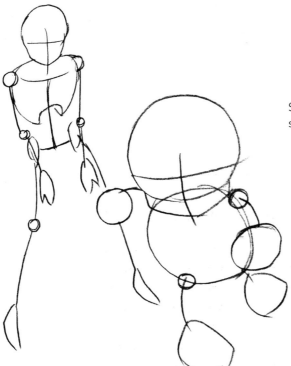

Sketch the monster as a fat figure with very simple curves, created from a series of circles.

2. Volume

Draw the trainer in a more passive attitude. She encourages the monster, which advances with pronounced movement—indicated with a foreshortening effect.

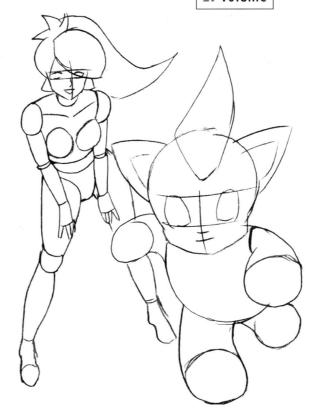

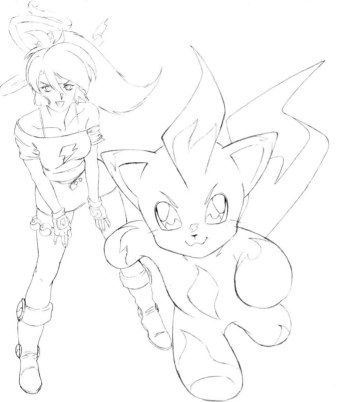

Monster trainers use spheres to trap the creatures. The monsters go in and out of the spheres like genies do a magic lamp. Always include some spheres, like those hanging from a strap on the girl's leg.

4. Lighting

Source of light

Because this character is based on simple lines, the shadows on the skin of the monster have to be drawn as continuous lines. These give the monster its volume, producing a curved and smooth surface effect.

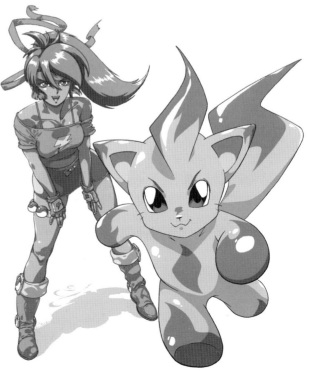

To complement the childish theme, use shiny coordinating colors. The motifs on the monster's skin should stand out nicely and should be drawn in shiny colors.

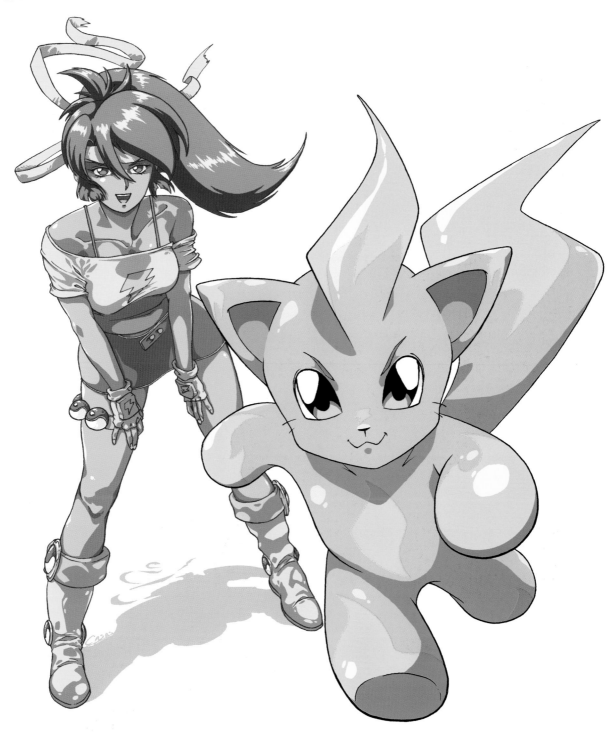

GIANT TEDDY BEAR

Who hasn't seen it in a movie or an illustrated children's book: the typical giant monster that can be gentle and sweet-tempered and makes friends with children? This creature should look like a teddy bear. Let's imagine a chubby and very soft body, covered with fur, with big round eyes. To give the scene an affectionate, likable feel it would suffice to have the girl hug the monster and play with it in a carefree manner. The monster coddles the girl passively, and she is the active one in the scene. The monster's good nature will be obvious.

1. Shape

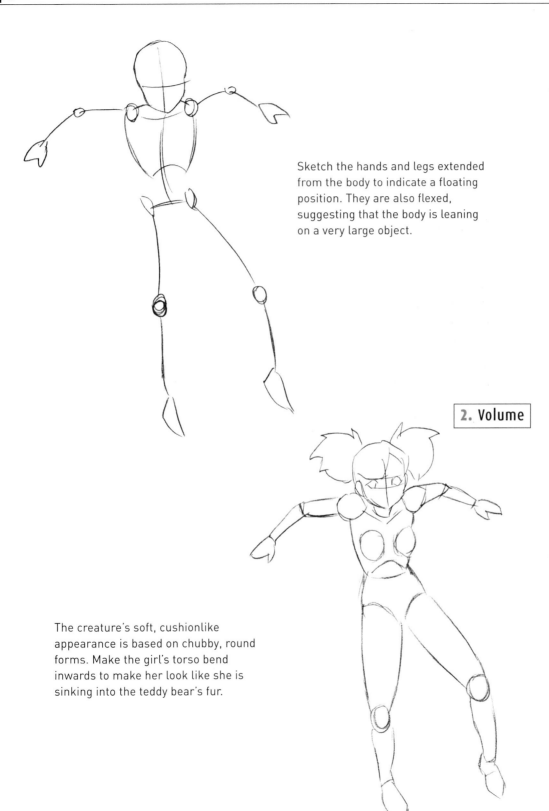

Sketch the hands and legs extended from the body to indicate a floating position. They are also flexed, suggesting that the body is leaning on a very large object.

2. Volume

The creature's soft, cushionlike appearance is based on chubby, round forms. Make the girl's torso bend inwards to make her look like she is sinking into the teddy bear's fur.

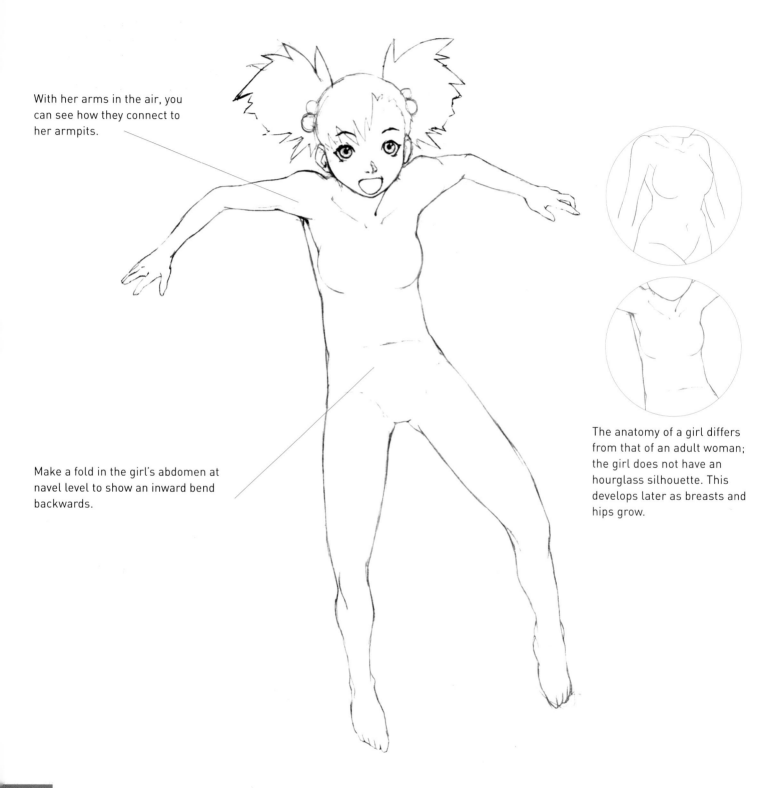

With her arms in the air, you can see how they connect to her armpits.

Make a fold in the girl's abdomen at navel level to show an inward bend backwards.

The anatomy of a girl differs from that of an adult woman; the girl does not have an hourglass silhouette. This develops later as breasts and hips grow.

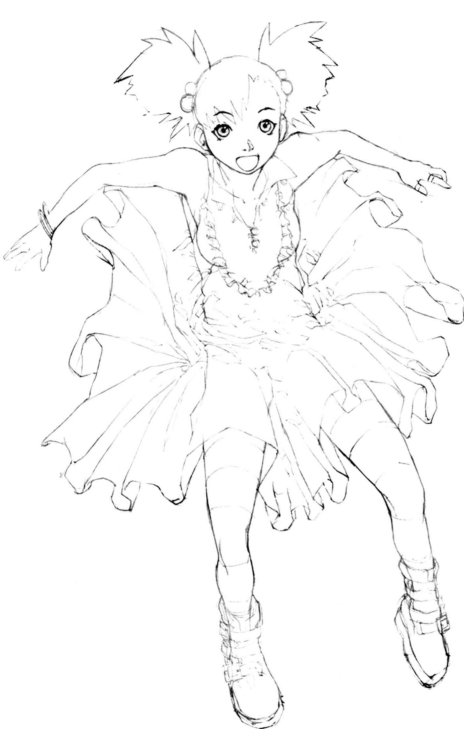

The girl's slightly punkish appearance is achieved with the addition of torn, striped stockings and heavy military-style boots. A wild, angular haircut underscrores the rebellious look.

Use dark shading to show the wrinkles in the center of the skirt as well as the shadows on the larger folds. Make square-cut, irregular shadows on the monster's fur.

Source of light

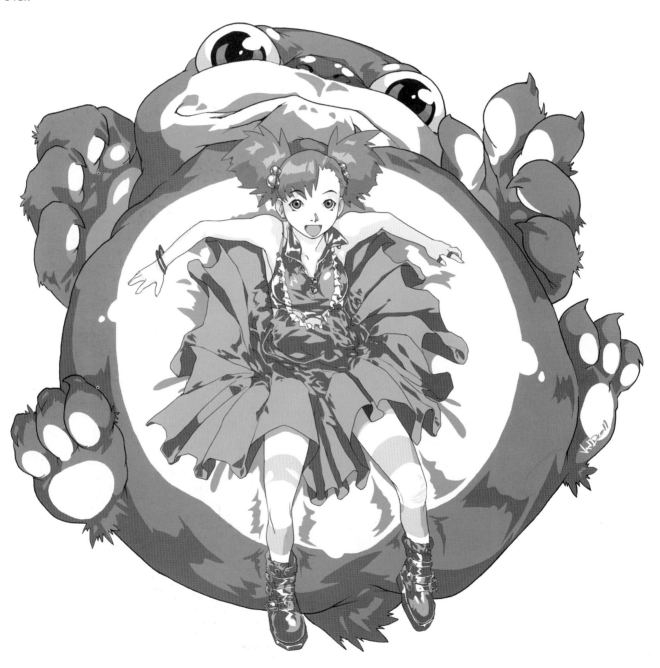

6. Color

Use less saturated, cold colors, predominantly violets and blues, to give a lighter skin tone and a soft look overall.

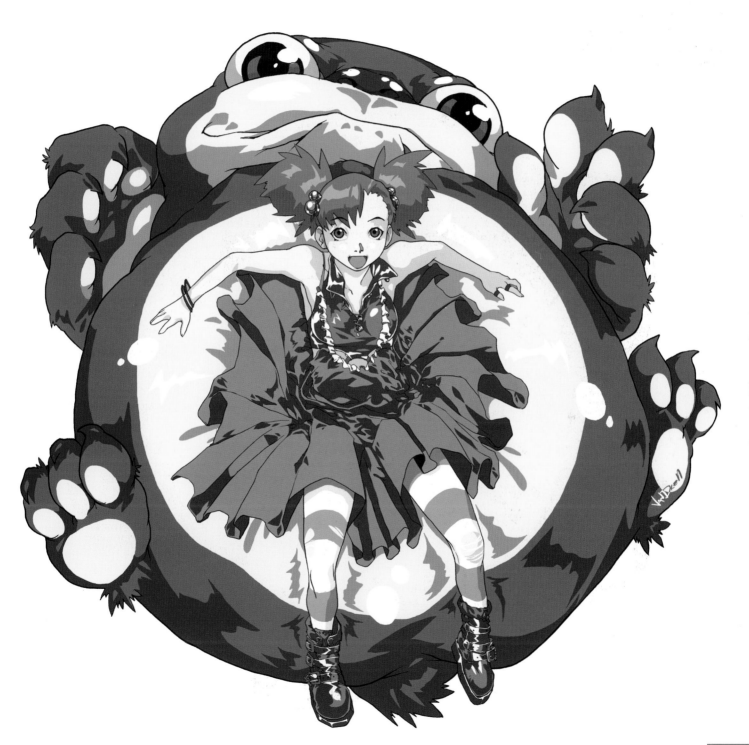

TECHNO-PET

The most commonly used formula to draw monsters in children's stories is to turn these monsters into pets for kids: they adopt them, take care of them, and become partly responsible for their lives.

The techno-pet is a futuristic version of the monster-pet. Usually it is a kind of virtual creature that seems to appear as a hologram or a shape of light that suddenly takes a physical form. These types of stories are very frequently based on the relationship between children and their pets, and they extol ethics, values, and responsibility, as well as feelings of friendship and comradeship in the kids.

Before drawing the child, draw two lines that determine the position of the board.

The boy's feet should be located on the plane delimited by the board.

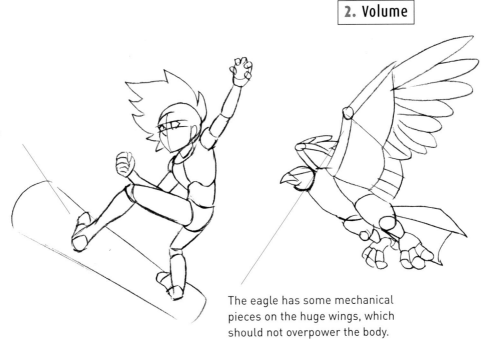

The eagle has some mechanical pieces on the huge wings, which should not overpower the body.

Draw each character separately, so you can focus on their design and not on the way they overlap. Techno-pet designs tend to be eye-catching and usually combine the most typical body parts of the animal or monster, with futuristic elements added. These creatures change their appearance as they evolve, going from simple, chubby shapes to more advanced, complex, and aggressive figures—all of which indicates an increase in their power.

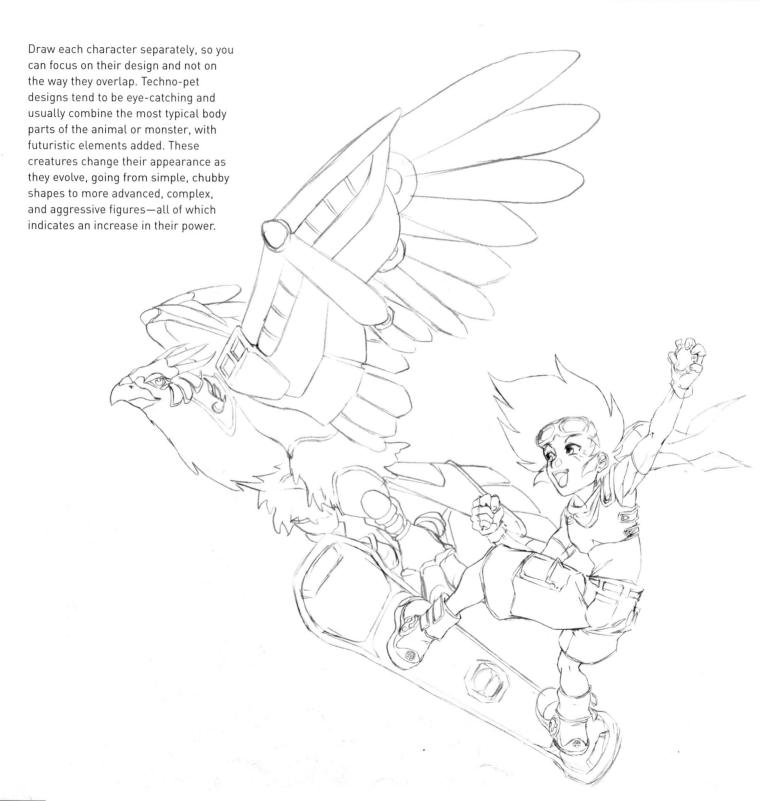

The device the kid is lifting with his left hand produces a sort of hologram with a logo that reveals the connection between him and his techno-pet. The logo that the techno-pet has around its neck also lights up. The strongest light comes fom the boy's device, which emits powerful shafts of light.

Source of light

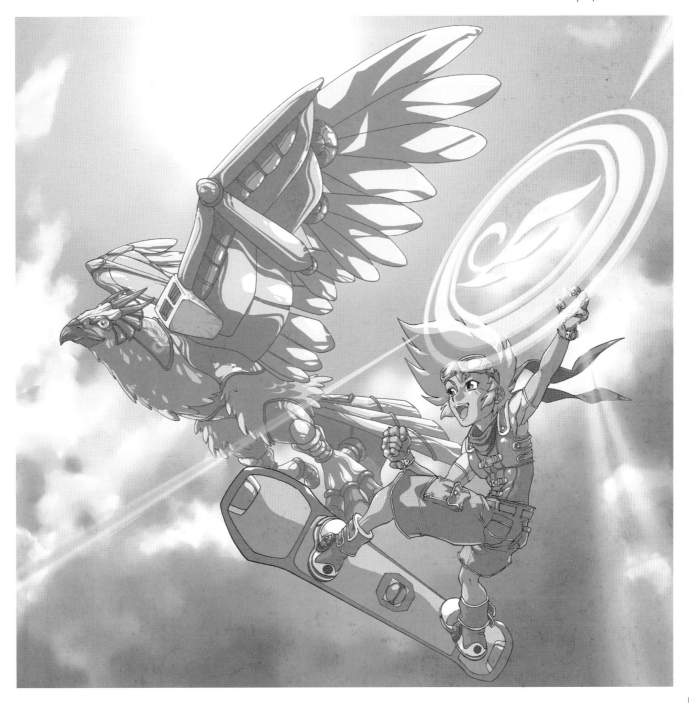

Color the figures with outlines in flat colors, and represent volumes with flat and well-defined shadows.

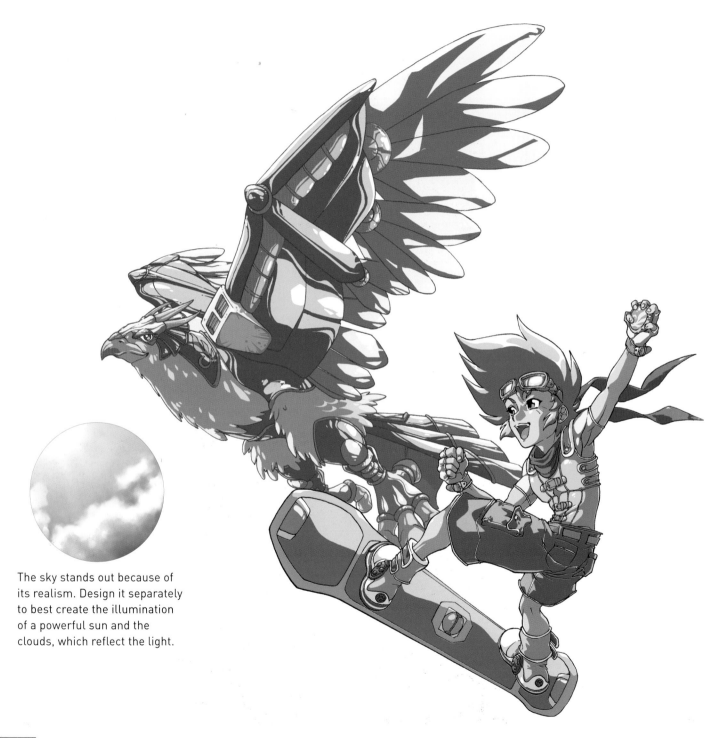

The sky stands out because of its realism. Design it separately to best create the illumination of a powerful sun and the clouds, which reflect the light.

Add more effects with white trails that follow the movement of the figures, creating an extremely dynamic scene.

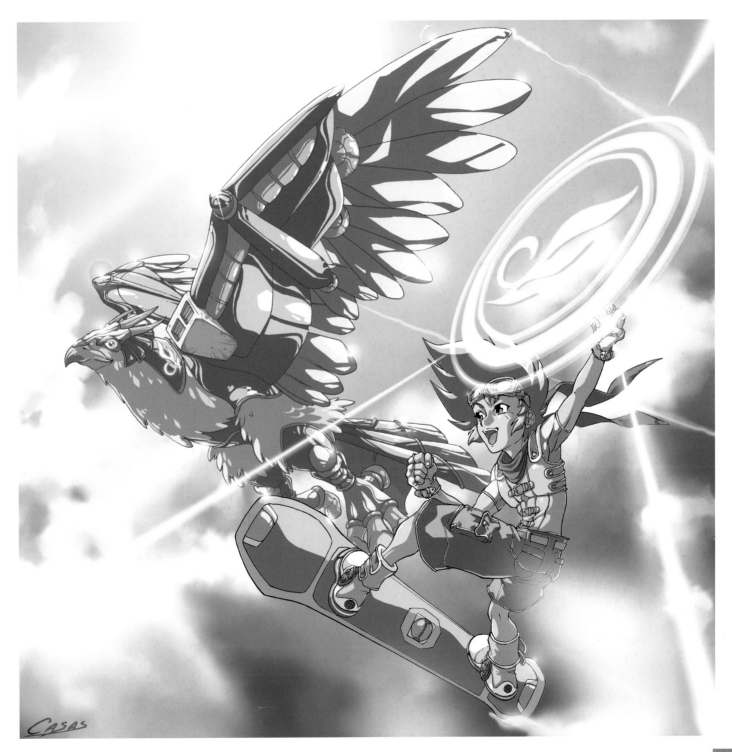

BEAUTIES

PRINCESS

Princesses are as archetypal as the knights in their shiny armor who usually come to their rescue. However, there are also different versions depending on the characteristics of each culture; even within the same kind of story, there are personality features that differentiate the girls. We are going to draw an Asian princess, who has an exotic appearance but is clearly recognizable as a princess. She's a beautiful young lady, the daughter of a king who spoils her with all kinds of luxuries, and she's innocent and romantic, always dreaming of her prince's love. We will draw the princess as super-deformed i.e. a humorous version, almost a caricature, with childlike proportions and a round head with enormous eyes.

1. Shape

Sketch in childlike proportions and a big, round head. Her extremities should seem short in comparison to the rest of her body.

2. Volume

Super-deformed characters have a very simple structure. Synthesize the elements that form the figure, and make the features of the character look smoother.

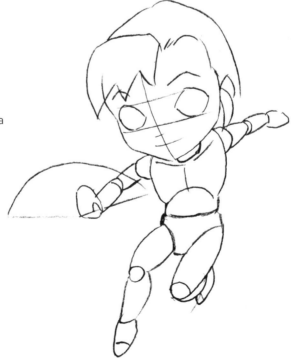

3. Clothes

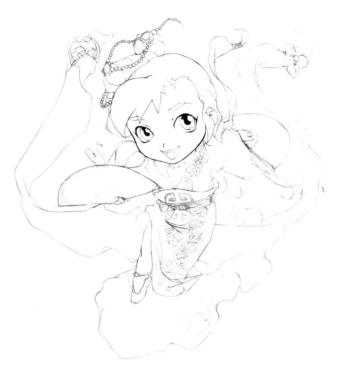

Clothing is the most telling element of this figure. Focus in on the detail as much as possible.

Source of light

4. Lighting

Darker, shaded areas give the figure volume, separating the layers and the main folds.

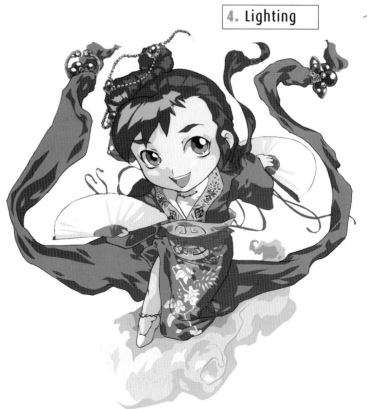

Color gives the clothing presence. Use pleasant, calm colors as well as contrast to make as happy an image as possible.

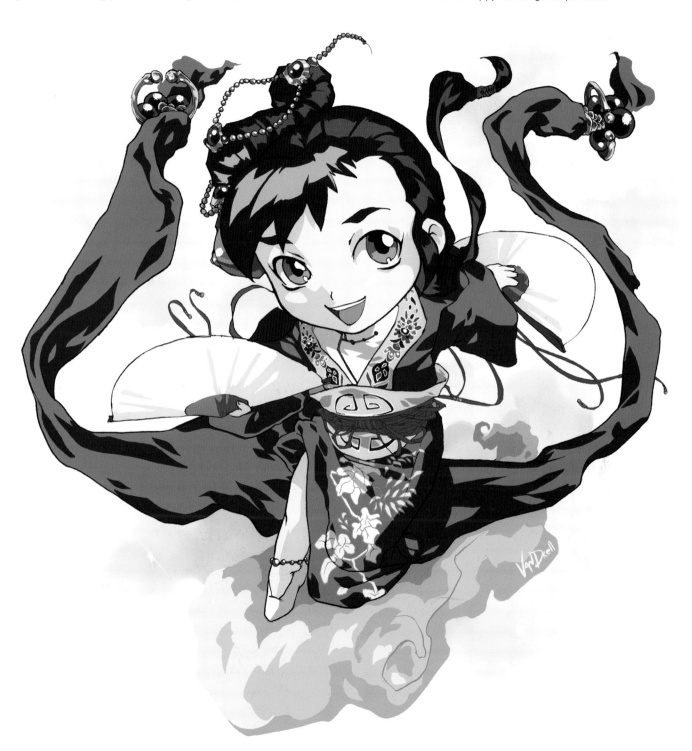

MAGICAL GIRL

Magical girls are young girls who obtain special powers as a result of magical phenomena or other similar means. They have to combine their normal life, with their lives as fighters against evil forces, which usually originates with the same source as their powers. Due to this role play, the crisis point in the story is always solved with a transformation scene, in which the girl changes into her magical-girl uniform.

In the Anime series, there are usually gestures or special magical rituals that are repeated so that the transformation can occur. In these stories, it might be necessary to include some type of object that serves as a catalyst of magical energy, or a special symbol or badge drawn in the air.

The figure is leaning backwards, and seated; its arms are spread apart as if it were on an air mattress that prevents it from falling abruptly.

2. Volume

Make the legs overlap the torso to the front and partially cover it. Make the pelvis and the abdomen fit in their own spaces as well; they should be proportionate to the other features.

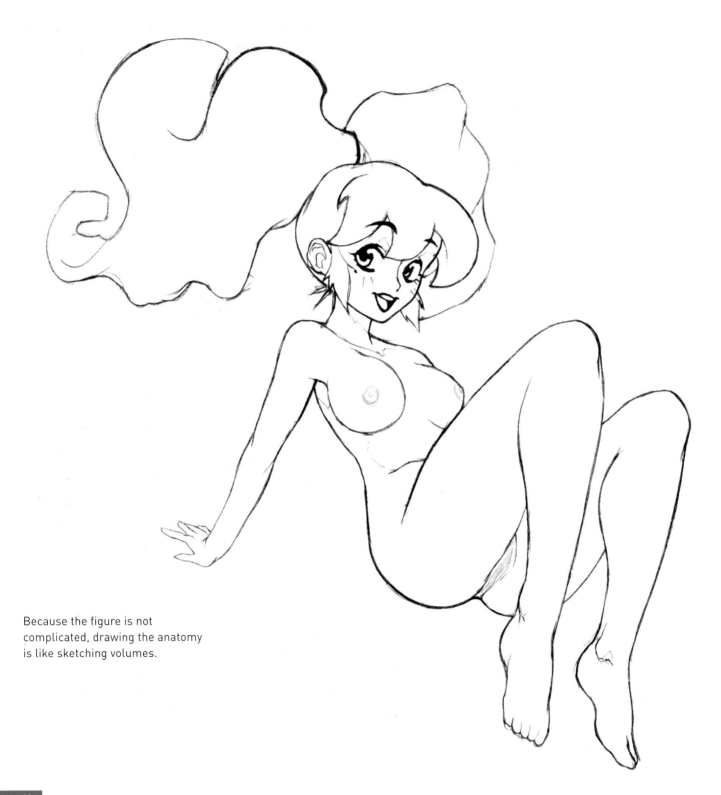

Because the figure is not
complicated, drawing the anatomy
is like sketching volumes.

The real difficulty is the complexity of the costume. Start by drawing the costume's main volumes.

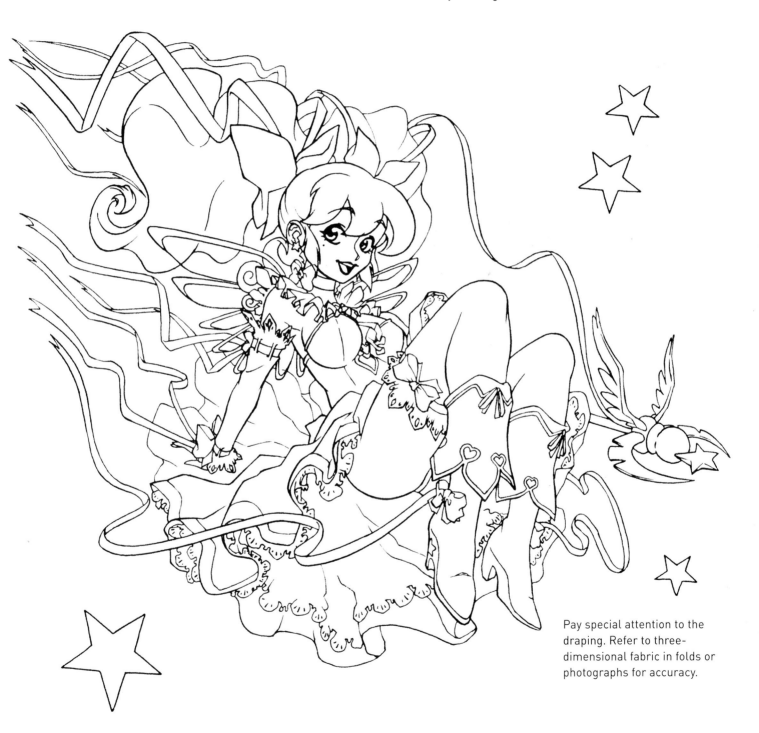

Pay special attention to the draping. Refer to three-dimensional fabric in folds or photographs for accuracy.

5. Lighting

Light in this case does not come from a specific source. It comes from the magical effect surrounding the girl. Spotlights should shine on the figure: they exentuate the outlines of shadows in the darker areas so that you can draw them.

Source of light

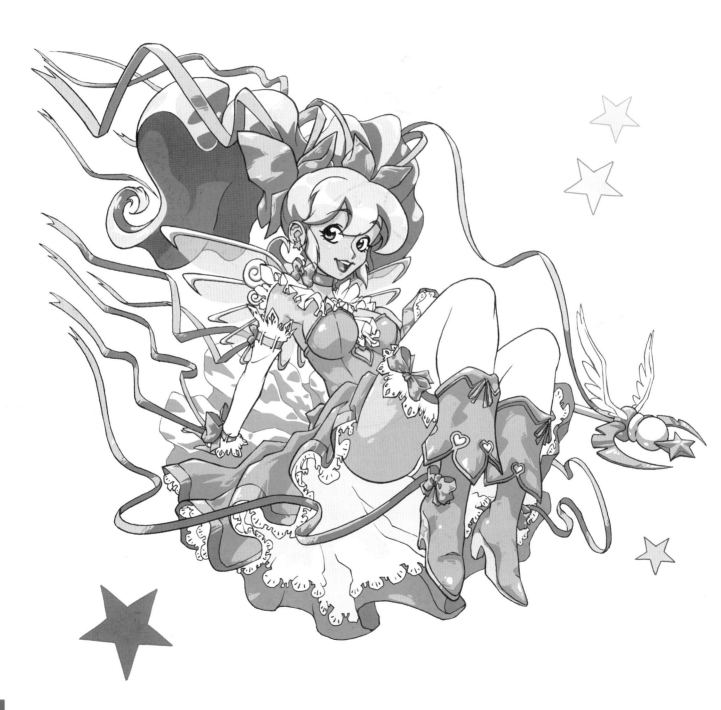

Highlight the magical girl's uniform with the yellow in the dress, boots, and wand.

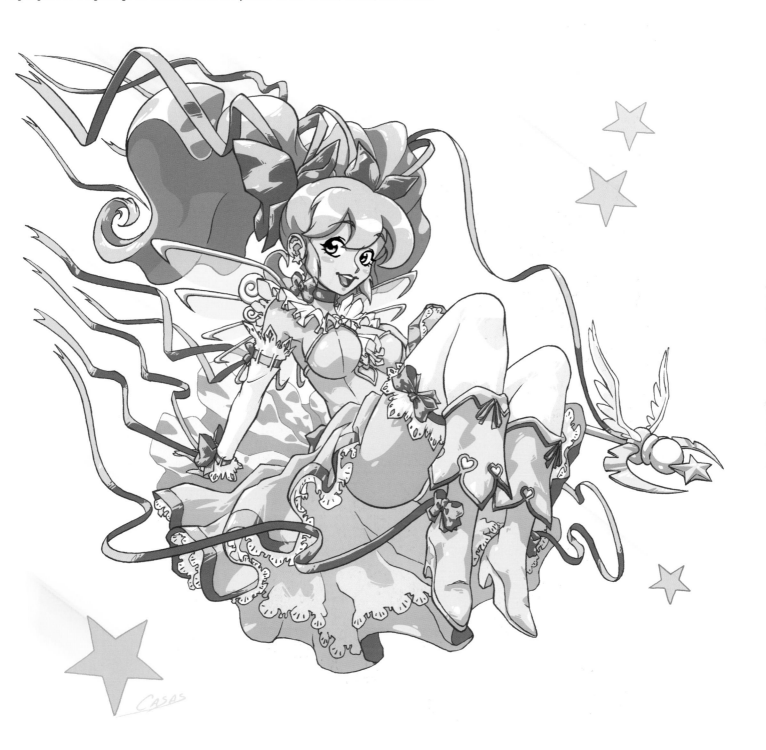

BEAST GIRL

Beast girls are a race of creatures that could very well pass for a tribe of wild girls were it not for the pointy ears, the claws, and the tail—which are not part of their attire but are really what they seem to be: parts of a beast's anatomy. The most common beast girls are hybrids of human and feline, as is evident in the catlike face, claws, and tail. However, there are also beast girls akin to other animal species, such as bears, wolves, or dogs. These are designed simply by adapting details, from the ears to the hands and feet in a way that reminds us of the other animals.

1. Shape

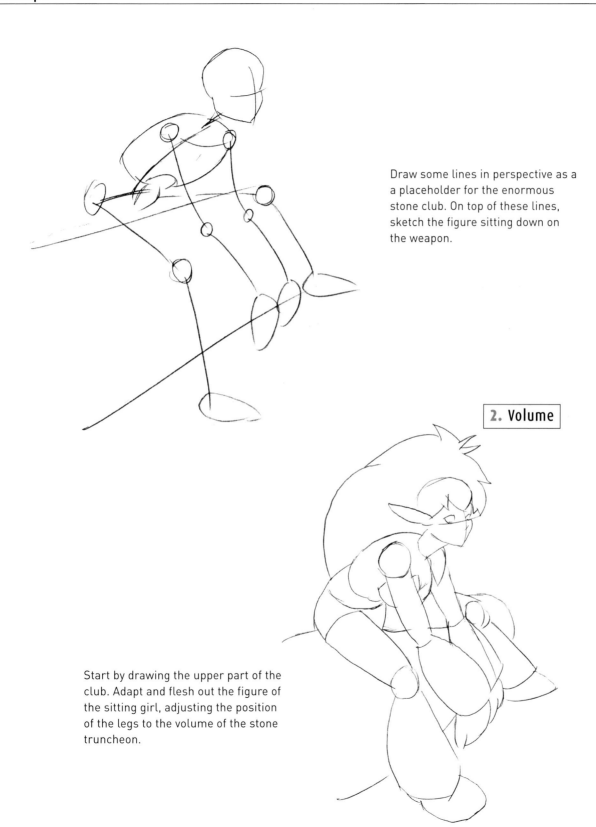

Draw some lines in perspective as a a placeholder for the enormous stone club. On top of these lines, sketch the figure sitting down on the weapon.

2. Volume

Start by drawing the upper part of the club. Adapt and flesh out the figure of the sitting girl, adjusting the position of the legs to the volume of the stone truncheon.

Draw a few pieces of animal skin to cover the girl's anatomy, which must appear muscular enough to handle the heavy, outsize club. Make the clothing look like tiger fur with its typical spots to reinforce the girl's feline nature.

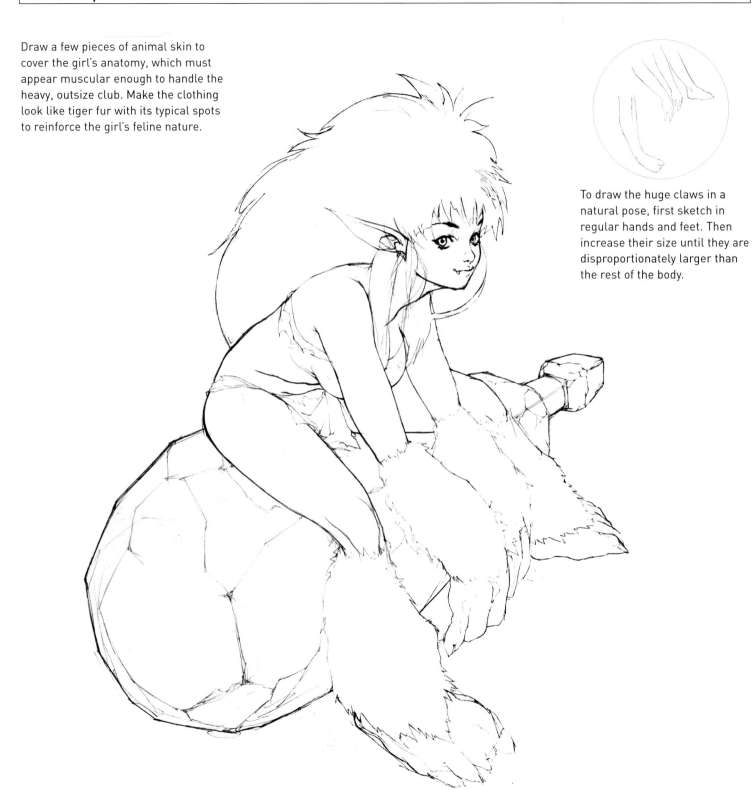

To draw the huge claws in a natural pose, first sketch in regular hands and feet. Then increase their size until they are disproportionately larger than the rest of the body.

Source of light

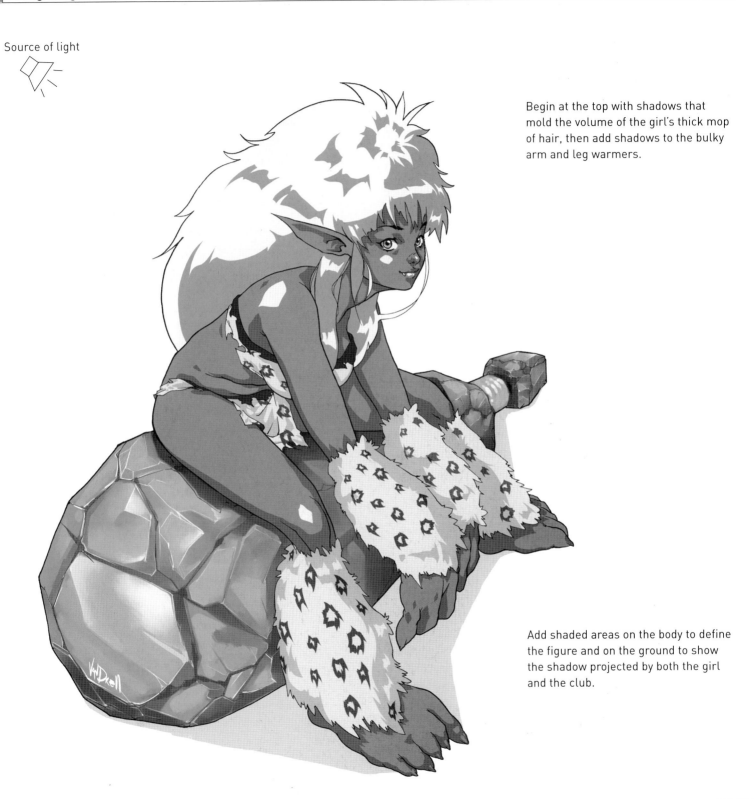

Begin at the top with shadows that mold the volume of the girl's thick mop of hair, then add shadows to the bulky arm and leg warmers.

Add shaded areas on the body to define the figure and on the ground to show the shadow projected by both the girl and the club.

Define the skin tones of the character, then the tones of the clothing, keeping to the same chromatic range or at least a narrow range of colors.

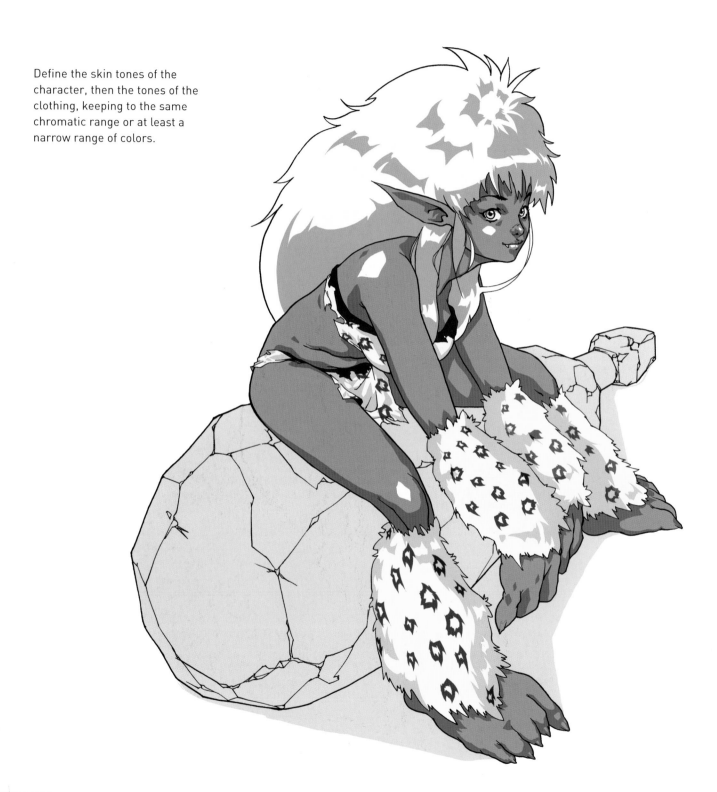

Try a palette of reddish browns, as in the skin, and earth-colored creams like the tones of the club.

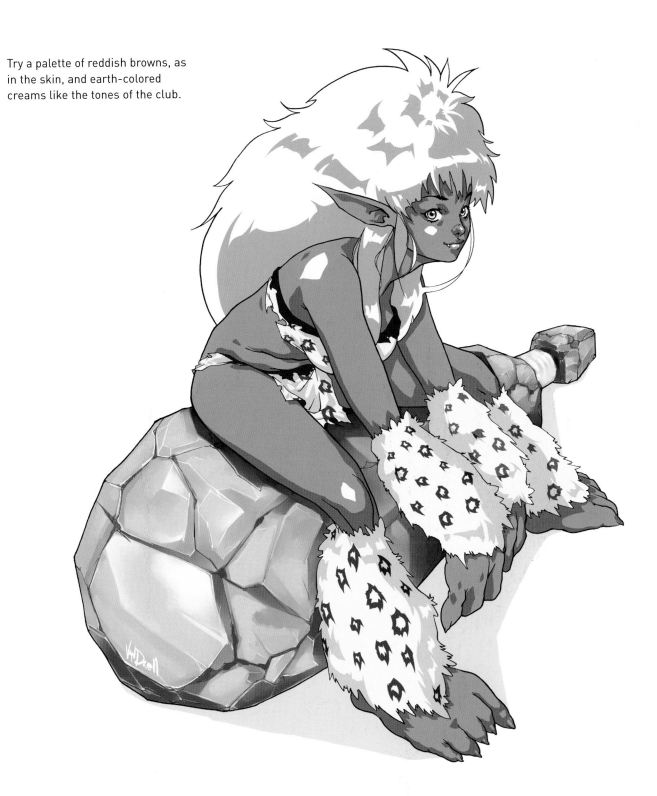

GODDESS OF GOODNESS

The gods and goddesses of Goodness usually have discrete roles in these stories. Paladins and heroes work on their behalf whenever necessary. The Goddess of Goodness may well play the role of an Oracle, a crucial character in the story who is devoted to supporting the heroes and warning them of dangers. The Oracle knows everything that is and has been, so she knows the future and can advise the heroes on crucial issues. The Goddess supplies the hero with magical objects or special gifts that enable him to face monstrous mortal enemies. Rarely, she is forced to interfere directly and shows herself as a formidable warrior with magical powers and sacred weapons that are invoked as a last resort.

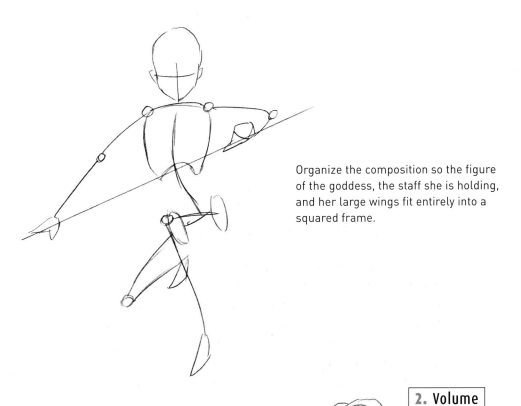

Organize the composition so the figure of the goddess, the staff she is holding, and her large wings fit entirely into a squared frame.

2. Volume

The figure follows the perspective given by the point of view of the scene. Therefore, indicate the ground plane with lines that form the underside of the legs.

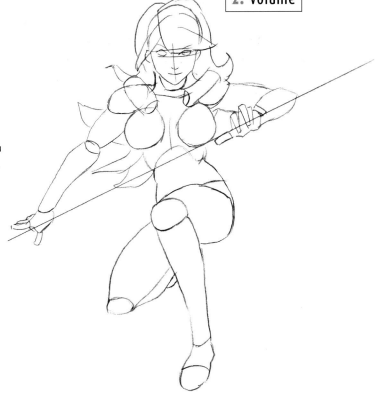

Make the facial expression penetrating and the pose defiant. They underscore her strength as she presents the weapon in front of her.

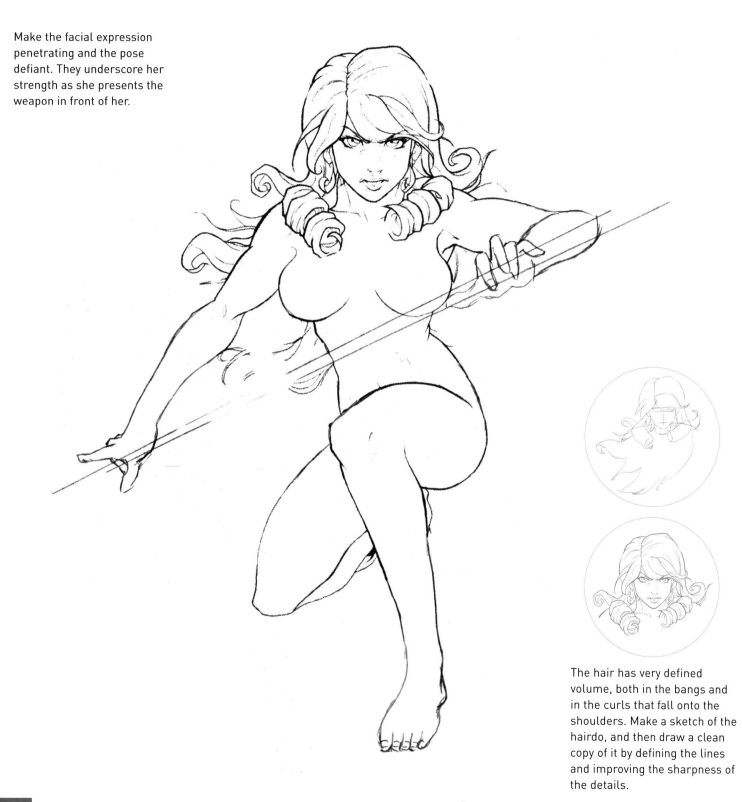

The hair has very defined volume, both in the bangs and in the curls that fall onto the shoulders. Make a sketch of the hairdo, and then draw a clean copy of it by defining the lines and improving the sharpness of the details.

4. Clothes

The figure is half-naked, save a fur loincloth and decorated boots and gauntlets. But she exhibits goddesslike dignity with her stern gaze and firm gesture.

To hide the breasts in an almost casual manner, swirl the wide ribbon attached to the staff in front of the torso.

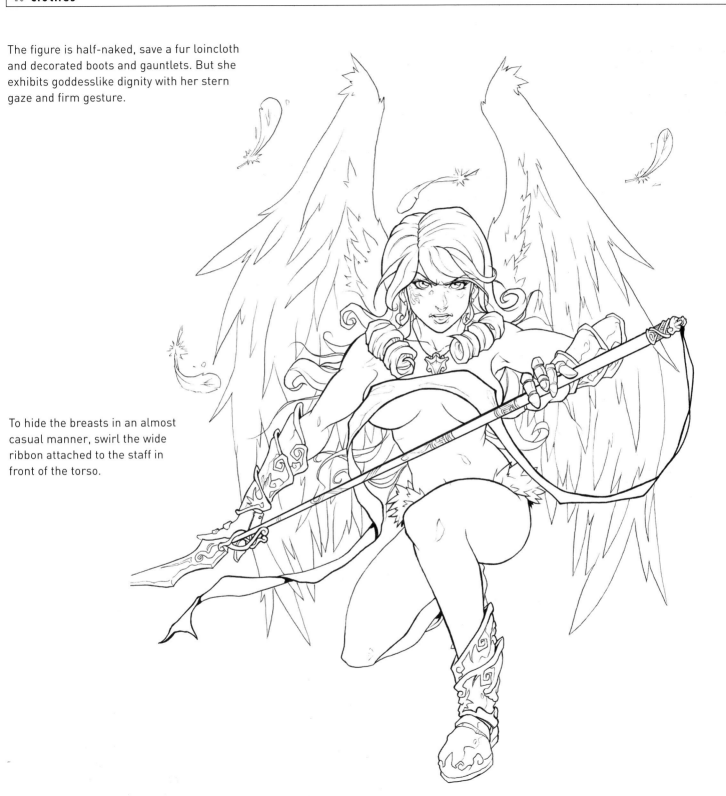

Light is important in modeling the godesslike body, and every part should be clearly displayed. The feathers of the huge wings can be made more realistic with shading. Apply more nuances to the character's face than to the rest of the figure.

Source of light

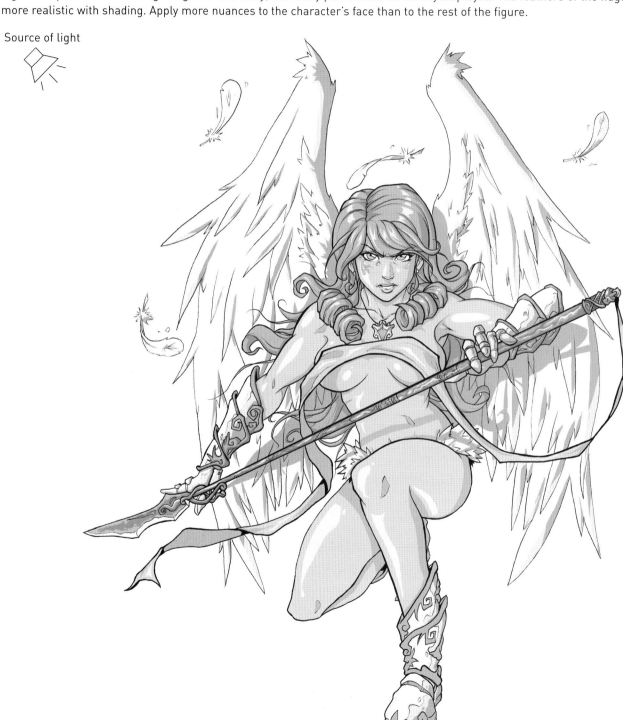

6. Color

Add the final lighting effects, which will contribute to a clear and bright atmosphere, the symbol of the purity of Goodness. Colors for this goddess should be cool and regal.

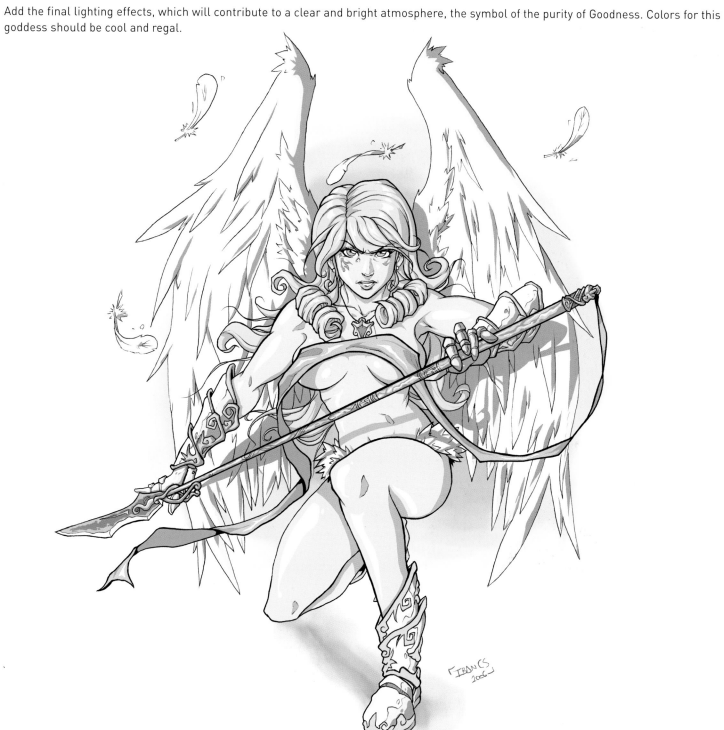

ALIEN

When thinking of an alien or another extraterrestial being, one typically imagines little green men with big heads. Let's design a more original alien character, and assume it is an attractive female, for example, with elements like wings, horns or a tail that are much different from our own shape. We should leave behind the idea that aliens have a sickly body and are intellectually superior because they have a big brain. In fact, we should not presume that this character comes from a more advanced civilization than ours but rather from some wild paradise on a lost planet.

1. Shape

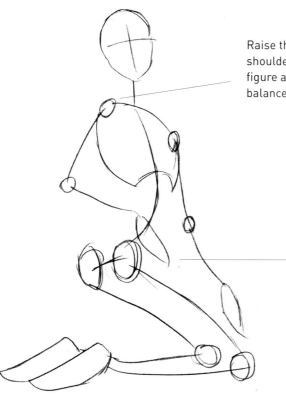

Raise the front shoulder to give the figure a more balanced position.

To obtain a natural turn of the torso, make sure the axes of shoulders and hip match up.

2. Volume

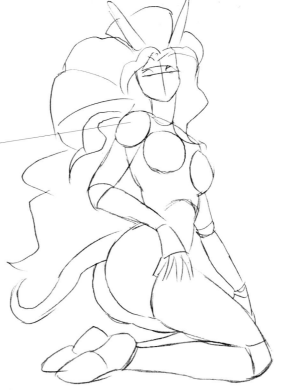

Now draw the raised shoulder and the inclined line of the collarbones. Notice that, with the turn and the foreshortening, one side of the far breast and the corresponding shoulder disappear behind the curved ribcage.

Once you are clear about how the figure looks when it bends and about how to form the breasts and the shoulders, the rest is fairly easy. Add a couple of details to a normal figure marking the difference between the alien and a human being, such as a tail, webbed fingers, pointed ears, and horns.

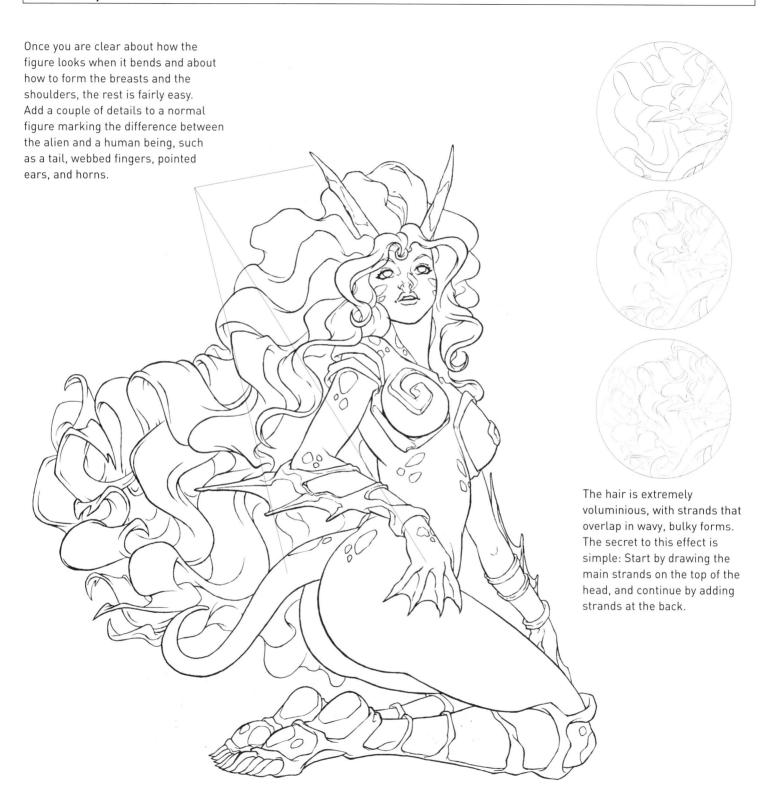

The hair is extremely voluminious, with strands that overlap in wavy, bulky forms. The secret to this effect is simple: Start by drawing the main strands on the top of the head, and continue by adding strands at the back.

Given the origin of light, concentrate
the shadows on the opposite side and
on the inferior parts of the hair,
breasts, and legs.

Source of light

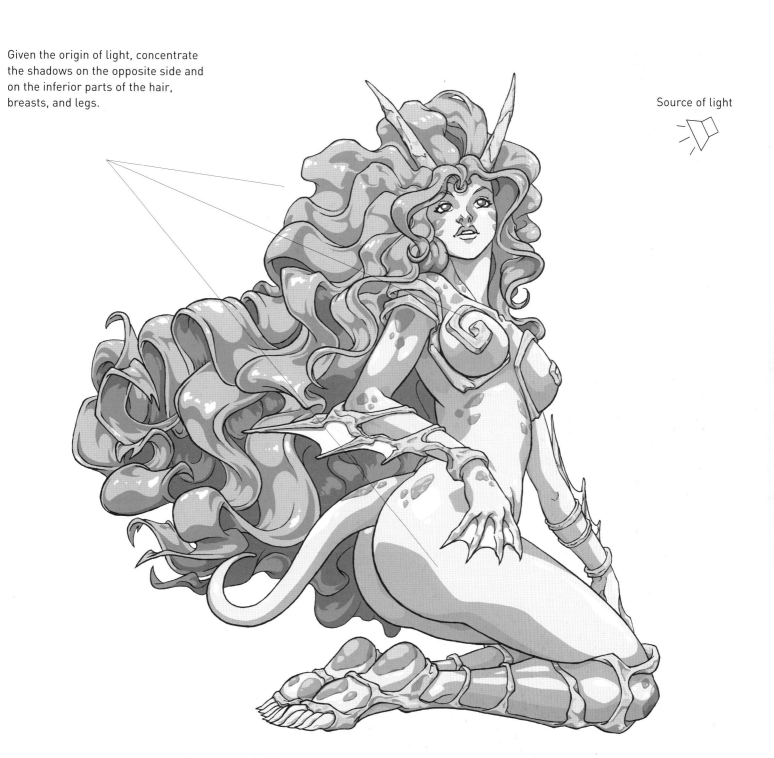

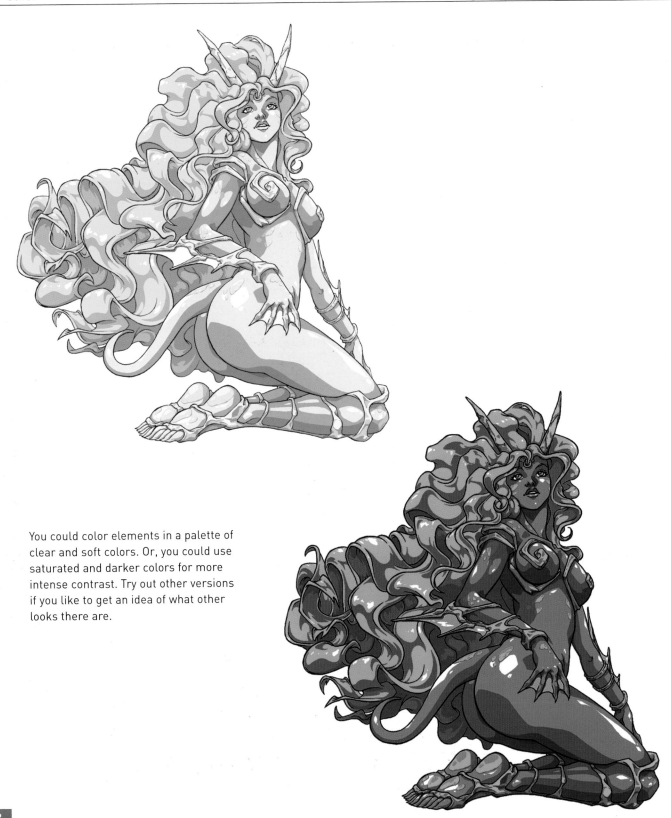

You could color elements in a palette of clear and soft colors. Or, you could use saturated and darker colors for more intense contrast. Try out other versions if you like to get an idea of what other looks there are.

As a final touch, combine the image with the background. Differentiate the two by making the background seem out of focus so that the figure stands out.

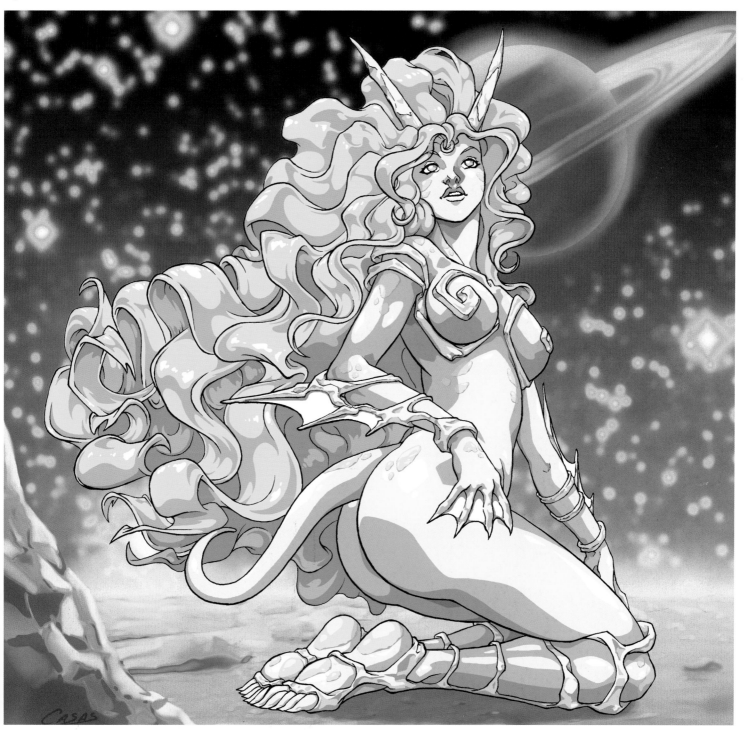

WARRIOR PRINCESS

Although we are generally accustomed to seeing girls in fantasy stories as the hero's object of desire or as a victim who needs to be rescued or defended from the forces of evil, the Warrior Princess breaks all these stereotypes to incarnate the heroine who must fight by her own means. In Manga and Anime, strong female characters are much more common. In these adventure stories, one can add the physical attributes of the girl, which allows for more versatility and takes us away from the typical testosterone-laden, frowning male warriors. Girls can be both tough and soft depending on the circumstances. The armor and the sword, which she wields with authority, characterize her as a warrior.

1. Shape

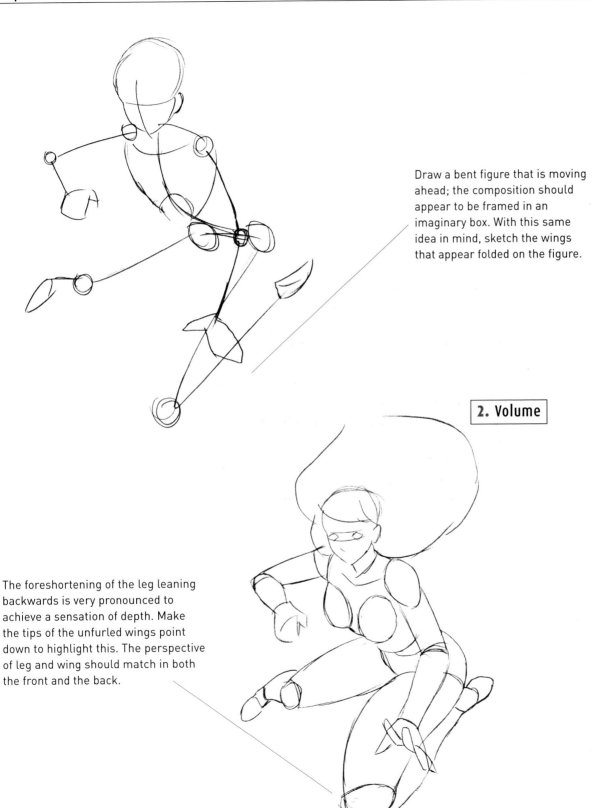

Draw a bent figure that is moving ahead; the composition should appear to be framed in an imaginary box. With this same idea in mind, sketch the wings that appear folded on the figure.

2. Volume

The foreshortening of the leg leaning backwards is very pronounced to achieve a sensation of depth. Make the tips of the unfurled wings point down to highlight this. The perspective of leg and wing should match in both the front and the back.

To create a beautiful warrior, combine a beautiful body and a sweet face with an aggressive stance. Draw the stance using a martial pose or some extra detail, such as a tattoo or a piercing. Long hair highlights her femininity; and long hair flowing against the wind completes this composition.

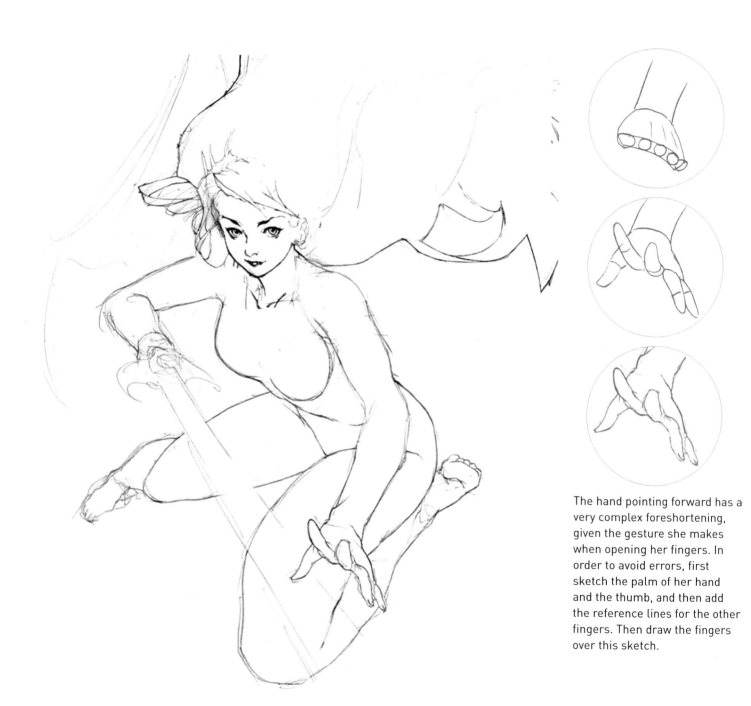

The hand pointing forward has a very complex foreshortening, given the gesture she makes when opening her fingers. In order to avoid errors, first sketch the palm of her hand and the thumb, and then add the reference lines for the other fingers. Then draw the fingers over this sketch.

The wings should also look like something between soft metal and flesh, as if they were a separate living entity.

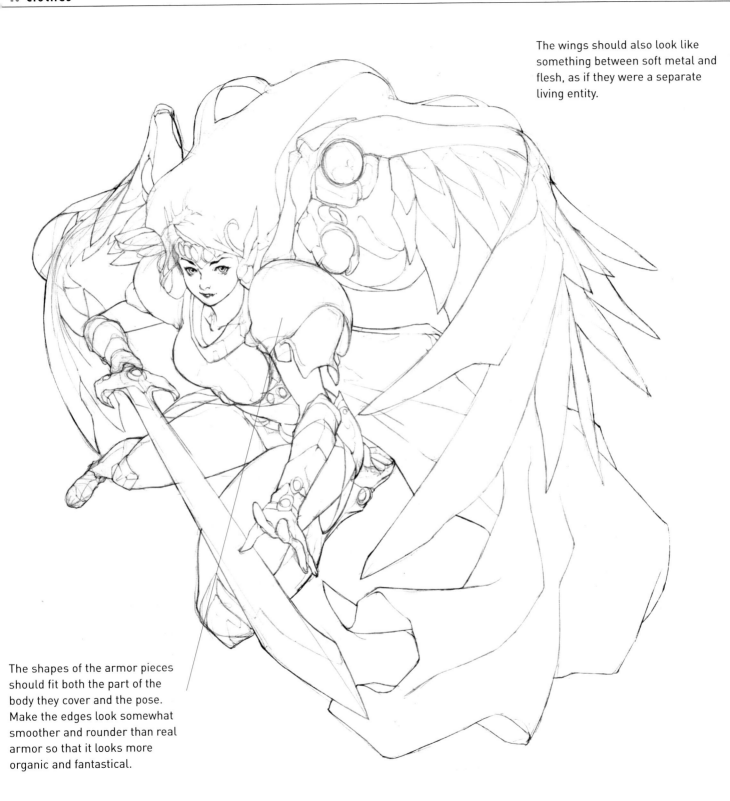

The shapes of the armor pieces should fit both the part of the body they cover and the pose. Make the edges look somewhat smoother and rounder than real armor so that it looks more organic and fantastical.

Source of light

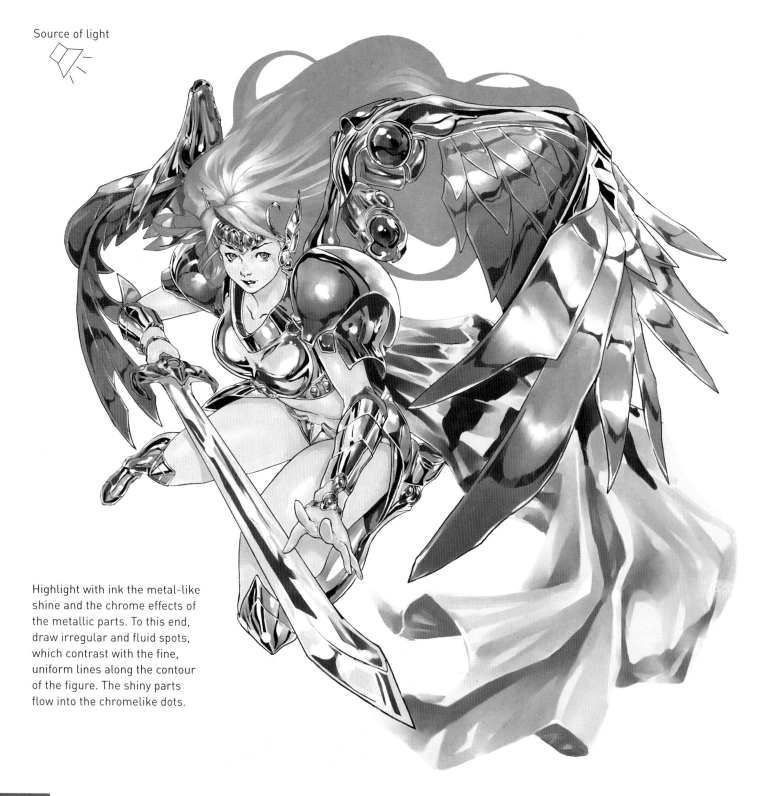

Highlight with ink the metal-like shine and the chrome effects of the metallic parts. To this end, draw irregular and fluid spots, which contrast with the fine, uniform lines along the contour of the figure. The shiny parts flow into the chromelike dots.

First apply the color base on the different parts of the clothing and the hair, and gradually determine the other colors. Once you have modeled the surface of the whole figure, add those details that require more definition, such as the interior of the eyes or the mark that the warrior princess has on her cheek. At the end, add the white shiny bits. Now the image conveys the strength required.

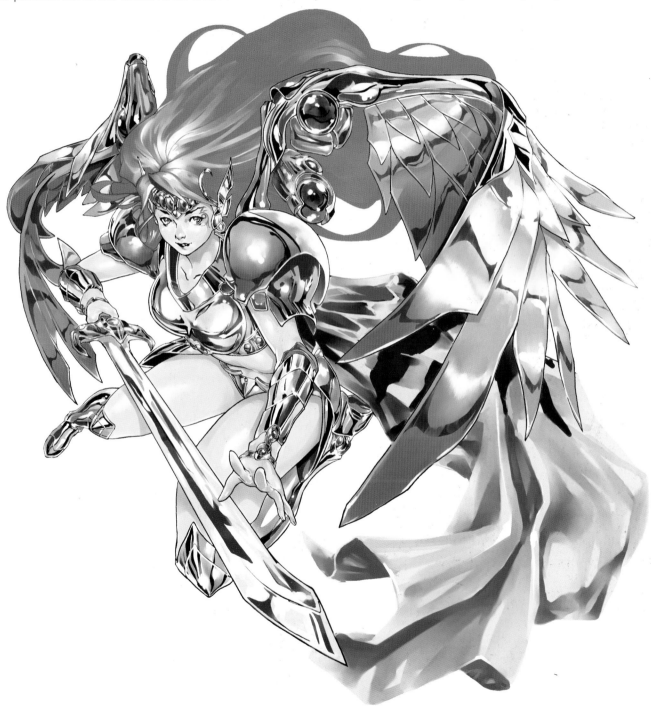

FAIRY

Fairies are small, winged creatures known as the spirits of nature because their appearance and clothing reflect their their natural habitat and surroundings. There are different types of fairies with very diverse looks, depending on whether they live in the trees of the forest, in a garden, in a pond, in the mountain, and so on until we reach as many different families or subspecies of fairies as there are environments in all the countries of the world. There are fairies all over the many regions of the planet, or at least that is the belief of the inhabitants. Fairies have different names and appearances, but they all belong equally to the family of fairies.

1. Shape

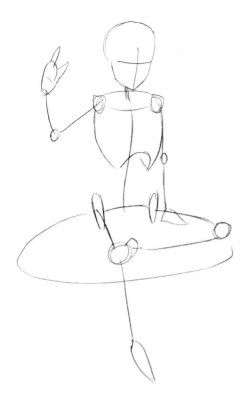

Sketch an oval as the support area—this will become the upper part of a huge flower. On top of this, sketch the outline of the figure of a sitting woman.

2. Volume

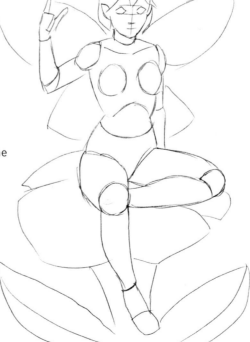

Give volume to the figure. In the pelvic area, carefully create the effect of the fairy leaning on the flower. Notice that the legs are positioned toward the front and are foreshortened.

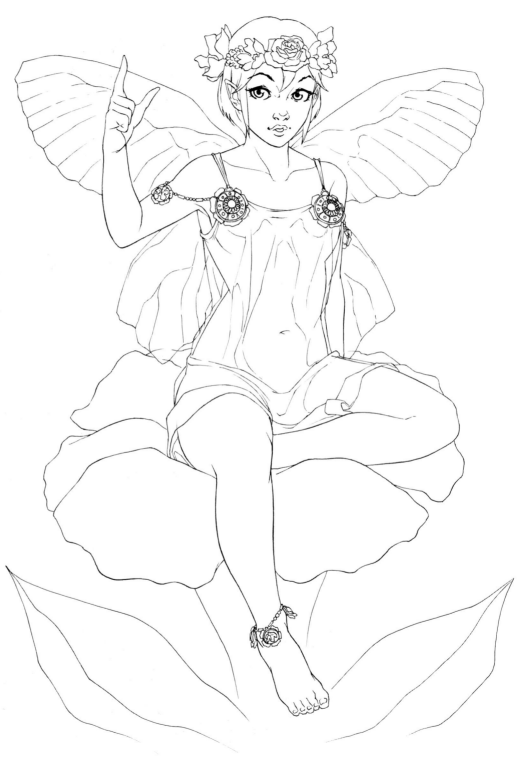

This fairy's symmetrical wings are similar to those of a dragonfly, like translucent insect wings with regular veins. Add a wreath of flowers to emphasize the fairy's connection to this aspect of nature. The dress is simple, but attach some elaborate jewelry to the straps. It should look quite pretty.

Source of light

To illuminate the figure, apply some subtle shadows that highlight the shape of the muscles. The shadows must make the wings appear to be crystal, like a type of stained-glass window. Apply many lights and shadows to the flower, which will help model the blossom's volume.

Start by applying a background of flat color to divide the different parts of the figure and the plant. On the figure, make the clothes look transparent with flesh showing through. The clothes are made of fine gauze, so play with the transition between light and shadows on the flesh, adding darker tones as you go.

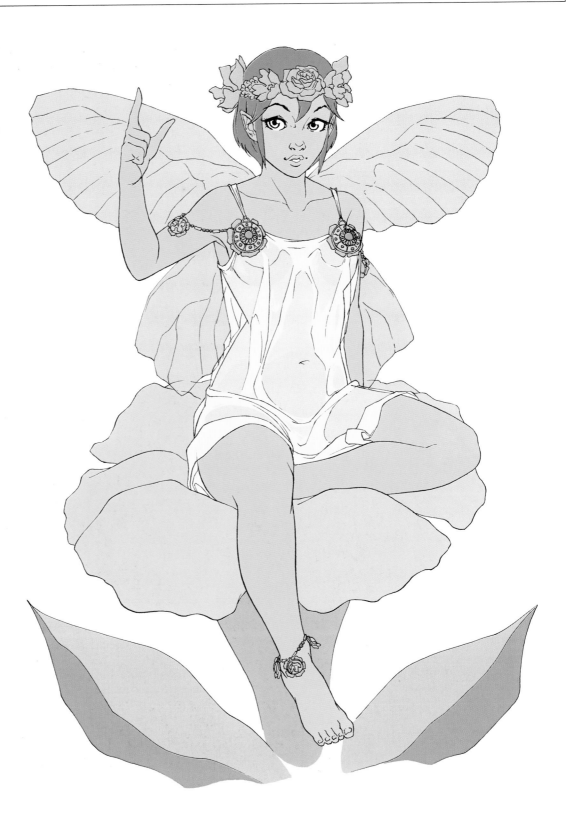

Use discrete colors on the jewelry and the floral tiara, but make the image overall quite colorful, using a range of colors in which magenta predominates. Don't forget to color the magical halo of light emanating from the fairy's raised index finger.

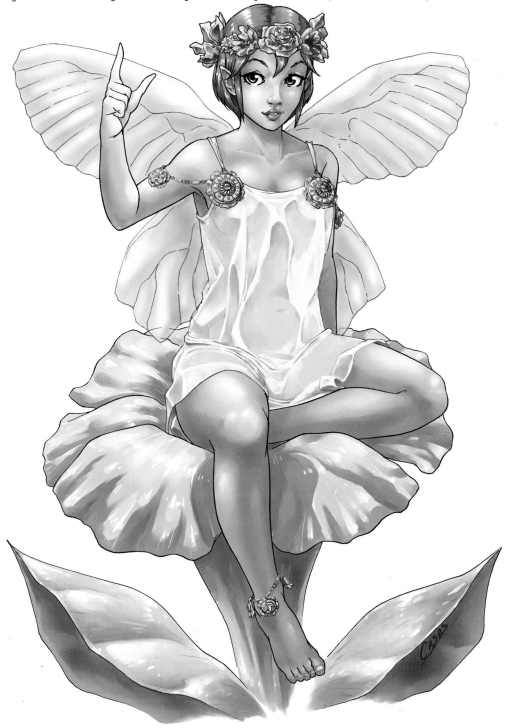

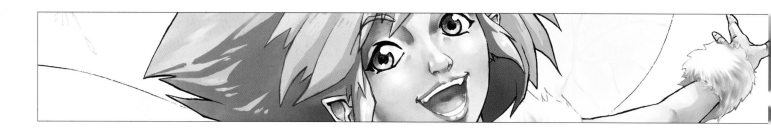

WINDY

This type of fairy is associated with the air; therefore, the image should include the effects of wind and a lot of movement, such as flying clothes or figures and objects that float in the air. We will take inspiration from figures that we can find in the forest: tree leaves, butterflies, and moths. We will design a fairy showing that this environment is its source, as reflected in its physical appearance and in the clothes and ornaments that it wears. The wind is a very light element, and it reminds us of joy and freedom, and open spaces, which is why the fairy should be depicted happily soaring through the air and floating freely.

1. Shape

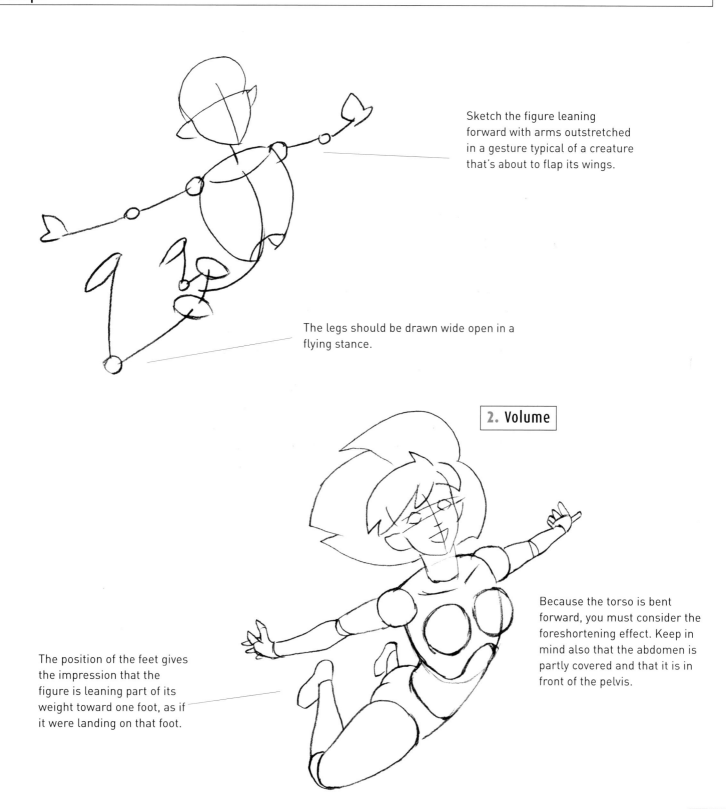

Sketch the figure leaning forward with arms outstretched in a gesture typical of a creature that's about to flap its wings.

The legs should be drawn wide open in a flying stance.

2. Volume

The position of the feet gives the impression that the figure is leaning part of its weight toward one foot, as if it were landing on that foot.

Because the torso is bent forward, you must consider the foreshortening effect. Keep in mind also that the abdomen is partly covered and that it is in front of the pelvis.

The legs, because they are behind and are foreshortened, may be difficult to draw. The fact that the legs are arched toward the inside complicates the task.

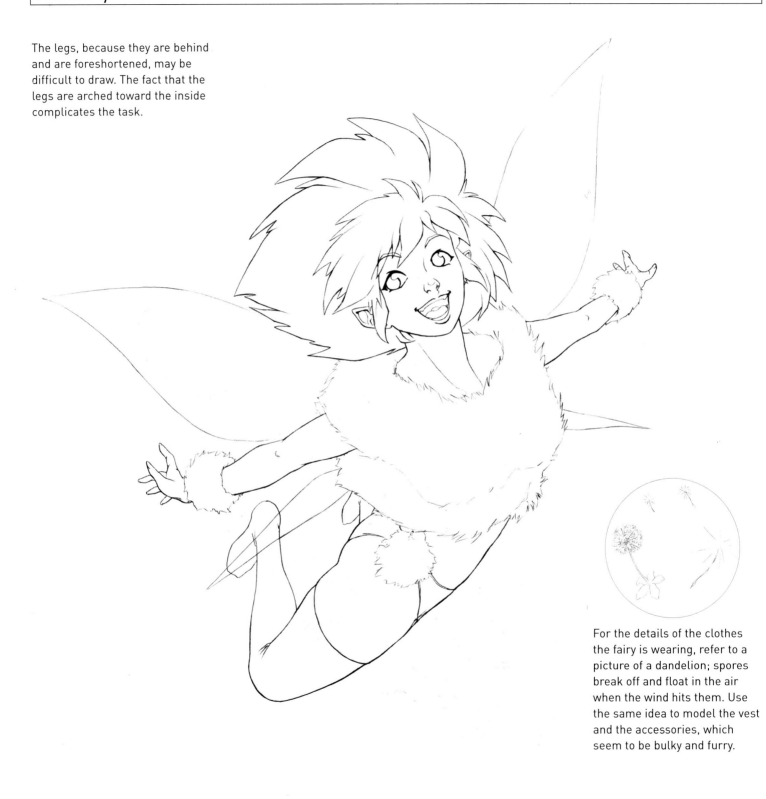

For the details of the clothes the fairy is wearing, refer to a picture of a dandelion; spores break off and float in the air when the wind hits them. Use the same idea to model the vest and the accessories, which seem to be bulky and furry.

Powerful light from above as though
from the sun produces shafts of
light. Draw some shadows that
contrast sharply with the areas that
the light reaches directly.

Source of light

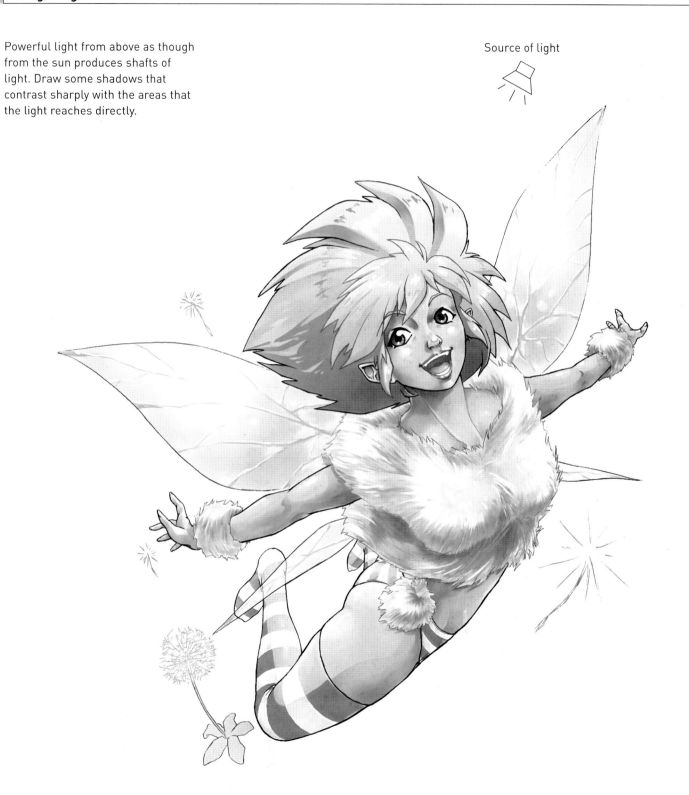

Create a sort of single-color mask to isolate or select the inner area of the figure. Use flat colors within this area; on top of them, add some effects of fading inside the borders of the mask—this will help you avoid coloring outside the figure. After this, add more brushstrokes (make them slightly blurred) to help define the legs. More defined strokes will help give the fairy's clothes a fuzzy appearance and will reinforce the shiny areas of the abundant hair.

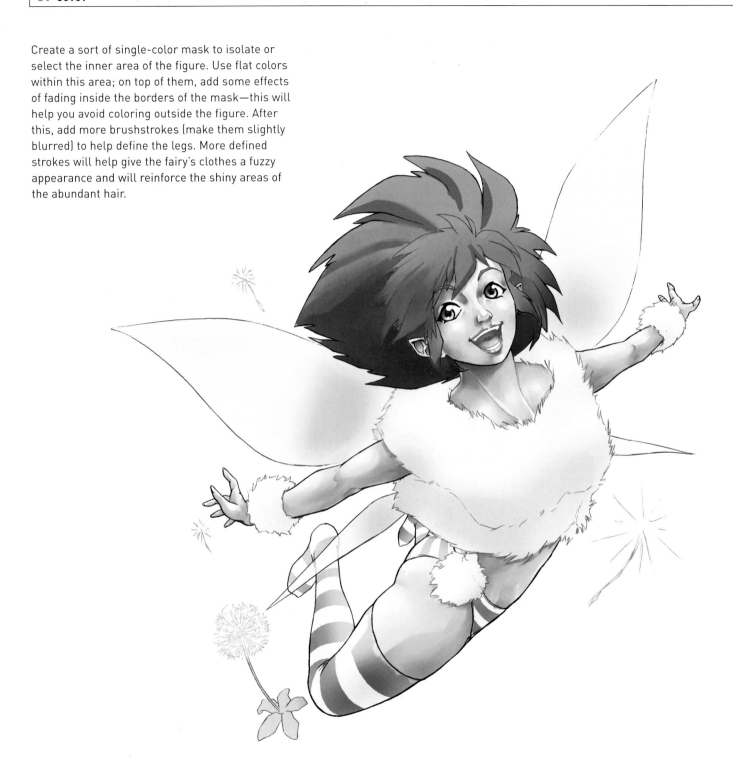

Because we want to evoke the wind and the possibility of flying in open air, the colors should include different shades of blue and white, combined with yellow tones, which are produced by the shafts of light.

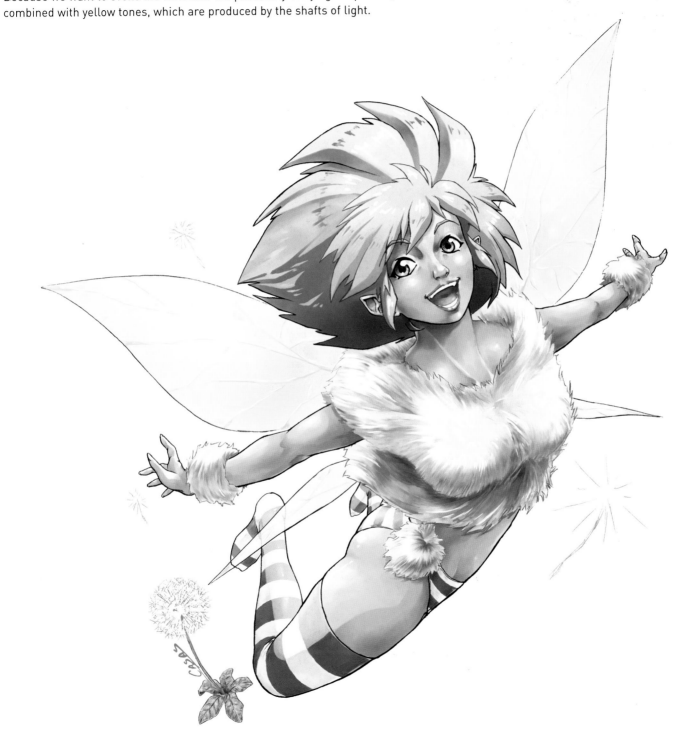

PIXIE

This type of fairy is associated with fire; therefore, the image should include flames and light in strong red and orange tones for greater effect. We will take inspiration from figures that we can find in the forest: tree leaves, butterflies, and moths. We will design a fairy that shows it is a product of its environment, both in its physical appearance and in the clothes and ornaments that it wears. Fire is a very unstable element that evokes heat and vital energy; hence, the image of the fairy should capture the vivacious spirit and the dynamic attitude that naturally belong to this creature, in a pose that communcates strength and movement.

1. Shape

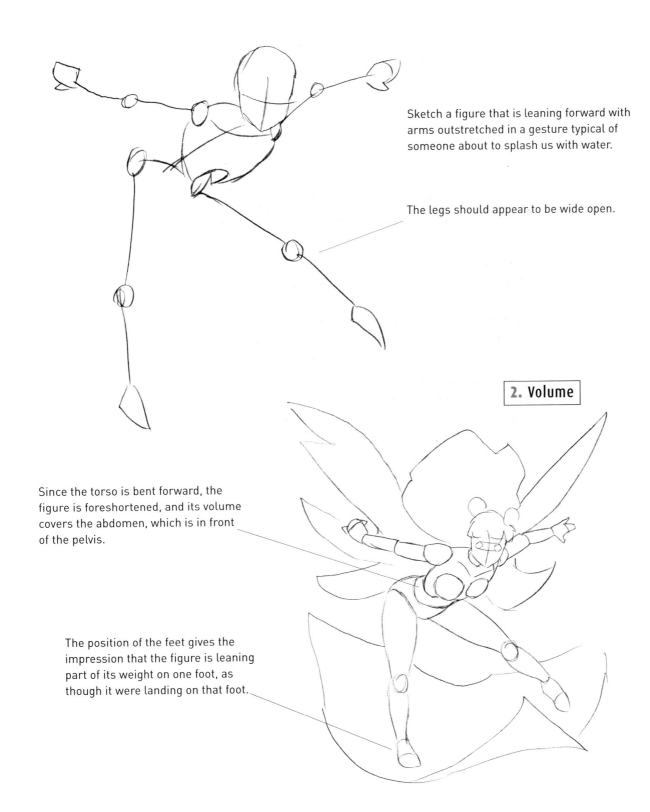

Sketch a figure that is leaning forward with arms outstretched in a gesture typical of someone about to splash us with water.

The legs should appear to be wide open.

2. Volume

Since the torso is bent forward, the figure is foreshortened, and its volume covers the abdomen, which is in front of the pelvis.

The position of the feet gives the impression that the figure is leaning part of its weight on one foot, as though it were landing on that foot.

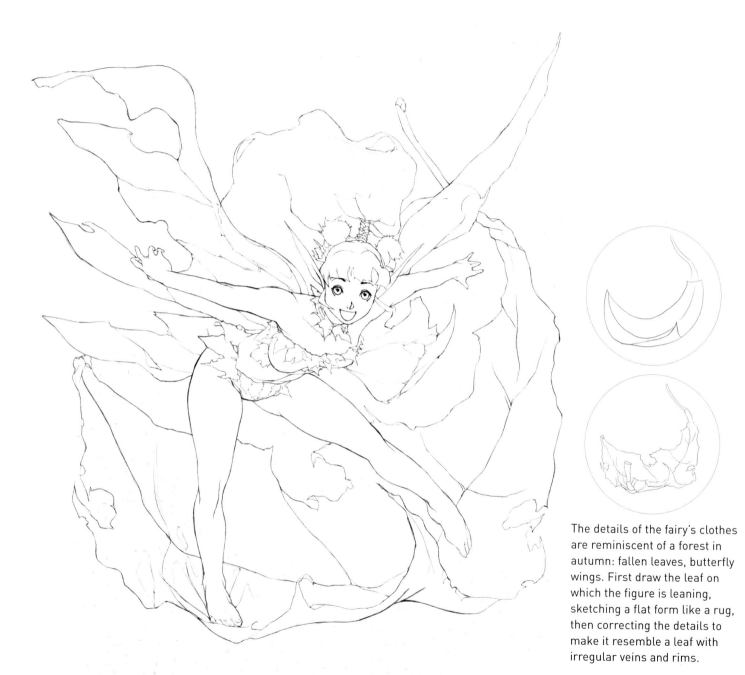

The details of the fairy's clothes are reminiscent of a forest in autumn: fallen leaves, butterfly wings. First draw the leaf on which the figure is leaning, sketching a flat form like a rug, then correcting the details to make it resemble a leaf with irregular veins and rims.

Note that one of the feet remains in a frontal position, and the figure is leaning all its weight on it. The other foot, meanwhile, is positioned in a way that gives the impression of this foot being in the air; this is communicated through the stretched leg and the pointed toes.

4. Lighting

The blaze is a very powerful spotlight, so draw some well-defined shadows, considering each zone of the figure as it blocks the light, preventing it from passing to the back. The figure projects defined shadows on the leaf, starting from the feet.

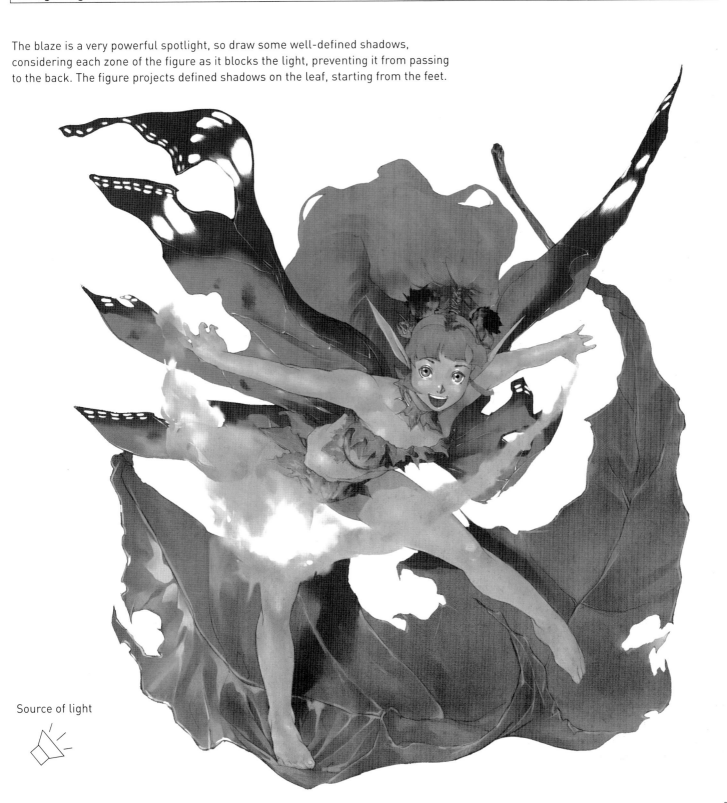

Source of light

Since the subject of fire calls to mind reddish colors, take your inspiration from the autumn, and make the leaves look brown and dry. The butterfly parts of the pixie are more similar to a moth, an insect that feels a special attraction to fire.

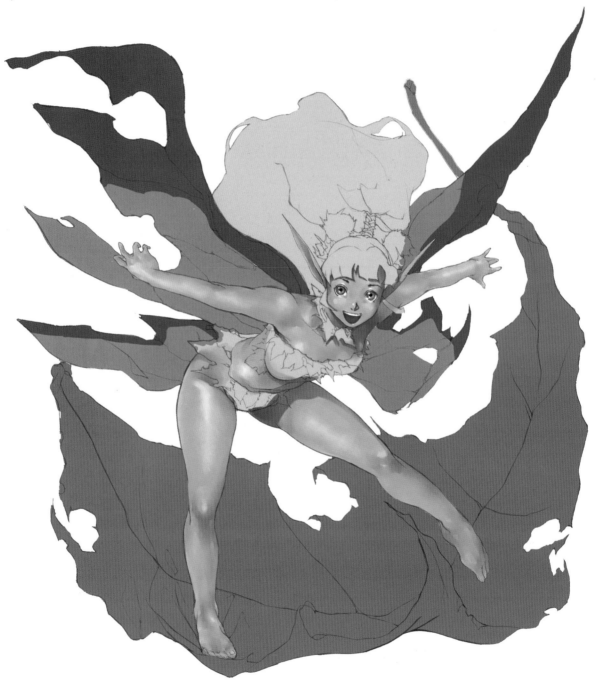

6. Finish

Draw the flames using color directly to do so, letting the white provide the effect of an intense flash. The strong contrast between the shadows and the sparkles makes the effect of the flames pronounced.

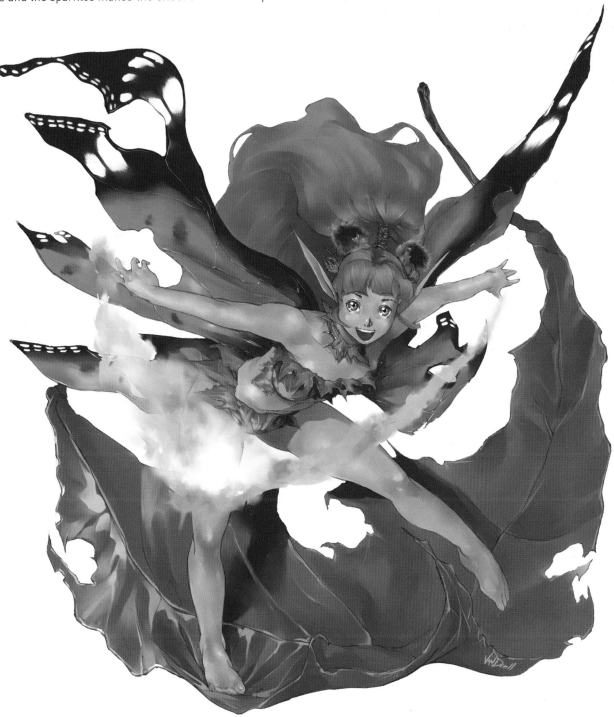

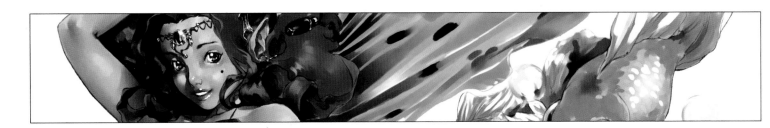

OCEAN FAIRY

As their name suggests, ocean fairies live beneath the water. That is why we have to think about bodies that are much different from the typical fairies living in the woods. When we illustrate water creatures, we need to surround them with the appropriate elements, such as water, fish or shellfish, seaweed, or similar things. We also have to provide the creatures with anatomical elements that allow them to adapt themselves to their environment, be it a fishtail, gills around the neck, fins, webbing between the fingers, or scales.

1. Shape

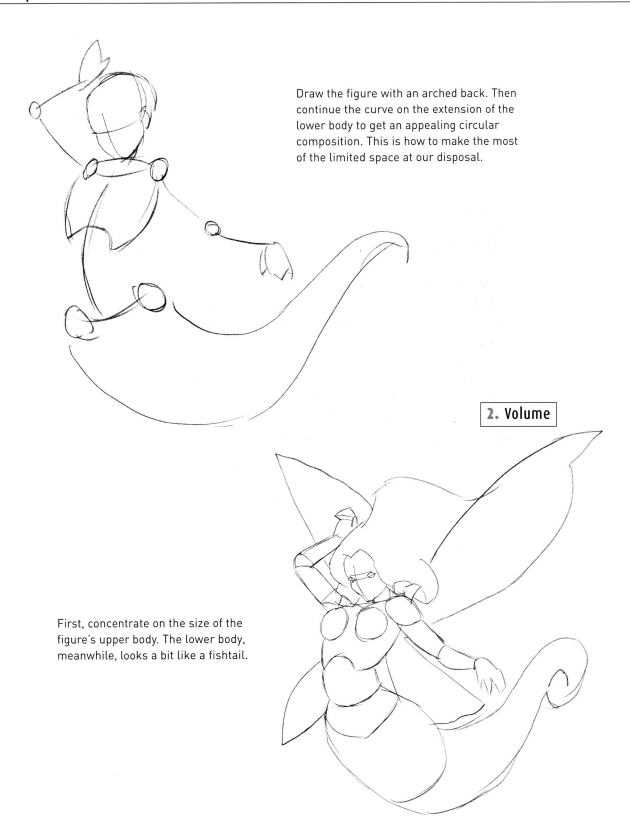

Draw the figure with an arched back. Then continue the curve on the extension of the lower body to get an appealing circular composition. This is how to make the most of the limited space at our disposal.

2. Volume

First, concentrate on the size of the figure's upper body. The lower body, meanwhile, looks a bit like a fishtail.

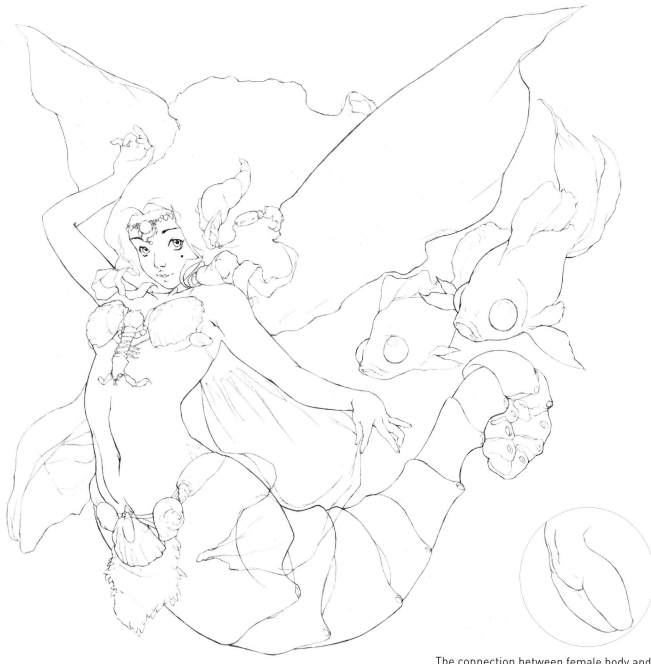

Ocean fairies are not exactly mermaids, even though the idea of humanoid creatures with fishlike anatomical elements is the first thing that comes to mind in both cases. To differentiate between the fairy and a mermaid, draw the lower part of the body in the form of a seashell instead of the typical fishtail.

The connection between female body and shell is created on the lower part of the abdomen. The woman's pelvis remains visible though. On top of the pelvis, draw the contour of the shell. Both forms merge so that the shell is integrated into the pose.

To reflect the illumination in the water correctly, emphasize the shadows on the inferior parts of the figure as well as those parts that are half-hidden by her voluminous hair. The folds of the wings are more pronounced in the inferior parts, where shadows become stronger and more defined.

Source of light

After finishing the color in all
areas of the picture, add some
bright shiny spots and blur the
lines a little.

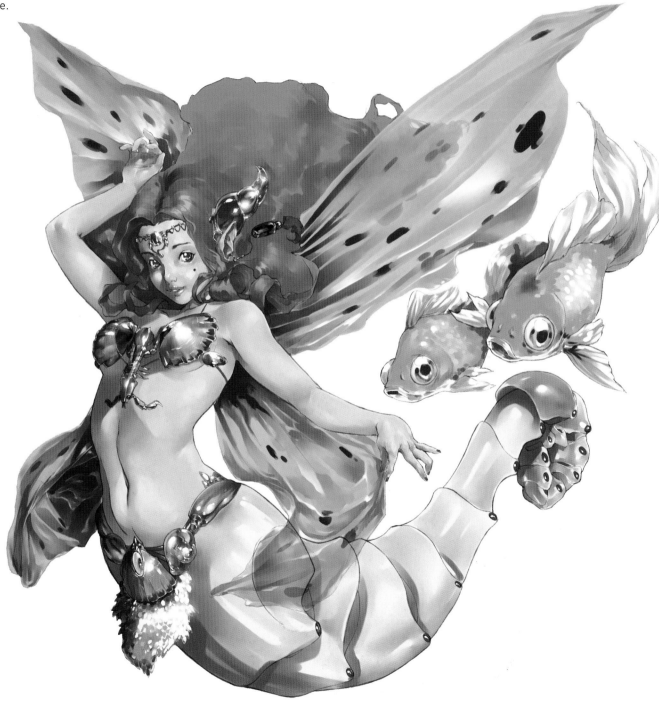

Add some bubbles with streaks of intense white, thus re-creating the atmosphere at the bottom of the sea.

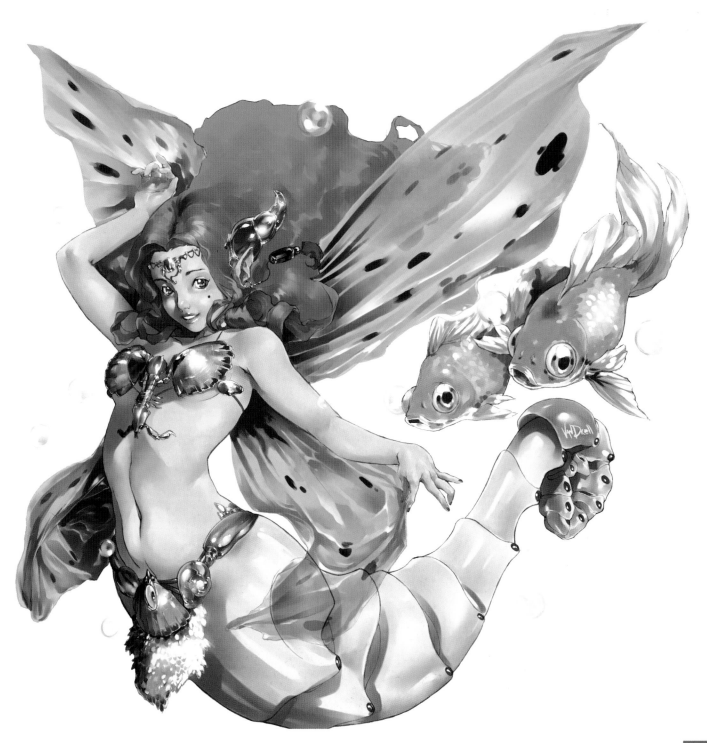

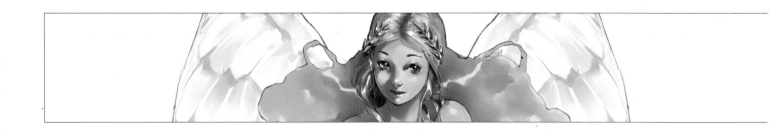

ANGEL AND DEMON

The fight between angels and demons is the representation of the eternal struggle between good and evil in absolute terms. Using these characters is very attractive because they have a very clear reference to the roles they play in history, and because mysticism is an interesting topic suitable to most settings. Of course, they are characters with a big aesthetic appeal, with their wings and spiritual paraphernalia. Because angels and demons are sides of the same coin, we present them complementing each other, in the same way as other antagonistic mystical elements, such as the ying and the yang.

1. Shape

Make the position of the figures nearly symmetrical; if you were to fold the page by its vertical axis, the two winged figures would almost coincide.

2. Volume

Draw the bodies of the two characters, and notice how the pose of the arms changes a little: when the angel makes a melodramatic gesture, the demon seems to be calling us.

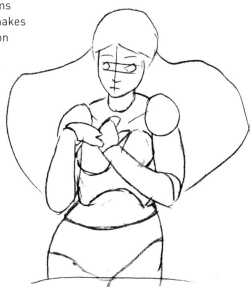

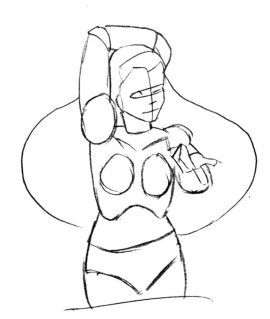

The two characters are very similar, except for some anatomical details—such as the horns and the more aggressive stance of the demon—which you add at the end.

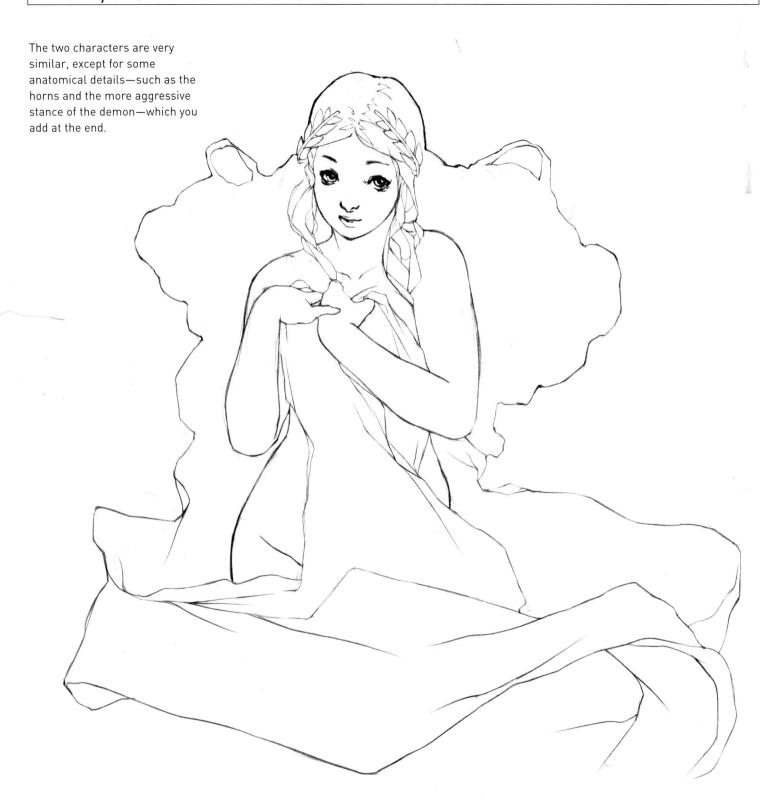

The only costume is a piece of fabric that covers parts of the two characters. Add the wings, which are similar in the two figures.

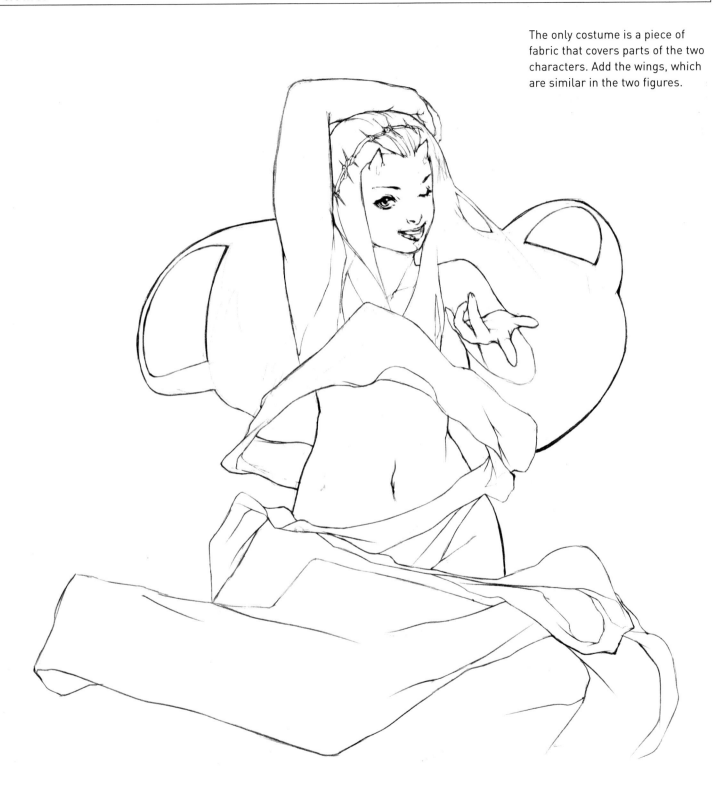

Drawing in shadows helps us define the pleats of the fabric, which in turn billows around in the composition, and plays an important role in defining the main feathers of the wings.

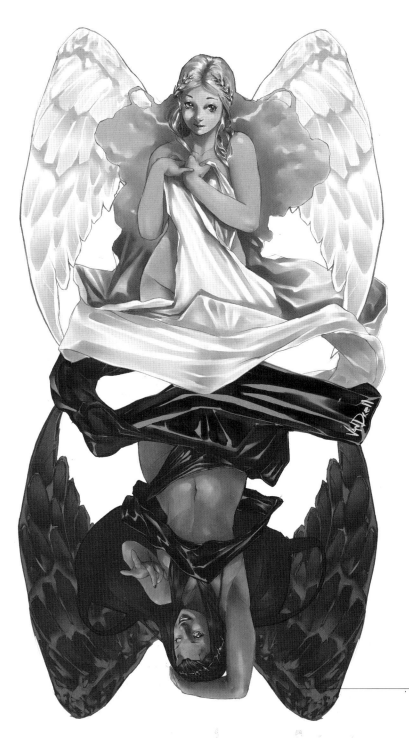

This drawing uses both the space provided and the square format in the composition, without affecting the size of the characters. Apply the typical white with lighter flesh tones for heaven and blacks/grays with darker flesh tones for hell.

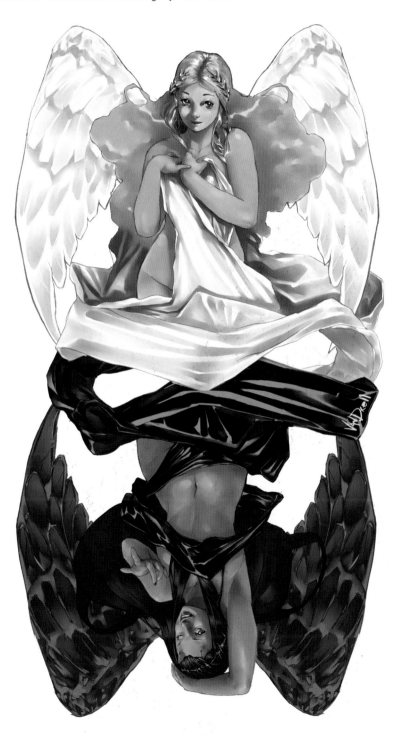

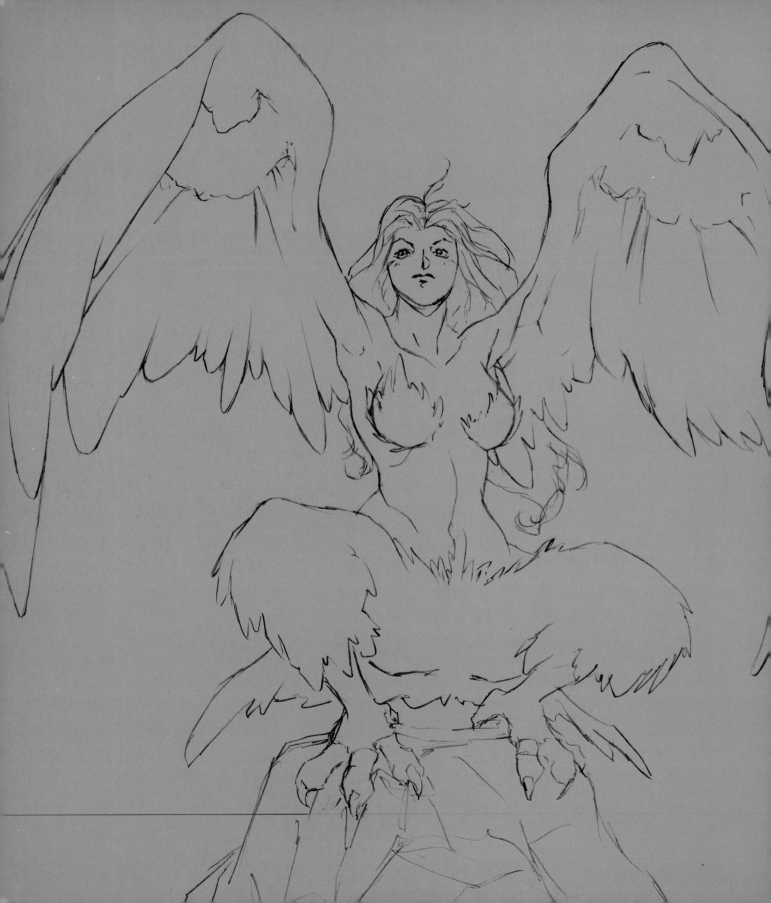

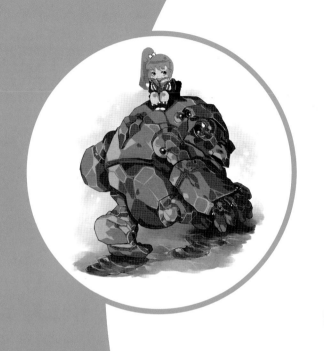

MYTHICAL CREATURES

CUTE MONSTER

Monsters can also be drawn as Manga characters that are super-deformed or that have big heads. Super-deformed monsters, whose features are smoother and proportions are changed to make them appear more childlike, with big and expressive eyes, look as cute as sweet pets or mascots.

In this case, we will draw a stone golem, a kind of giant made out of rocks and created with the help of magic. In spite of its size and impressive physical appearance, the stone golem tends to be an amicable character as well as a loyal companion. Since the rocks that shape its body give it its chubby constitution, it is quite easy to draw with the same proportions as a super-deformed model.

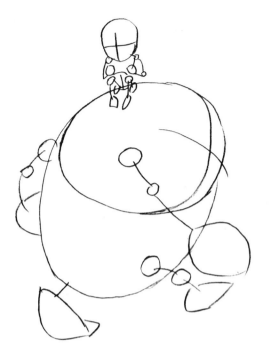

Construct the body of the golem from an oval. Sketch in its extremities, and then add the structure of the little girl.

2. Volume

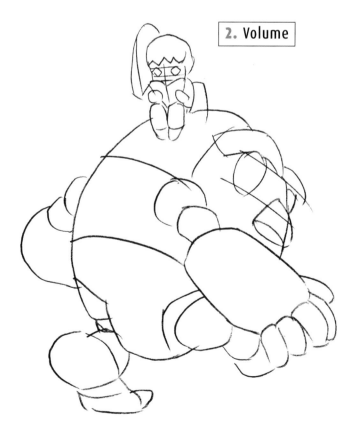

Play with proportion in order to make the figures appear big-headed, like super-deformed characters. The body of the golem should look as if a pile of stones or rocks had been fused together to shape its anatomy.

Source of light

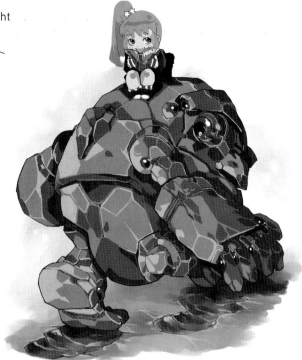

The enormous body mass of the golem generates huge contour shadows that give it a solid, opaque appearance. Place these shadows so that they define the bulky volume of the rocks properly.

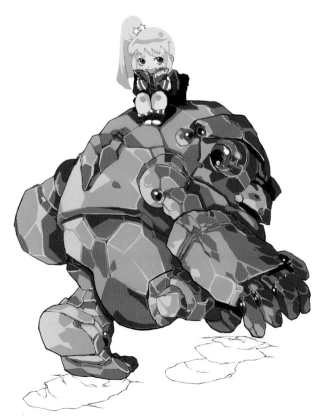

Apply a single base color on the golem to get a stonelike color. Then add several color layers to define the different body parts and give texture to its surface. Finally, add color around the figure so that it looks like the ground, and draw clouds to complete the background.

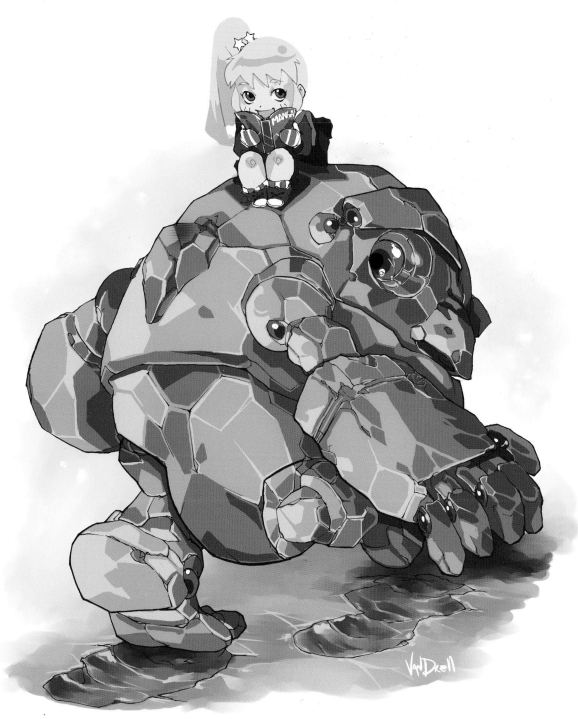

HARPY

A harpy is a pretty disturbing monster, with the head and torso of a woman but with the rest of the body deformed to look like a winged being with claws. Instead of arms, it has wings; and instead of feet, it has enormous bird claws joined to feathered legs. At first, harpies were secondary characters in ancient Greek narratives. Later, they became part of the medieval iconography as monsters of the wind, just as mermaids were considered monsters of the water. Harpies were identified with fury and with the harmful attributes of wind; they seemed dedicated to causing damage and pain to man. We do not show the harpy this way, but rather as a relatively beautiful woman with a neutral attitude.

1. Shape

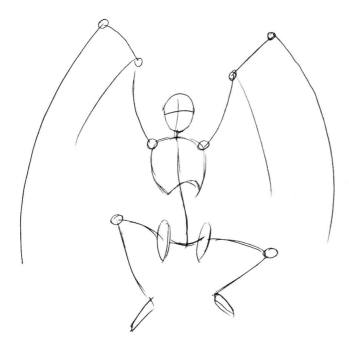

Sketch the main parts of the figure: the head and the chest. Trace what is going to be the internal structure of arms in the shape of wings, and draw the legs bent in a crouching position.

2. Volume

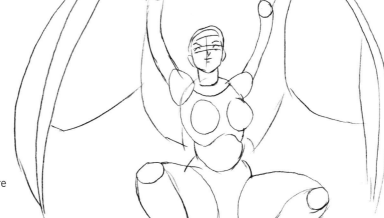

Represent the wings as if they were flat forms, showing the mechanism that allows them to fold and to push the figure upwards. Make her feet look like claws.

Make the female part look like a regular woman, allowing you to simply draw the anatomy of the chest and part of the arms. Be careful with the position of the shoulders and muscles when the arms are lifted this way.

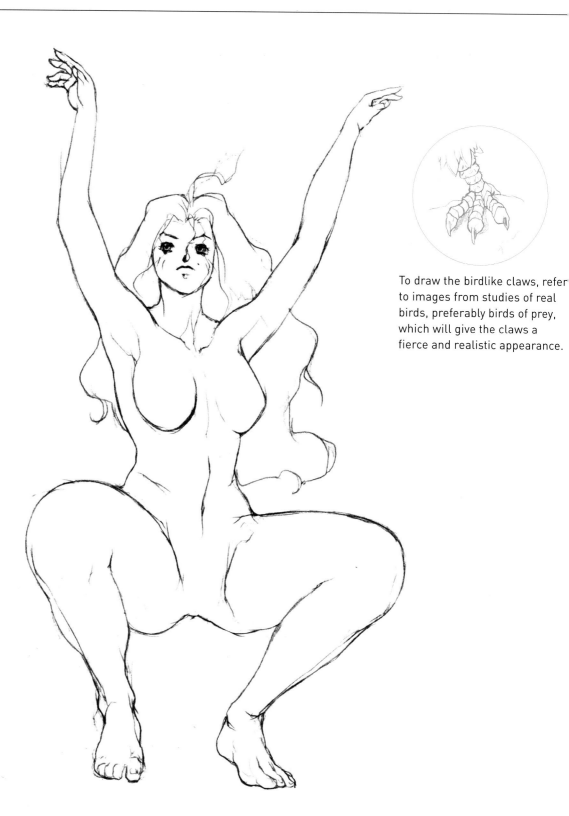

To draw the birdlike claws, refer to images from studies of real birds, preferably birds of prey, which will give the claws a fierce and realistic appearance.

4. Clothes

Now draw the wings and the plumage in detail, as well as the feathers that cover
the lower limbs and breasts.

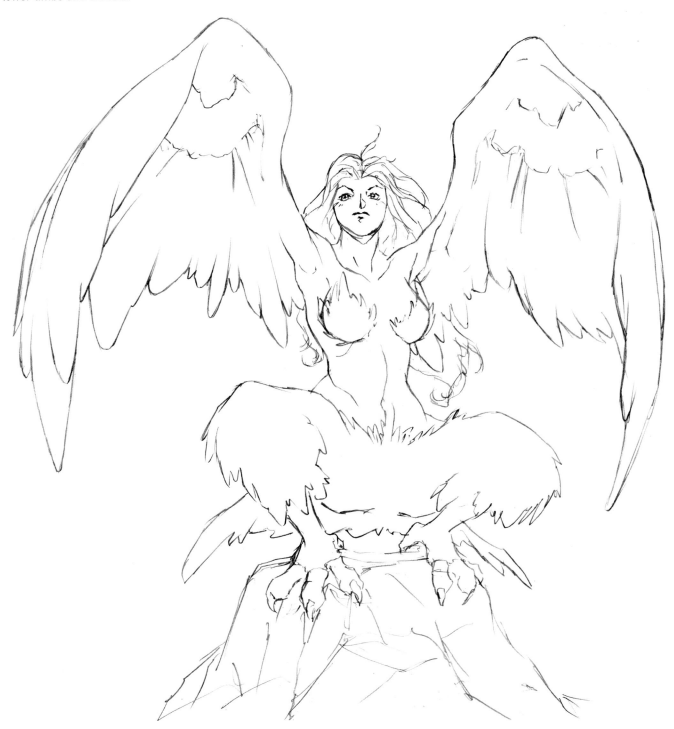

Source of light

Ceate shadows with both regular and irregular shapes. They will help articulate, on one hand, the smooth and continuous surface of human skin and, on the other, the texture of the plumage.

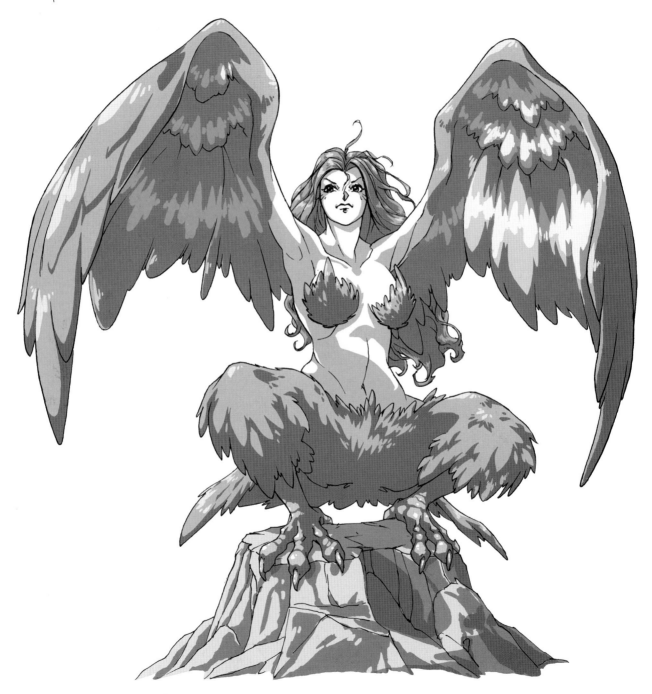

Finally, add a rocky platform, using earth tones similar to those in the figure.

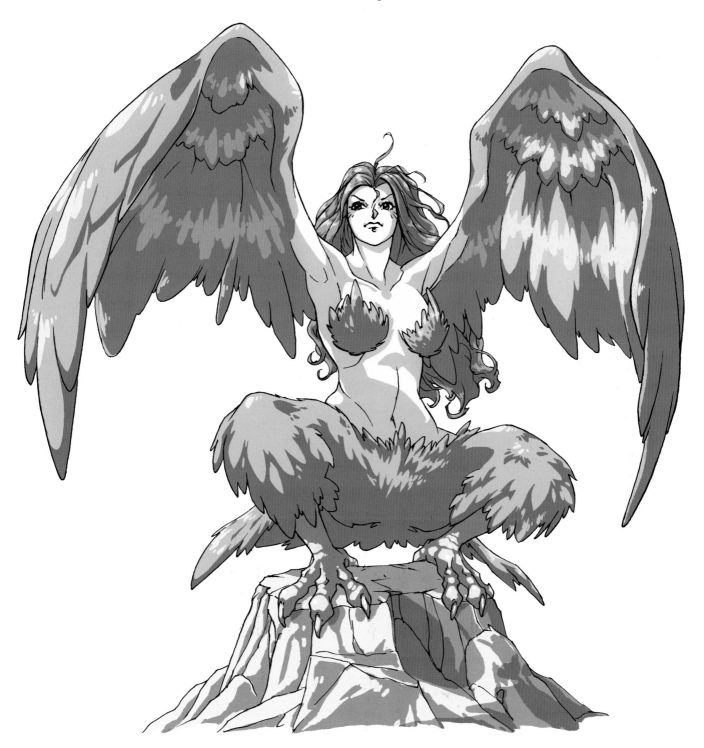

MINOTAUR

The Minotaur is one of many mythical creatures that are unique. Based on legends of ancient Greece, the Minotaur has come to be used as a generic character in contemporary stories and in table and video games. In the original legend, the Minotaur was the guardian of a huge labyrinth deep inside the palace of Minos, ancient king of Crete. It was a monstrous creature—half man, half bull. Nobody who entered the labyrinth came out alive, but the hero Theseus was able to slay him thanks to Ariadnae, the king's daughter, who gave him a magical sword and a skein of thread so he could find his way out. Theseus killed the Minotaur, but he could not eliminate it because it has been resuscitated in modern-day stories.

1. Shape

Sketch the internal part of the figure, concentrating on the head and trunk.

2. Volume

Make a huge head and a very wide back, with a large separation between the shoulders.

The Minotaur has a muscle
structure similar to that of a
human, at least from the waist up.
Make the creature's muscles
large and exaggerated, forming
well-defined blocks.

To draw the beast's legs and
hoofs, refer to images of real
animals, mainly bulls or
horses, but modify them to
make humanoid legs from
the knee up and animal legs
from the knee down.

Create a somewhat civilized
Minotaur with equipment tailored
for him, as well as some objects
that can be either decorative or
functional. In a world of fantasy,
the rings could be magical.

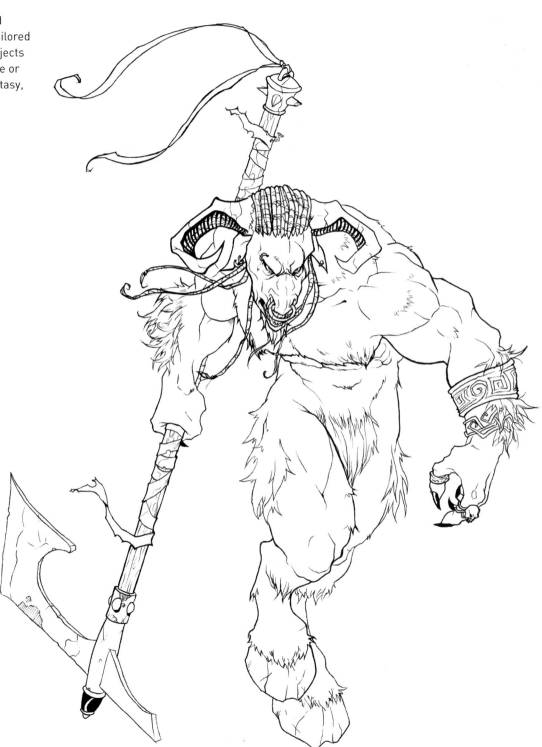

Create shadows that separate the legs and help represent how each one of them moves. Shadows should also highlight the muscles' large volume and the anatomical details.

Source of light

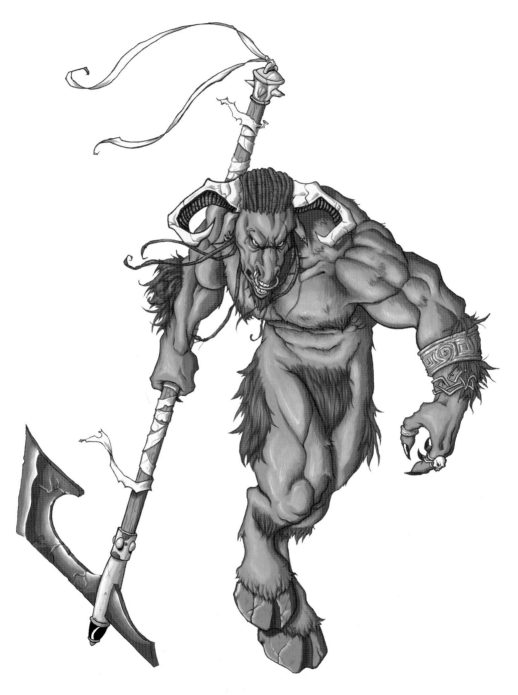

Due to its resemblance to a bull, the Minotaur has skin with a dark tint. Use brown and earth colors, which are in harmony with the discrete gray tones of the hooves and the metal in the weapon.

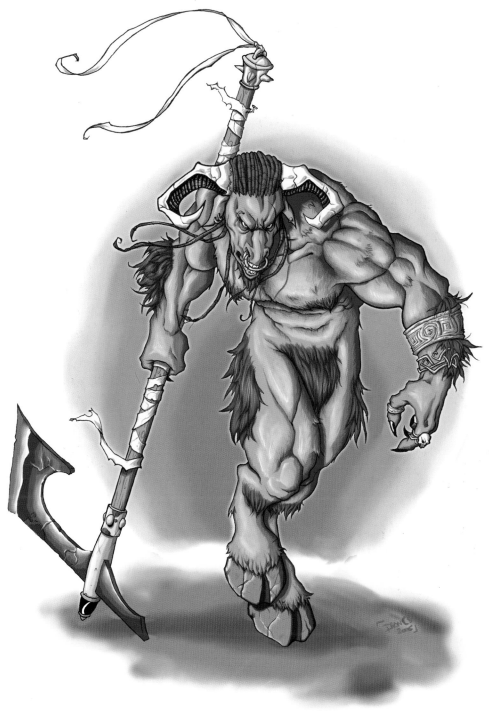

MEDUSA

Medusa is a mythological creature, a legendary monster that appears in ancient Greek tales. In spite of being a feminine figure, she represents a fearsome being. Medusa has the body of a woman from head to hips; below the hips, her body consists of a giant snake instead of legs. Medusa's hair is actually a mass of snakes, which gives this creature a much more fierce and cruel appearance. Medusa was known in legend as a dangerous archer, who poisoned the arrows she used with her own saliva. But she had an even more terrible power: transforming anyone who looked directly at her eyes into a stone statue.

1. Shape

Start by sketching a human figure. Instead of legs, make a continuous line. Simply prolong the vertical axis following the curve of the back.

2. Volume

Draw the upper body in a normal manner. Below this, draw the body of the snake; it should be all coiled up so that it fits completely within the frame.

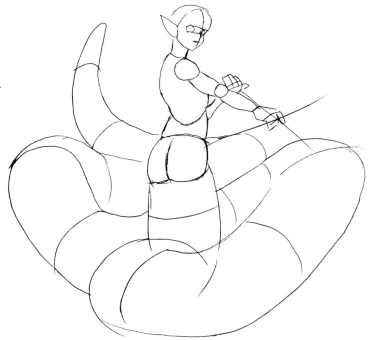

The body of the snake is soft.
So when it coils, it creates folds
similar to those in a sock or a
bag full of clothes.

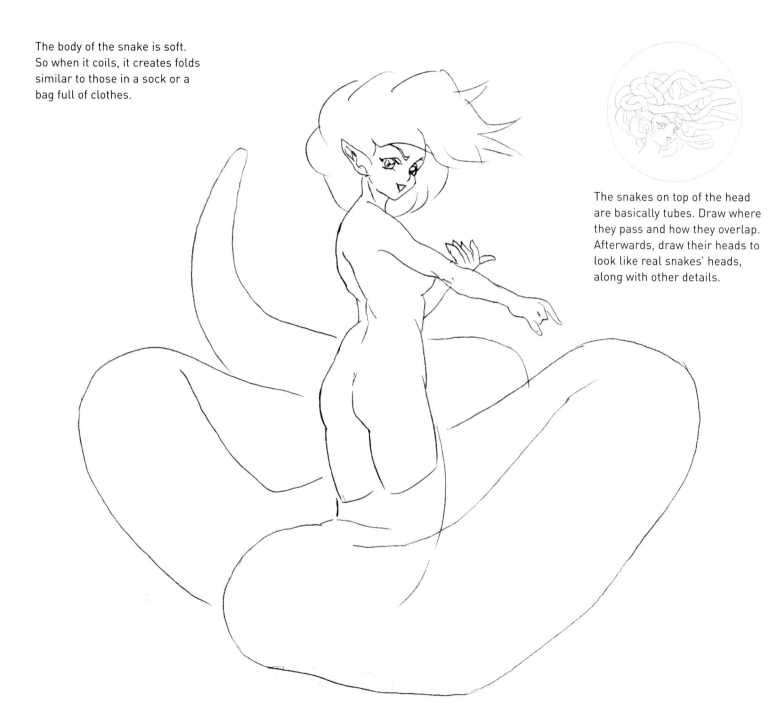

The snakes on top of the head
are basically tubes. Draw where
they pass and how they overlap.
Afterwards, draw their heads to
look like real snakes' heads,
along with other details.

Lighting is not so important in this scene. It is much more important to delineate the figure's volume and the snake's body. On the snake parts, shadows help to show the overlapping of the folds.

Source of light

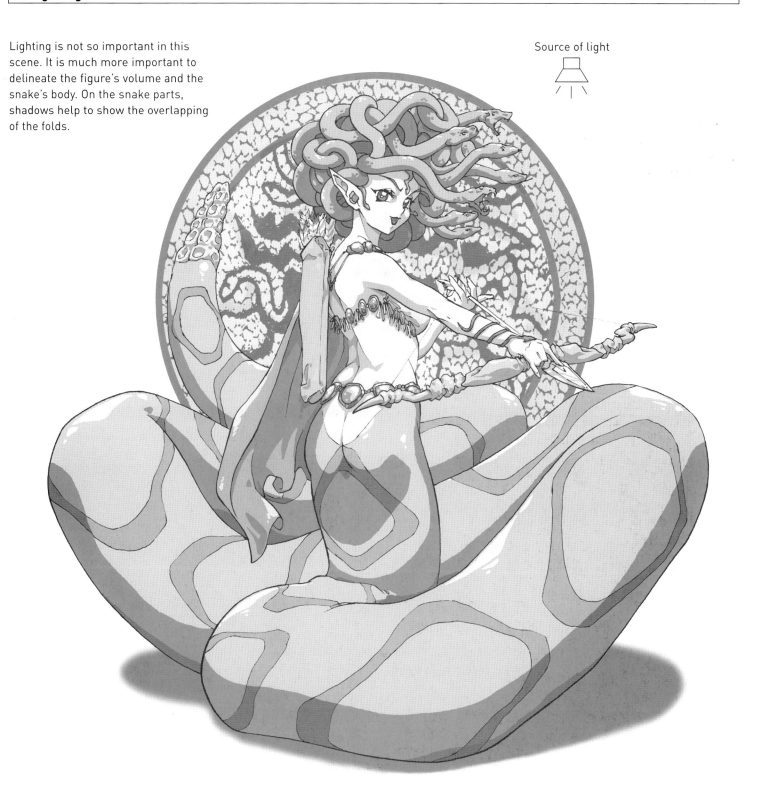

Apply a solid-color base to highlight parts of the figure and other elements, such as the bow. Then clarify each area with shading and shadows, and add the effects that give texture to the snake's skin.

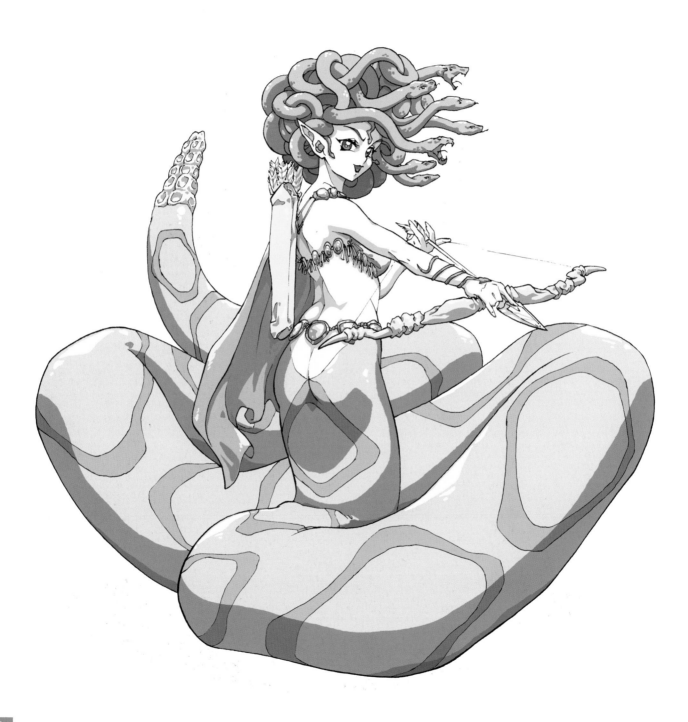

6. Finish

End by drawing the details, and define the bright areas with more opaque and defined strokes. The result is a more integrated figure. Finally, add the back image, a classical mosaic that suits the character and gives a better ambiance to the scene.

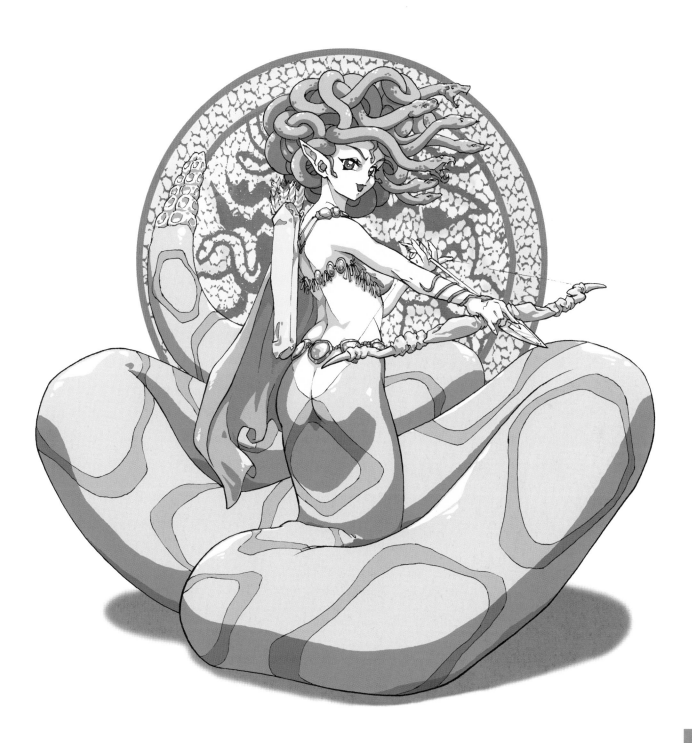

CENTAUR

A Centaur is a mythological creature of the woods, like fauns and dryads that ancient Greeks believed in. Half man and half horse, it became part of their stories about classical deities. Because of its imposing presence, the Centaur should communicate strength and power. In spite of being a wild, uncivilized creature, it is a lord of the woods and an ancient relative of the gods, and thus, it should transmit a certain nobility. We are going to try to reflect all these aspects in the drawing of the figure and the expression on its face.

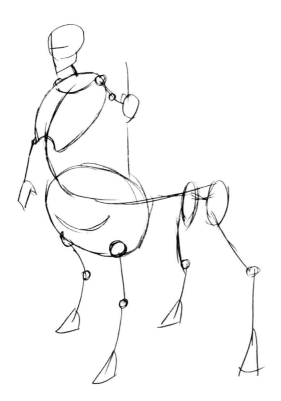

Sketch a body of normal proportions from the head to the waist, with a normal vertical axis up to this point.
At the waist, the spine merges with the body of a horse. Therefore, give the figure an extra thoracic segment and additional hips, from which the legs start.

2. Volume

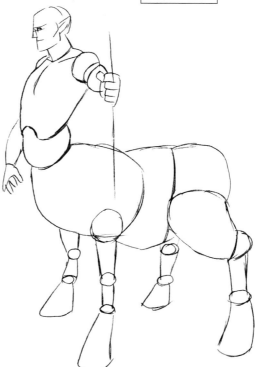

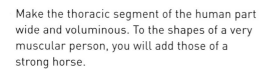

Make the thoracic segment of the human part wide and voluminous. To the shapes of a very muscular person, you will add those of a strong horse.

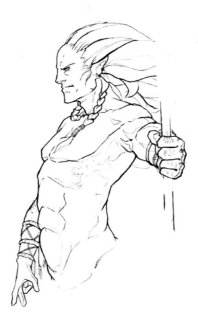

Make the muscles of the human part very pronounced so that they merge nicely into the body of the horse, which is also very muscular. Create a distinguished air and a look of nobility by adding a stern expression and pose.

Since this is a supernatural being, you can freely add some imaginative anatomical details. However, it is important to base them on images of actual animals, such as draft horses, so the figure takes on an air of realism.

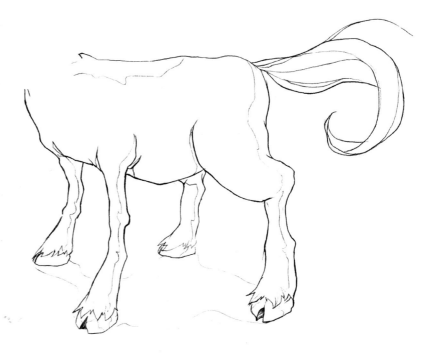

For the hairstyle, re-create the style and appearance of Native Americans; this underscores the relationship between man and horse that this figure seeks to communicate. Add ornaments on the head and the arms; these and the spear are fantasy elements that enrich the setting.

The flowing hair of the centaur endows the image with strength and dynamism. Sketch the general lines of the hair so that it looks like it's in motion. Then define the internal locks with thin and continuous lines.

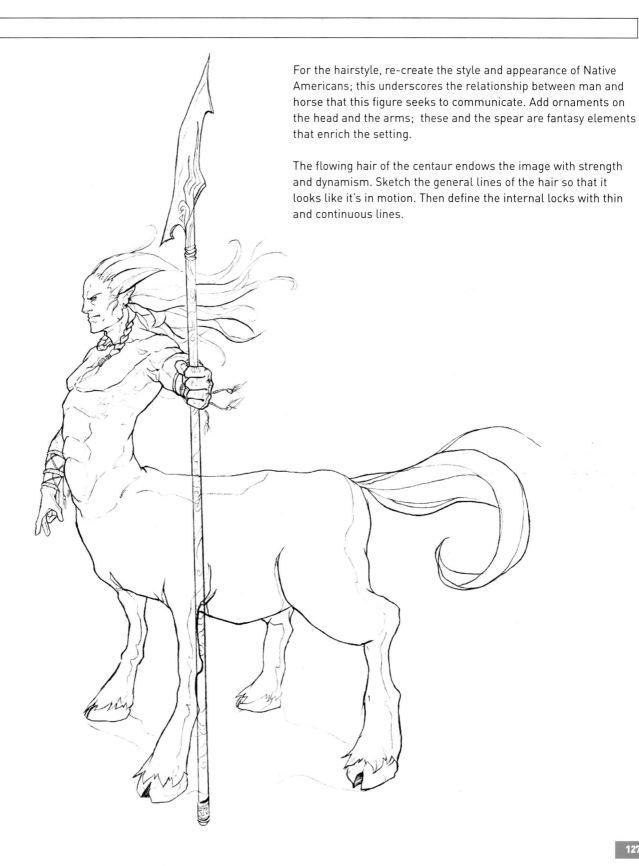

In order to portray the strong musclature of both the man and the horse, delineate the details of their volumes with shadows. Place several shadows strategically to define the contours properly.

Source of light

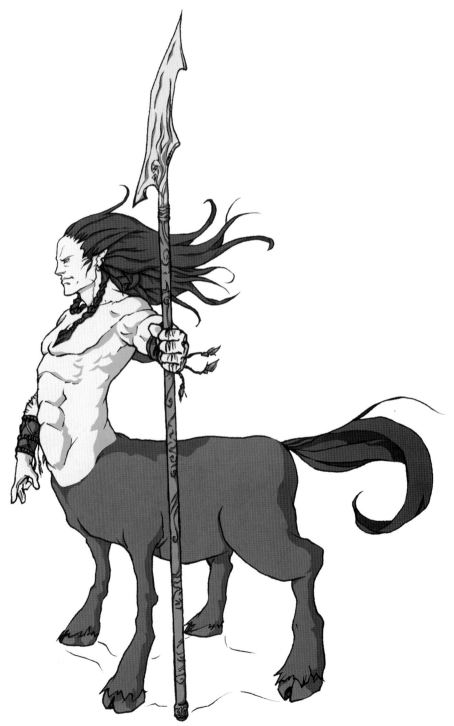

6. Color

Use contrasting shades for the human and the horse parts. The mane should approximate the color of the horse's coat. Add some detail to highlight the blade of the spear and its runic motifs.

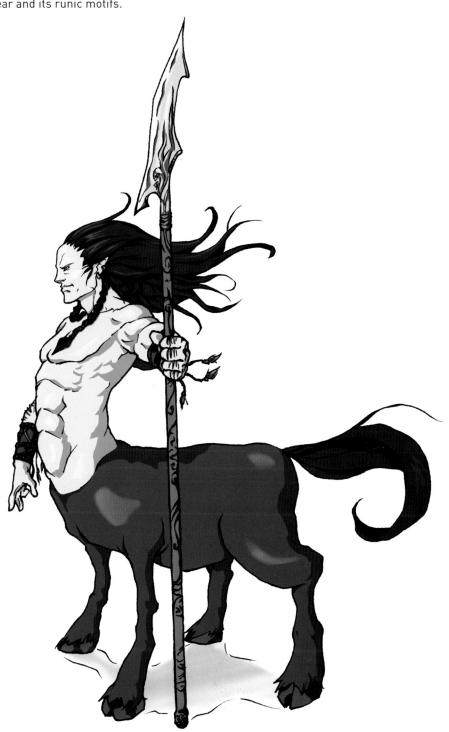

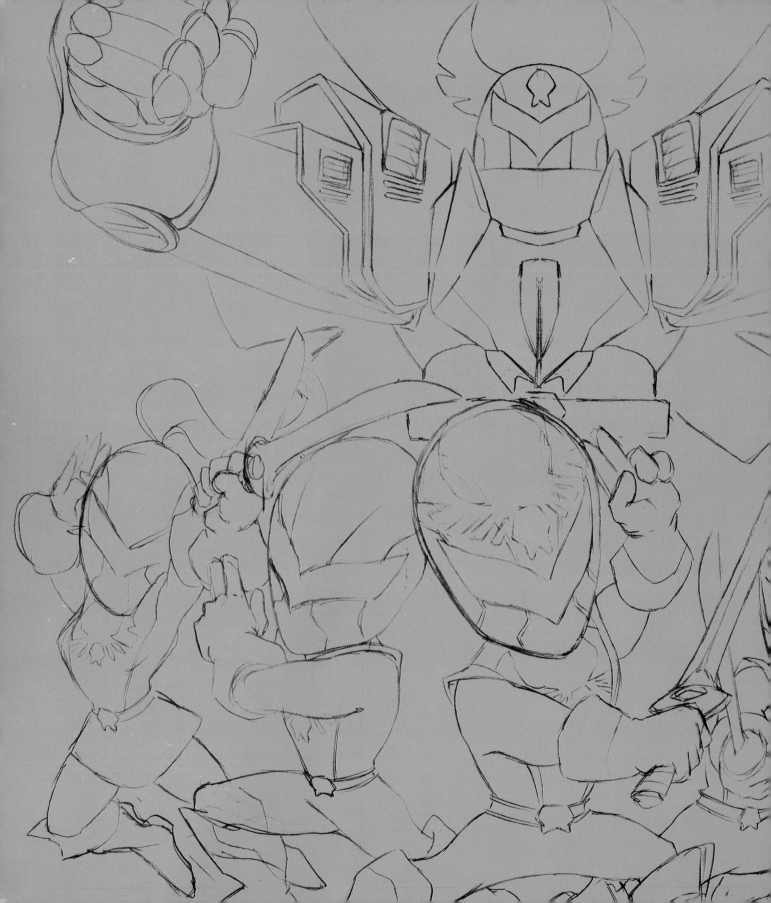

SENTAI

POWER RANGERS
TECHNO-MUTANT
MASKED RIDER
CYBER POLICEMAN

POWER RANGERS

Stories based on explaining the conflict between heroes with strange uniforms and the threat of an alien invasion or evil criminal gangs is part of the Sentai genre. This theme has led to many Manga and Anime tales. The Anime episodes basically consist in showing both an anecdote about the daily life of a group of people and the diabolical invasion plan of the villain. The latter usually entails sending in monsters to rain down chaos and destruction, or to eliminate the protagonists. The heroes use special vehicles or giant robots to battle the monsters. The heroes are also martial arts experts, so there are plenty of acrobatic fights with gangs of scoundrels who work for the villains.

1. Shape

Sketch the figures one at a time and all in a row. Do this on a curved line where the characters in the back are drawn in a smaller proportion to appear farther away. Add the general contours of the robot in the background.

2. Volume

Draw a simple reference to the characters' swords, and draw the characters themselves as super-deformed. Also define the shapes of the robot more clearly.

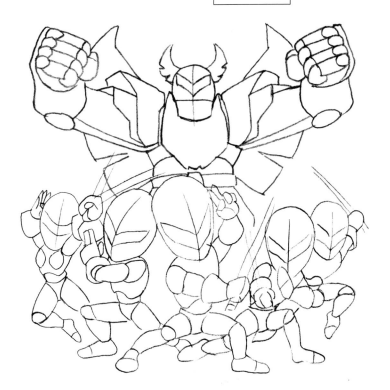

Special clothing and helmets are an essential element of the Sentai genre. We have to design uniforms that cover their bodies entirely, including their faces. They are almost identical except for the details that characterize the leader of the group.

Source of light

4. Lighting

Shade the lower body and wings of the robot to distinguish it from the background. In the figures, use shadows to model the muscles.

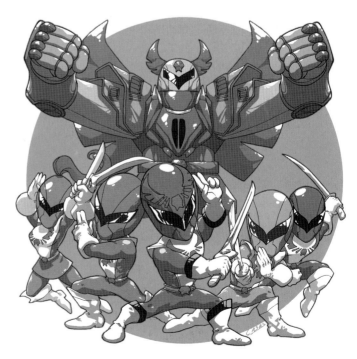

5. Color

Give each of the rangers its own bright color. The effect of the ranger alongside the color-saturated robot is almost akin to a rainbow.

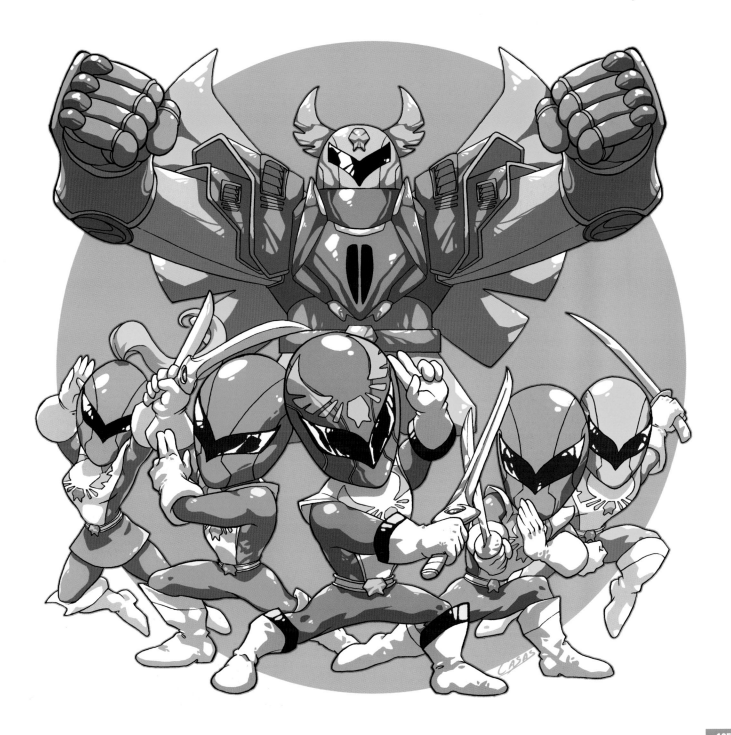

TECHNO-MUTANT

The Techno-mutant is a strange variation on stories about heroes with special suits. It consists of a sort of fusion between man and armor—half machine, half living organism. That's why it's usually referred to as techno-organic. The origin of techno-organic armor can be anything, although military experiments, visionary scientists, and aliens are the most common plots. The responsibility to use it is wisely always in the hands of the protagonist, by accident or obligation, but very much against his will. The armor merges with his body and the hero transforms his body with it, gaining a supernatural strength. An unpleasant side effect is that it turns him into a monster; wearing the suit is a burden he has to bear.

1. Shape

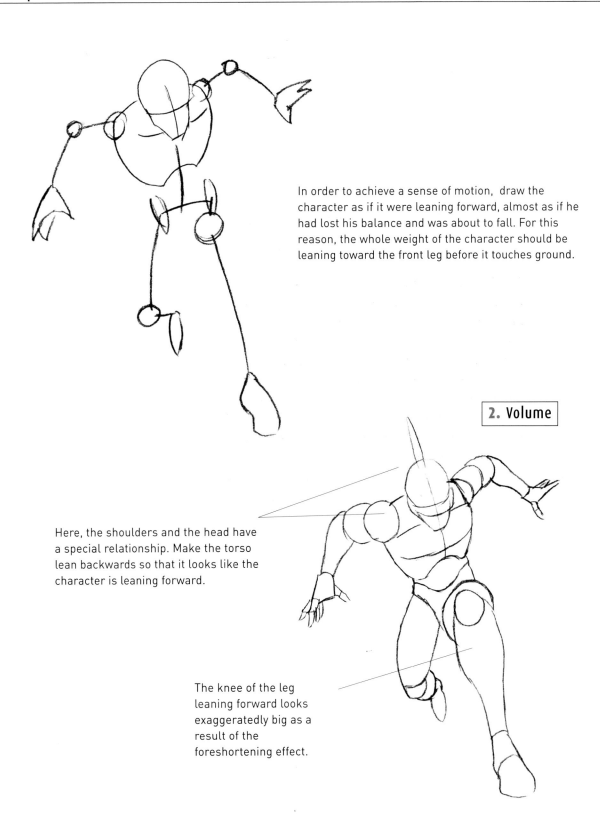

In order to achieve a sense of motion, draw the character as if it were leaning forward, almost as if he had lost his balance and was about to fall. For this reason, the whole weight of the character should be leaning toward the front leg before it touches ground.

2. Volume

Here, the shoulders and the head have a special relationship. Make the torso lean backwards so that it looks like the character is leaning forward.

The knee of the leg leaning forward looks exaggeratedly big as a result of the foreshortening effect.

Instead of a human head, draw a mutant head or helmet, which should have an intriguing appearance. Shorten the foreleg significantly to exagerate the sense of motion.

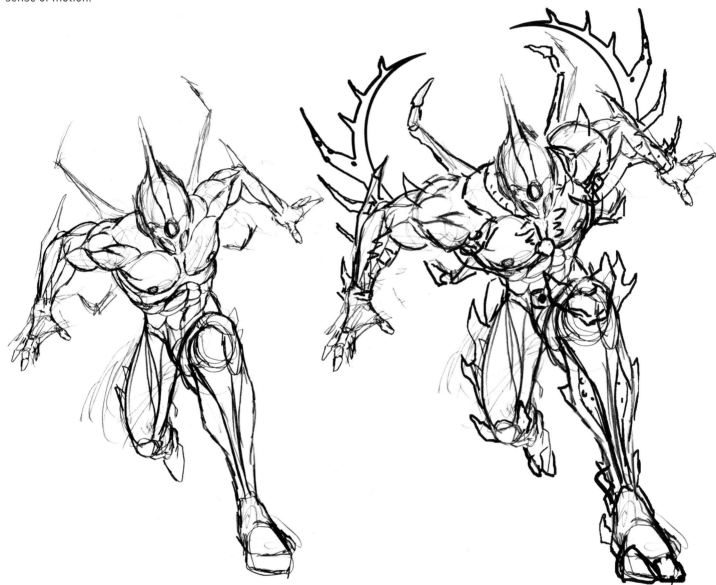

The foreshortening effect will become even more exaggerated once you alter the proportion of the figure. This will give a more superhuman appearance as the character becomes truly monstrous. Gradually add thorns and other protuberances that remind us of an insect's exoskeleton.

4. Clothes

Polish the thorns and protuberances
so that they look much colder and regular,
which is characteristic of machines.

The base of the figure should look cold and dark, and the techno-organic armor, sinister. Add some shine effects to play with the light originating from the gems, and give more volume to the figure.
Finally, draw the shadow that the figure projects on the ground.

Source of light

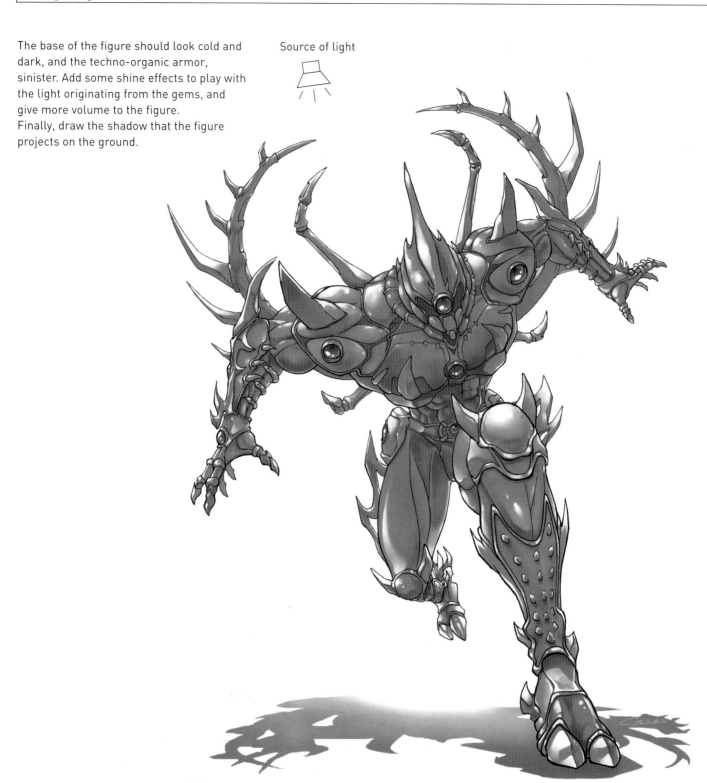

Color the shadow projected on the ground and the smallest and most intense shiny spots so that the figure gains in presence. Choose cold, steel-like tones.

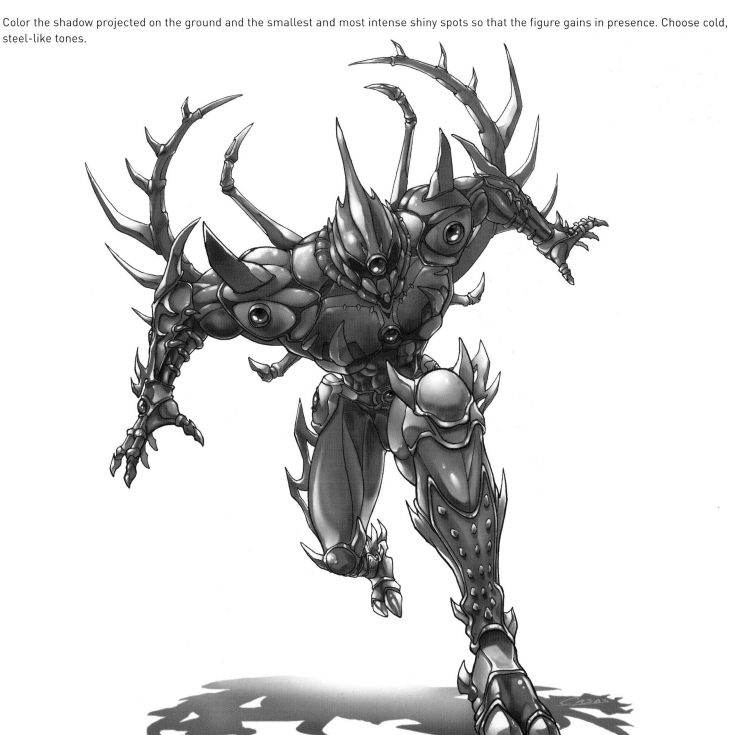

MASKED RIDER

The masked rider is a sinister avenger, a character that has received diverse interpretations in TV series, but which is generally presented as a taciturn and lonely hero, doomed to roam the streets of the city on its ghostly bike.

His special uniform and the mask are essential features of the masked rider, and they give him a certain diabolical air and highlight his lack of humanity. In general terms, the origin of the masked rider is related to supernatural events, or to the resurrection of a person who returns from the world of the dead in search of vengeance.

1. Shape

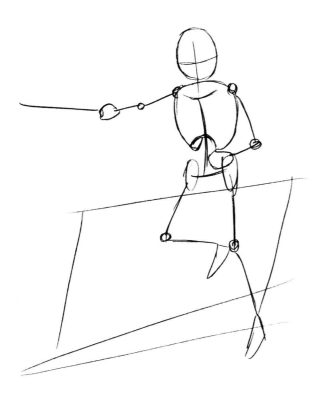

Begin by sketching the ground and the bike. Use a couple of lines to indicate these two elements as well as the background perspective.

2. Volume

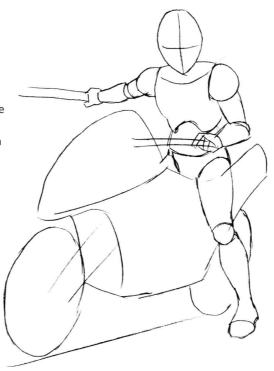

Sketch the basic frame of the bike. Place the bike on the ground plane so that we can see the foreshortening of the bike in the desired perspective. Then draw the figure of the character riding the bike.

Since the face of the rider will not be seen, draw a neutral face, without features or hair. This will facilitate drawing the helmet, which you'll draw by following the contour of the cranium.

It is very important to focus on the placement of the legs and the hips, with the figure leaning and adapting to the position of the bike.

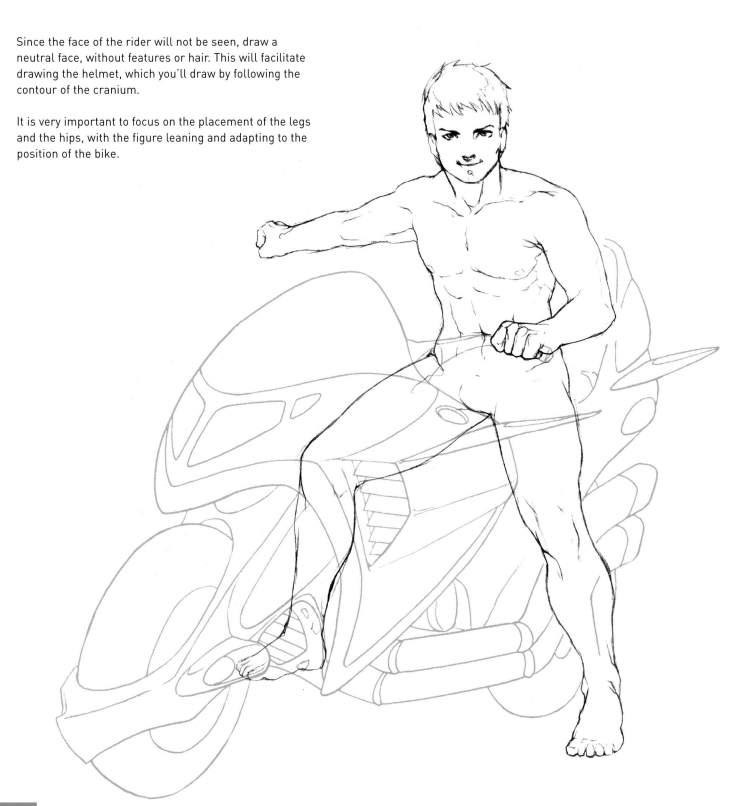

4. Clothes

All the strength of the masked rider is in the helmet. Hence, the piece that covers his eyes should have an angular and aggressive design. The costume is very elaborate and combines practical features, such as the quilted material that protects his body, and plenty of aesthetic details.

Now complete drawing the bike. First sketch the main parts, then use some firm lines to define the contour, and finally add the smaller parts and other details.

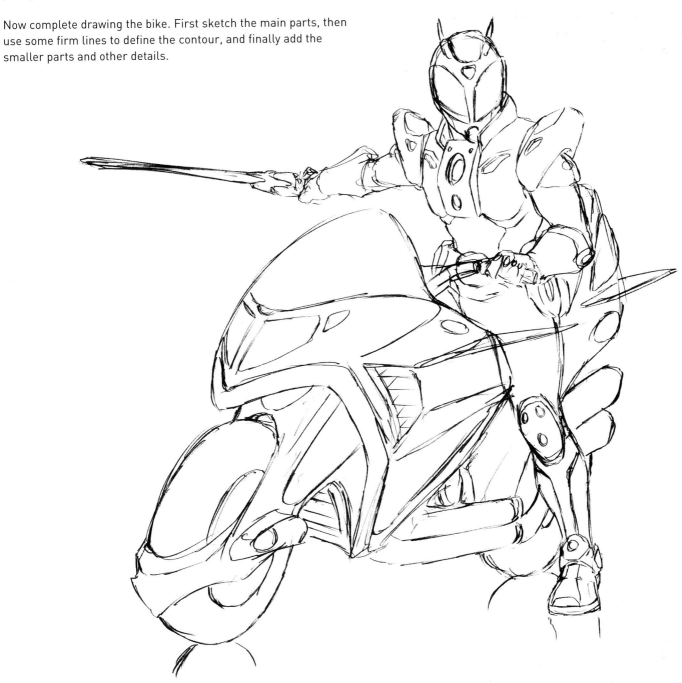

The rider's costume is dark, so draw the shadows with big spots. Shiny areas drawn as reflections of light on pieces of the costume and on the bike give the figure a polished-metal effect.

Source of light

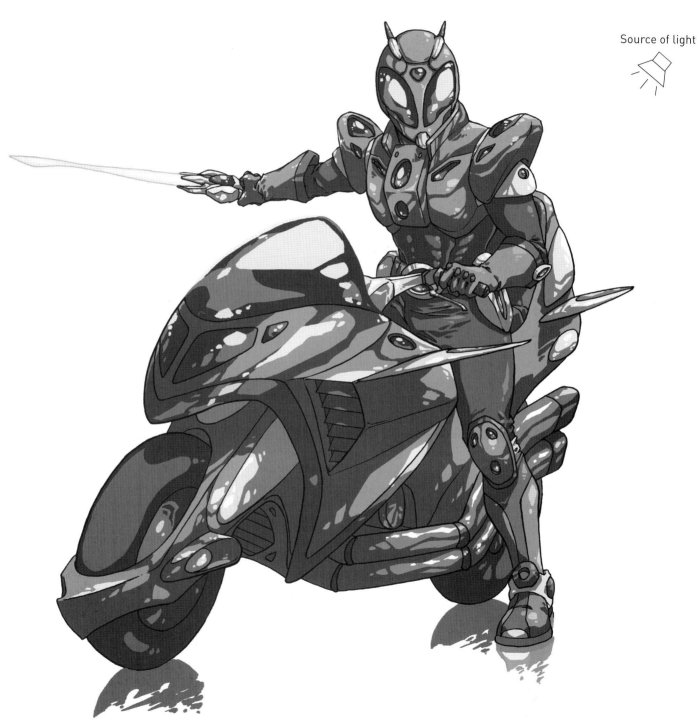

6. Color

Finish by drawing the special effects of the sword, coloring the line and surrounding its contour with a shine made as if you were using an airbrush. Use bright, bold colors, and make the rider and motorcycle match, as if they were one.

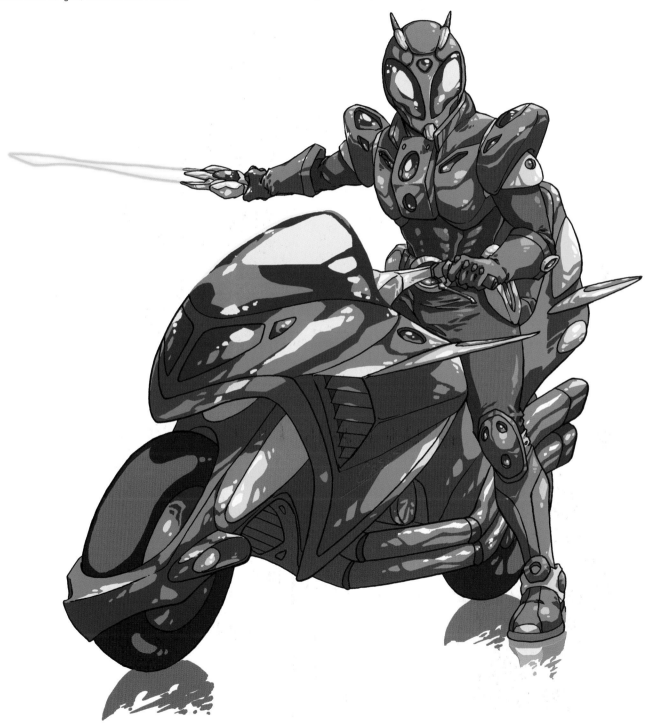

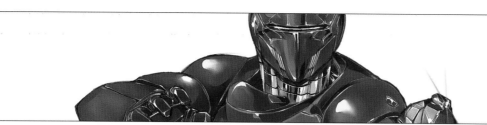

CYBER POLICEMAN

The Japanese have long been interested in the relationship between mankind and machines. The gradual loss of humanity to technology in today's word constitutes a concept that Manga designers have exploited to frame their stories of giant robot pilots, futuristic armor that merges with human minds and bodies, and more directly, to cyborgs: half-human, half-machine organisms. The point is that human flesh are supposed to be forcibly substituted with metal parts, which implies a loss of the hero's humanity. And the hero wonders about the effects on his soul. Such characters tend to have a tragic and sinister edge, though they might be avengers working to save the good in man and to advance the rule of law.

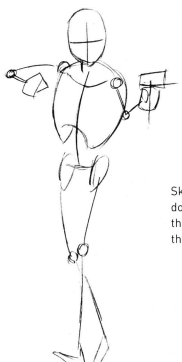

Sketch a figure that moves smoothly. To do this, draw it on a straight line from the vertical axis of the ground, and draw the foreleg, too, as a straight line.

2. Volume

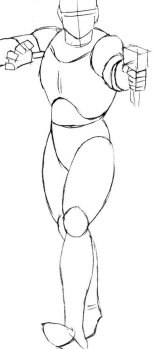

The cyber policeman closely resembles a dummy. Therefore, the drawing is actually very close to its final appearance. The chest is more square-shaped and angular than normal— almost like a box.

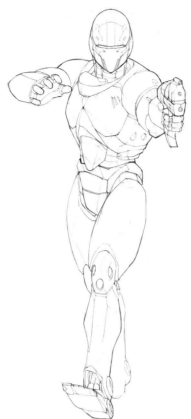

The cyber policeman doesn't wear a costume, but rather a series of sophisticated mechanical parts and pieces that need to be drawn on its armor. Refer to images of the latest generation of electronic gear so that the body of the cyborg appears more functional and real.

Source of light

4. Lighting

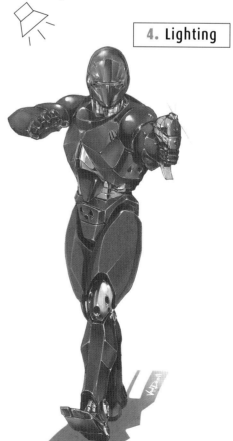

The shadows are concentrated on the center and left side of the body. Highlight the silhouette with high contrast. Here, this is produced by dark surface color and shine effects, and the lighter areas on its sides.

The cyber policeman should have an elaborate finish, with plenty of detail, while the background should be formed by a single-color dot matrix. Use steely, machinelike colors for the body, and keep the color range limited.

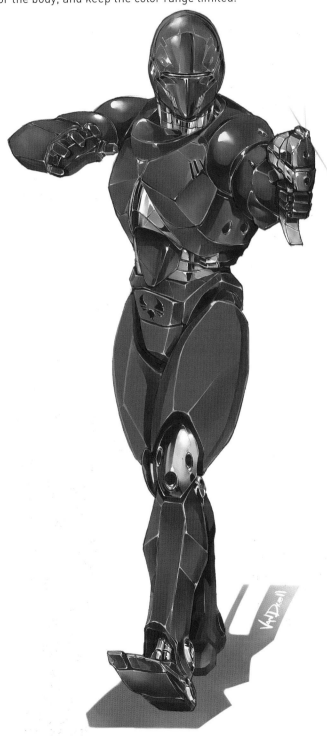

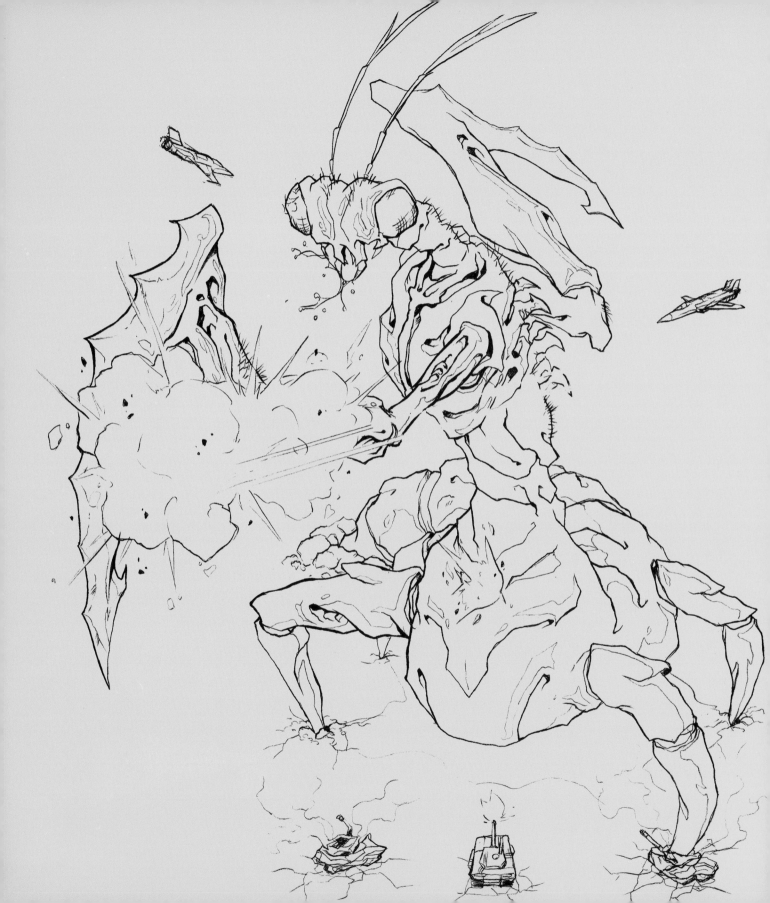

GIANTS

SD ROBOT / IRON MAN
ANIMALIZED ROBOT
GIANT MONSTER
GIANT INSECT

SD ROBOT / IRON MAN

For the Japanese, stories about giant robots are a genre unto themselves in the same way that there is a fantasy or a science fiction genre. Stories about giant robots can take place in the future, when they serve as armored vehicles in intergalactic wars. In this case, we find combat scenes where dozens of giant robots fight, equipped with weapons in proportion to their size. Or, they can take place in modern times, where giant robots are something exceptional. In such stories, the protagonists are usually boys who see themselves as forced to pilot giant robots in order to save humanity from some threat, which usually involves monsters or other giant robots.

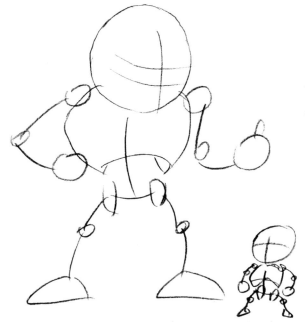

Assume you have to deal with the same kind of blocks and articulation points you would use with a person; draw the structure of the robot as such.

Draw the general outlines of the robot and boy which, because they are simple figures, will be almost the same as the final version.

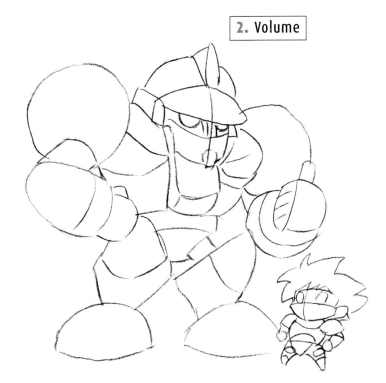

Draw some continuous shading where the
dark areas contrast with the reflections.

Source of light

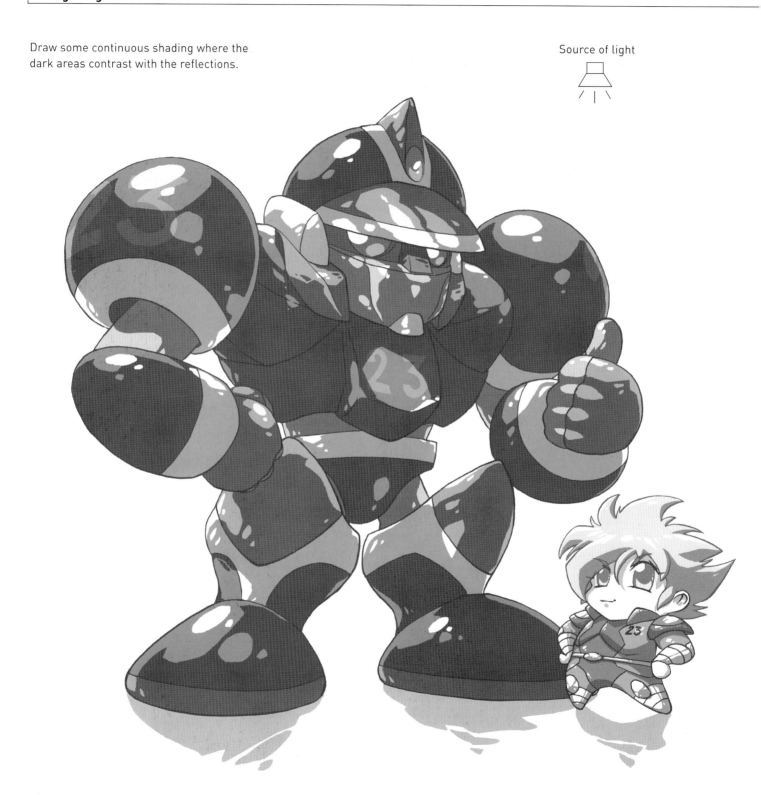

This is a big-bodied and big-headed figure, so use a perspective that helps us see it as something with big proportions. The metal-tone body should have bright details to convey the robot's role as a friendly protector. The boy should have lighter, more innocent colors.

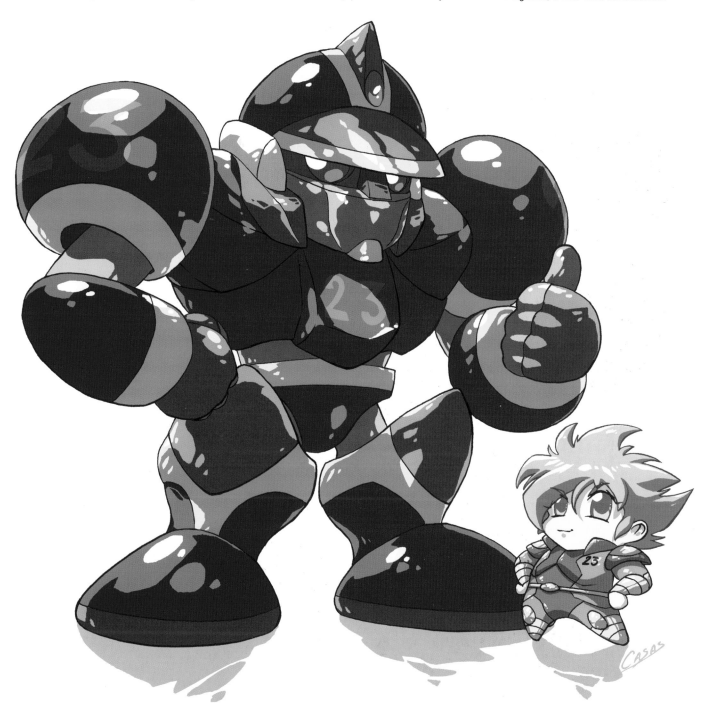

ANIMALIZED ROBOT

In the same way that we can find robots whose structure and appearance are inspired by human beings, there are still more whose design draws upon other life forms, such as insects or common animals. There are also robots capable of changing shape, transforming themselves from human, with a human's two legs and two arms, into an animal, with four or more legs and a distinctive torso. Such a monstrous robot may partly or entirely resemble an animal, and its animal features perform similar animal functions. It may have, for instance, wings to fly, prehensile tails to catch objects, or horns to attack.

1. Shape

Begin by drawing a simple structure, like that of a human being, adding a disproportionately large chest and a tail that emerges from the back.

2. Volume

Construct the blocks that constitute the volume of the figure out of simple geometric forms. The way it moves and distributes its weight should seem logical.

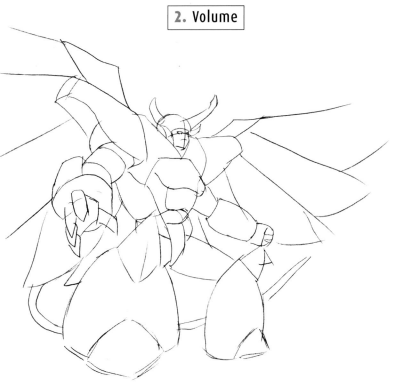

The armor around the robot is based on regular shapes, with straight lines and a smooth contour. Draw it so that the lines are firm and continuous; this should give rise to fluid forms.

So that the lines are as straight and regular as possible, use rulers. First, draw the shapes of the figure, and then use rulers in order to define the lines better.

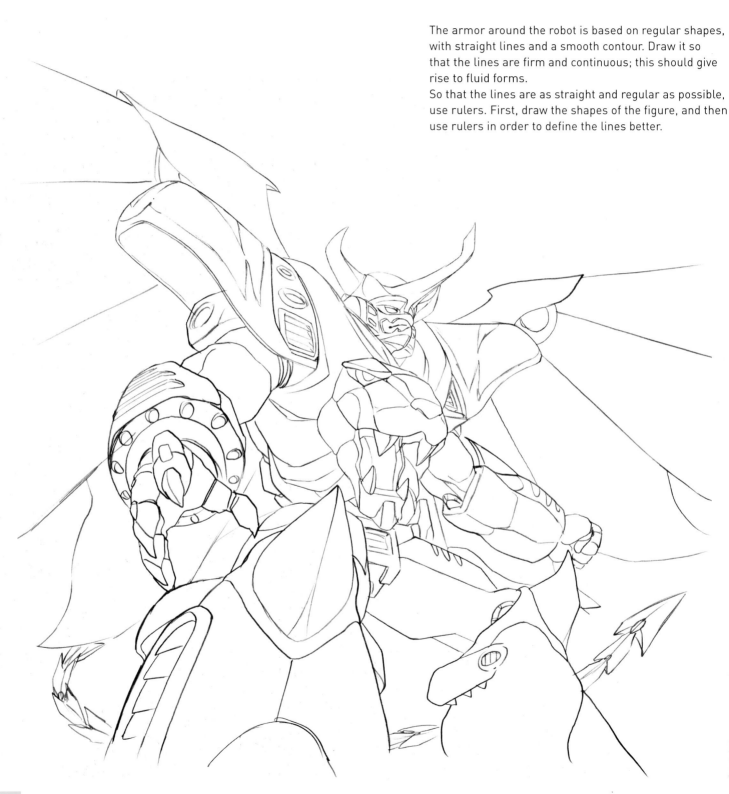

4. Lighting

Source of light

Since we want to achieve the appearance of a machine, try to use lighting that lets you play with the reflections and shading that delineate the surface of the robot.

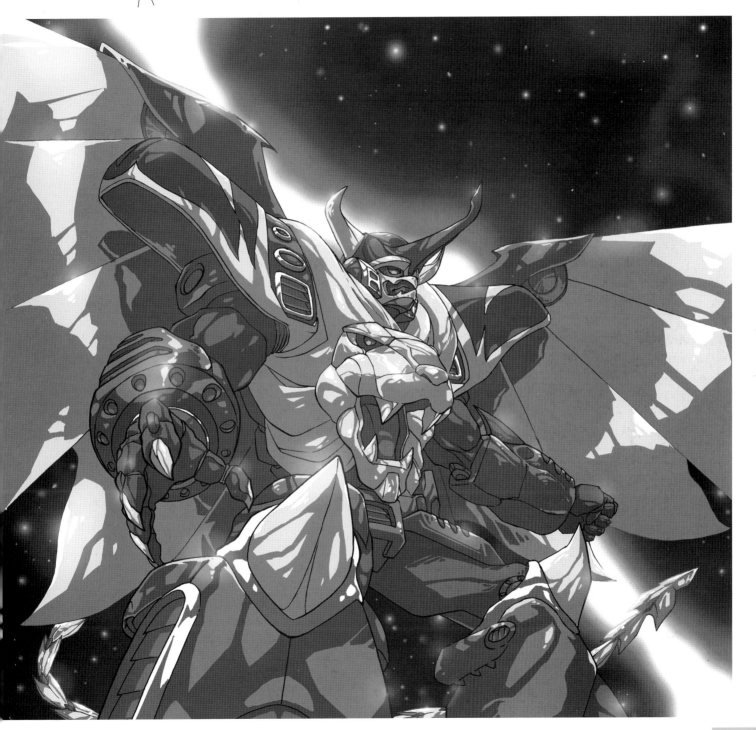

Use a simple base color to distinguish the different pieces of the robot. On top of this base, you can use light and dark colors to highlight the various elements, model the volume of the figure, and add some texture effects.

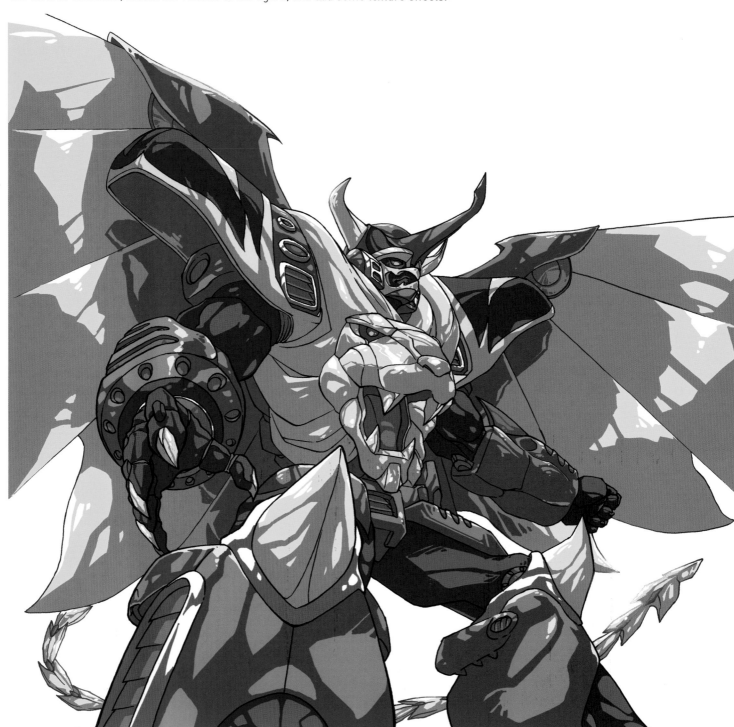

The final robot is the sum of several animal-shaped pieces. Combine them in a logical manner so that it looks as if the robot can change shape and make smaller robots (in the shape of these animals) come out of its body. Add a dark, spacelike background.

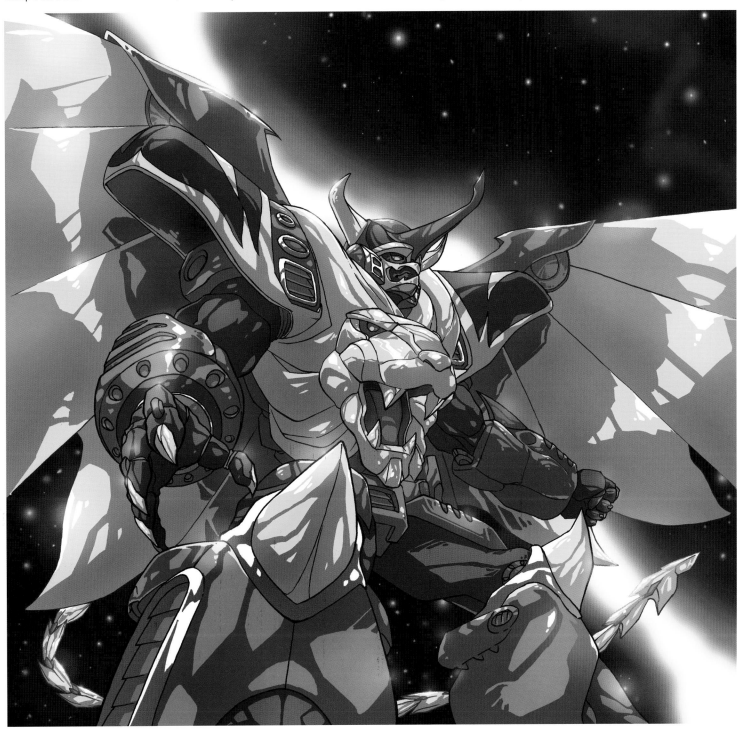

GIANT MONSTER

One of the icons of postmodern Japanese culture is the giant monster Godzilla, an enormous lizardlike creature that emerges from the depth of the seas to destroy the country. It is the Japanese equivalent of the mythical King Kong. The origin of this type of creature, at least in Japan, is generally the misuse of atomic energy. There is a kind of moral story to it all: if you fiddle with nature, it will retaliate in some way or another to destroy civilization. In this case, those threatening Japanese cities with destruction are the monsters from Monster Island: creatures mutated by radioactivity that take on terrible shapes and colossal size; they are endowed with powers such as the ability to fly, laserlike eye beams, and mouth flames.

1. Shape

First, draw the structure of a human body. Although this is a kind of lizard, its shape and attitude are in principle those of a neckless obese person, with its head stuck to the shoulders.

2. Volume

The base of the figure is an enormous belly, to which you'll add the shoulders and the head (drawn under the line of the back). Then draw the tail of the monster as a prolongation of the dorsal spine.

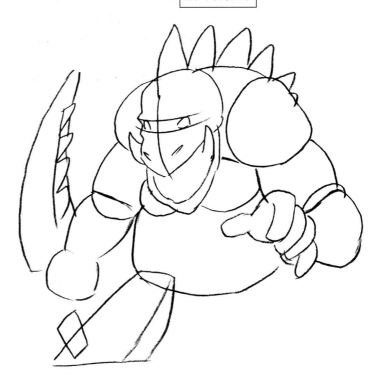

Draw only the body down to the waist because this is the only part that's visible. The anatomy and details of the muscles are similar to those of a very beefy man.

The head details give the monster its appearance as a half-human, half-lizard hybrid. The tail and the scales on the back make it a mutant monster that resembles a dinosaur or a Chinese dragon.

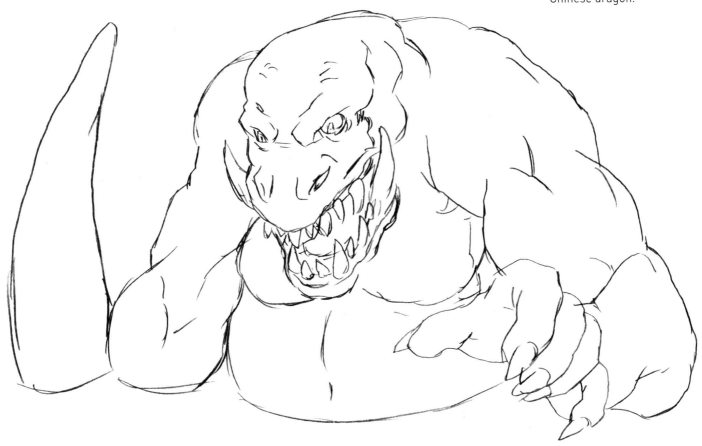

There is actually no clothing on this monster. Instead, you can add some background designs as well as other elements. Here's a good exercise: Draw a battleship in front of the creature before it is destroyed. Then modify it in a new version with the battleship destroyed, and add some effects to show the devastation produced by the monster. Be careful to use the right perspective.

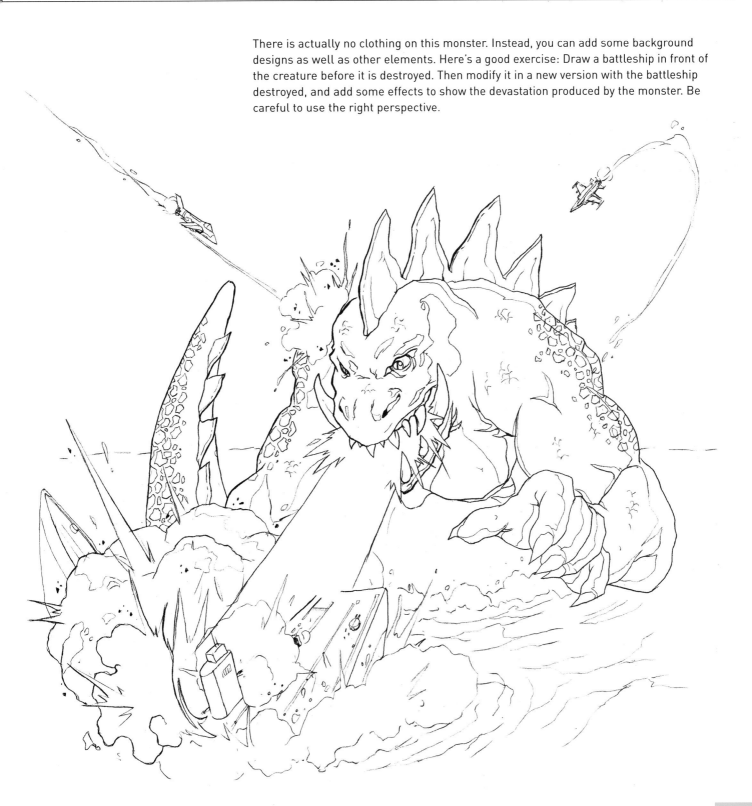

Draw the shadows on and around the contours of the parts opposite the source of light.

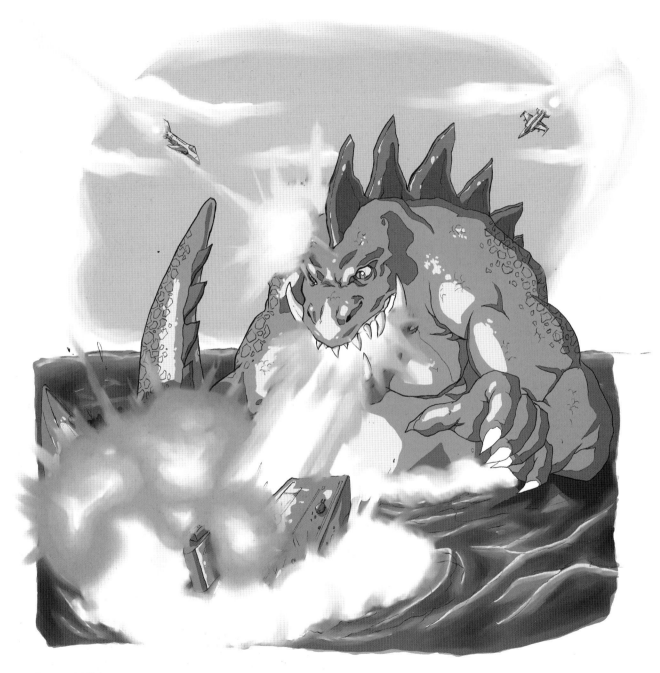

Source of light

In order to end up with a credible monster, make sure the texture of the skin has a hard, irregular appearance.

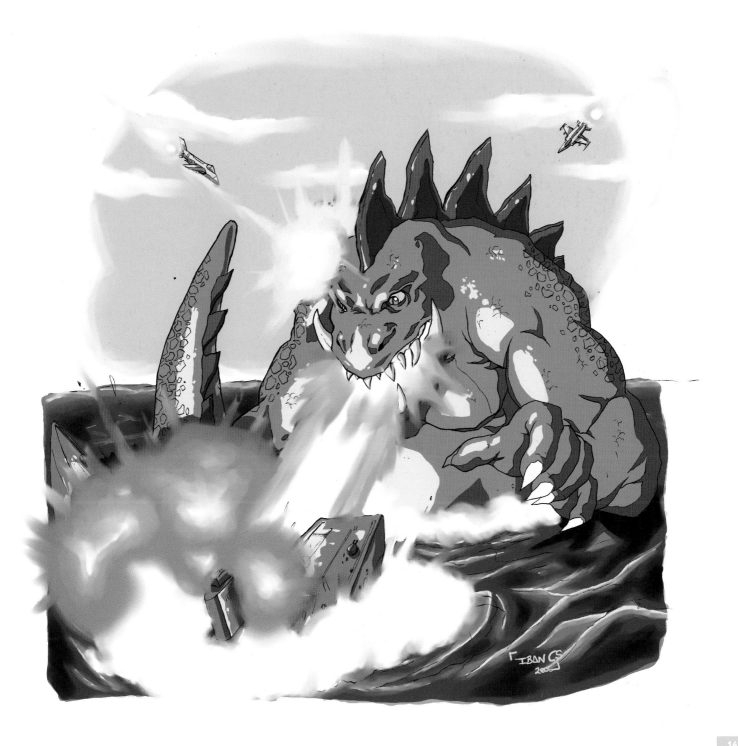

GIANT INSECT

For many reasons, insects inspire revulsion and fear. The unpleasant and aggressive exoskeletons of most insects are often copied in the design of monsters and robots used in the science fiction genre. It is common to portray them as common insects that have been endowed with monstrous proportions. The reason for making an insect with such dimensions can range from mutations caused by contact with radioactivity, to rays that change the size of objects and simple alien creatures that belong to an ecosystem with giant monsters. But, ultimately, any reason is valid when you extract a monster from a natural-sciences encyclopedia.

1. Shape

Sketch the insect's shape as if it were a person from the hips up. It should resemble the body of a snake from the abdomen to the tail.

2. Volume

Adapt the figure to make it look more like an insect. Modify the head's shape, as well as the arms or front legs. Note that the hind limbs are attached to the enormous abdomen.

Insects have an exoskeleton, which means their skeleton is on the outside, and their soft tissue is on the inside. This exoskeleton looks like a cuirass—like plates covering the entire body.
In order to draw the exoskeleton appropriately, refer to pictures of insects, and adapt their features to the monster's simpler shapes.

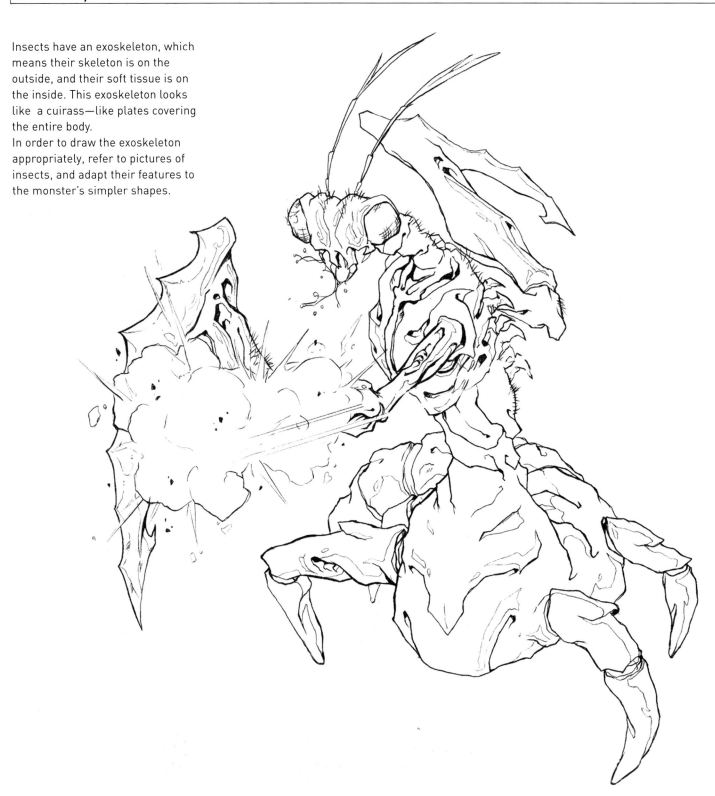

In order to give this creature a more realistic look, add details such as hairs, stingers, and bumps, which it would have if it were a real insect.

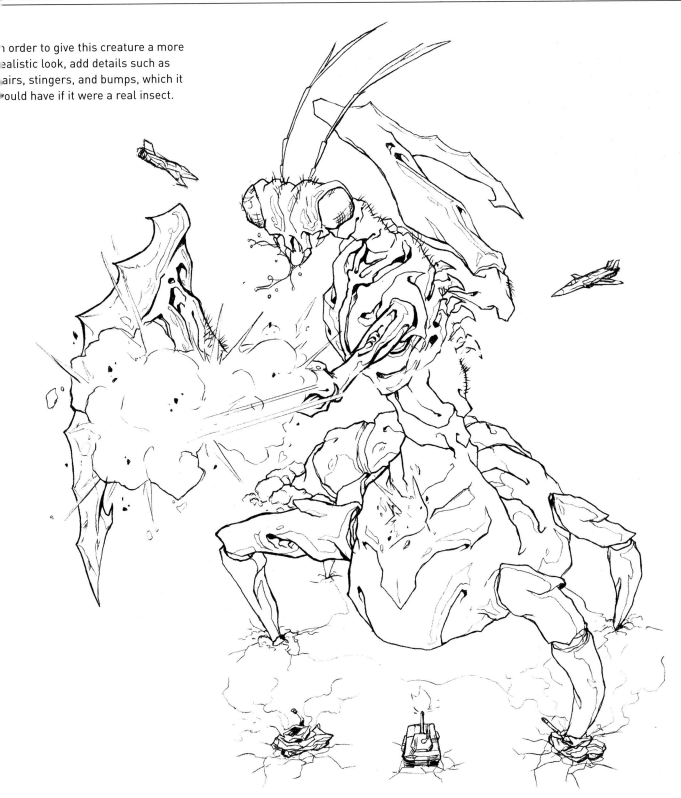

The explosions and the different sources of light in the scene are very specific. Note that the monster is too big to be covered completely by only one source of light. Mark the light on the figure with contrast, shading the areas that are not so brightly lit.

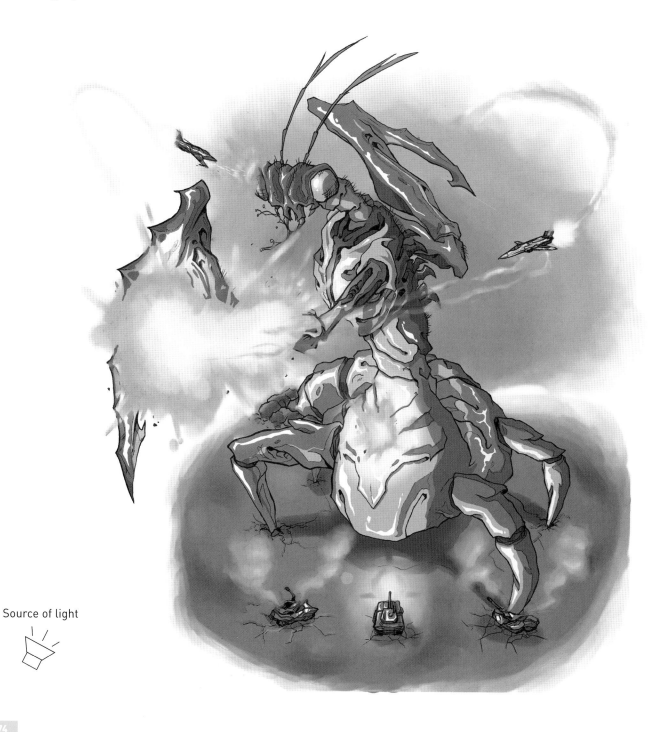

Source of light

Finish the background with stains, highlighting the explosions and special effects with bright colors. The monster could take on the color of the insect that inspired it. Here, the upper-body model may have been a green preying mantis.

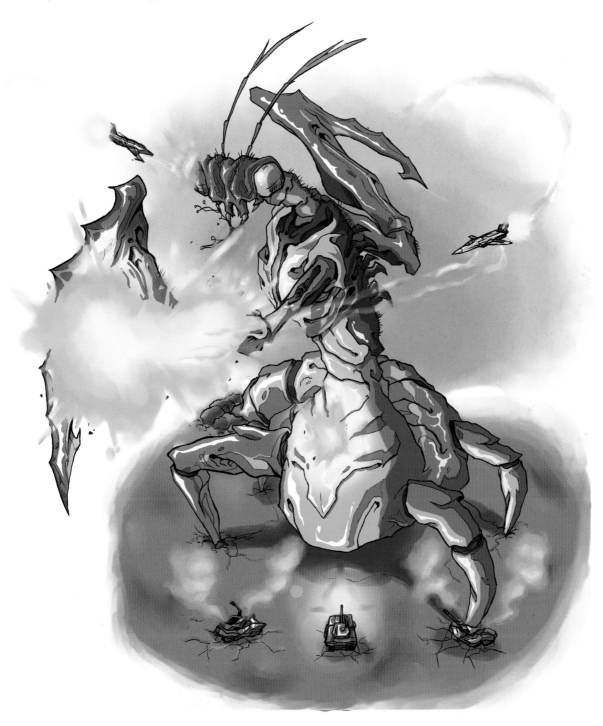

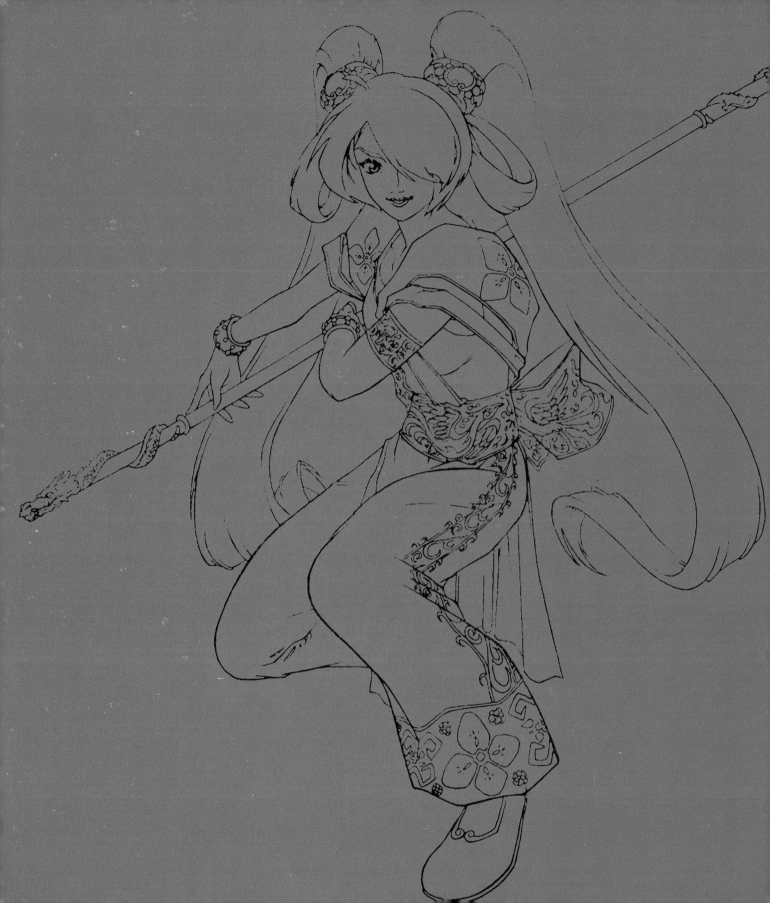

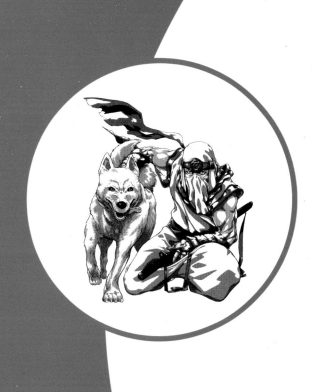

MARTIAL ARTS

SD MARTIAL ARTS
KUNG FU
WRESTLER
SUMO
BOXING
KICKBOXING
NINJA

SD MARTIAL ARTS

The heroes in adventure Anime usually resort to wrestling in order to overcome the dangerous situations they're in. The scenes tend to be much more appealing when they involve martial arts and other similar combat disciplines where they use their bodies alone or in combination with weapons such as knives, swords, and clubs. Martial arts fighters do not use their knowledge for the sake of violence alone. On the contrary, each martial art is rooted in a specific kind of philosophy that can be applied to various aspects of daily life. In addition to action and adventure Manga, it is common to find sport-based Manga where athletes compete to prove who is best and where the lives and feelings of the characters are often key.

1. Shape

Sketch the structure of the figure on a series of curves in motion so that its appearance looks more dynamic. The axis of the shoulders and the hips produce an accordion-like effect over the curve of the spine.

2. Volume

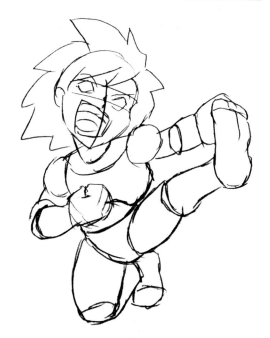

Add the various volumes, making the muscles of the figures look like pronounced spheres. This helps highlight the way the torso protrudes over the foreshortened leg.

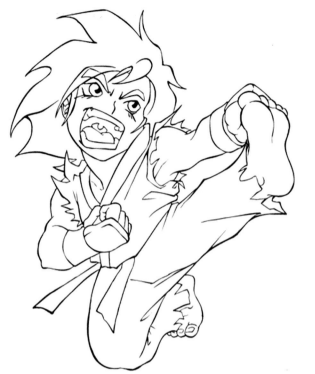

Given that this is a very dynamic figure, the folds in the clothing should follow the inertia of the last movement. To achieve this effect, draw some reference lines to mark the direction of the folds. Then define their shape more accurately, depending on the type of fabric and how loose you want to make it look.

4. Lighting

Source of light

The shading will help define the folds of the clothing. To this end, draw continuous shading contours next to the wrinkles.

Finish by coloring the scene in energetic, positive tones. Add some shiny effects to the figure, which in turn helps highlight its volume.

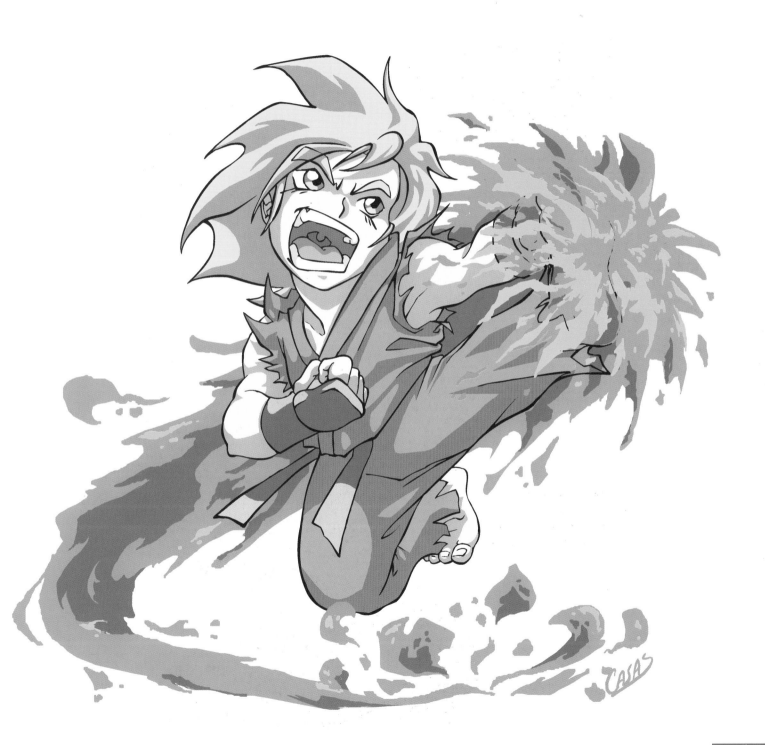

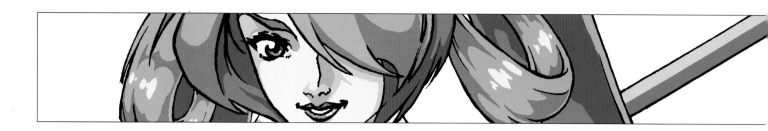

KUNG FU

When we think about martial arts, the first thing that comes to mind tends to be the aesthetic: the exotic clothing, the kimonos, and the loose silk clothing as well as the studied postures or the weapons of the fighters. The relationship between the figure's pose and the idea that he or she is practicing kung fu is usually drawn from Asian films, where martial arts are performed with such coordinated moves that the fighters look like they're dancing. Such poses are often inspired by the movements of animals, such as the tiger, the snake, or the crane (some kung fu styles are associated with the latter) and by formal gestures referred to as kata, which form part of one kind of martial arts.

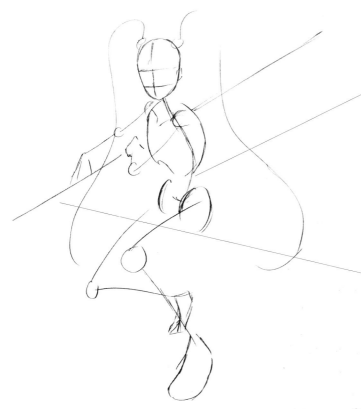

Sketch a base for the position of the figure. This should be an undulating line, descending vertically from the head to the feet; the latter are aligned with the ground.

The back and the arms are reduced to a sinuous and continuous line. The position of the arms determines the way the character holds the staff.

2. Volume

The arm is moving aside. This is important in order to understand the way she holds the staff. The position of the knees must reflect the fact that she is moving one of them ahead. When drawing the extremities, be careful to sketch the way these elements become deformed as a result of the foreshortening—which helps the scene achieve a sense of depth of field.

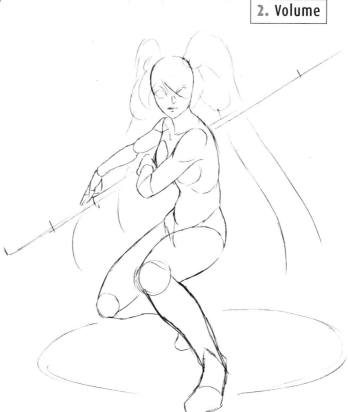

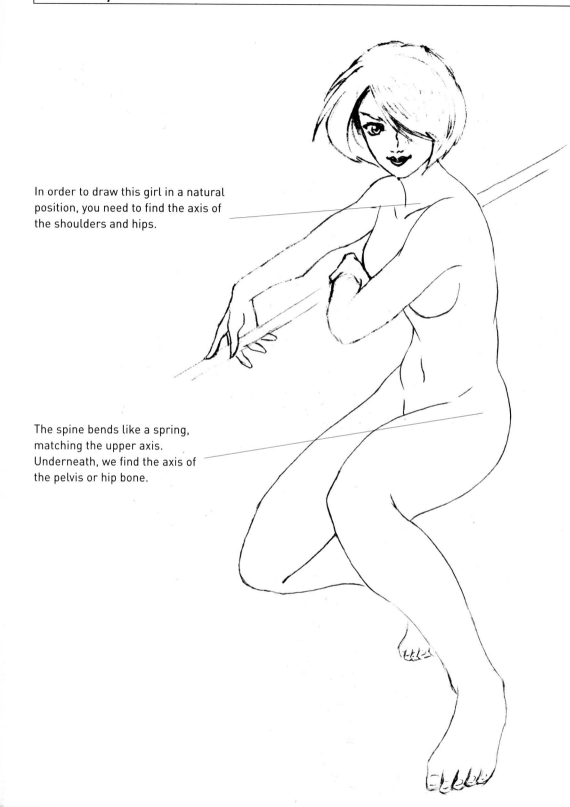

In order to draw this girl in a natural position, you need to find the axis of the shoulders and hips.

The spine bends like a spring, matching the upper axis. Underneath, we find the axis of the pelvis or hip bone.

The hairstyle is a key element of this character. In order to draw such long pigtails and make them look dynamic, sketch what could be a piece of fabric and imagine how it would look when it's moving. We define the hair more sharply on this sketch.

4. Clothes

The clothing of the kung fu fighter is complex, with fabrics that intertwine and adapt to the shoulders or hang down to the waist.

There are many detailed designs and filigrees on the clothing. To draw them, first sketch their shapes very simply. These will serve as guidelines for integrating the folds of the fabric—the last step in this drawing.

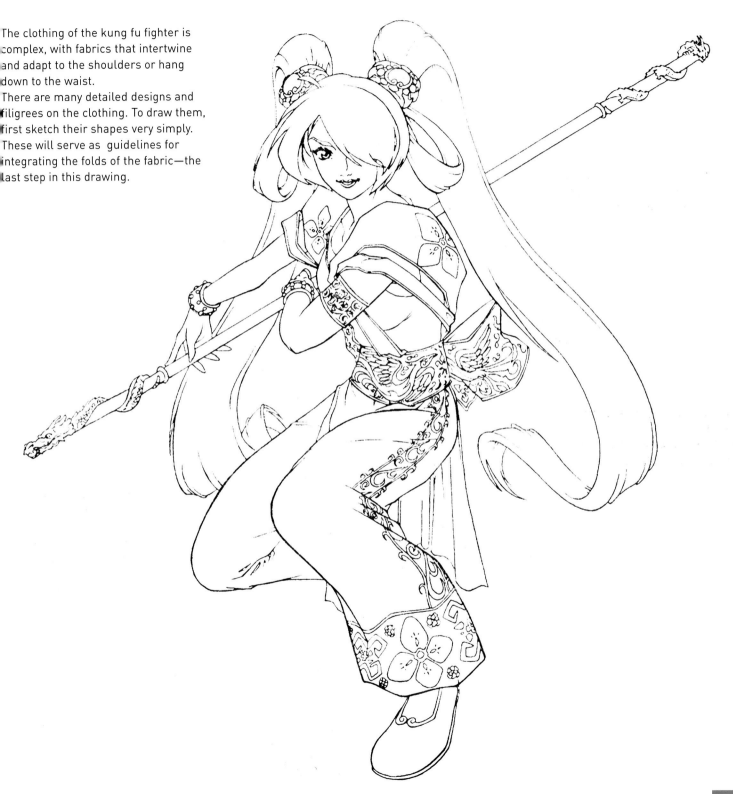

Source of light

To represent the texture of silk, draw the typical reflections of a shiny fabric with sinuous contours, adapting them to the different folds of each garment. Do a similar thing with the hair, reinforcing the sense of volume with strong, shiny contrast with the internal part of the pigtails.

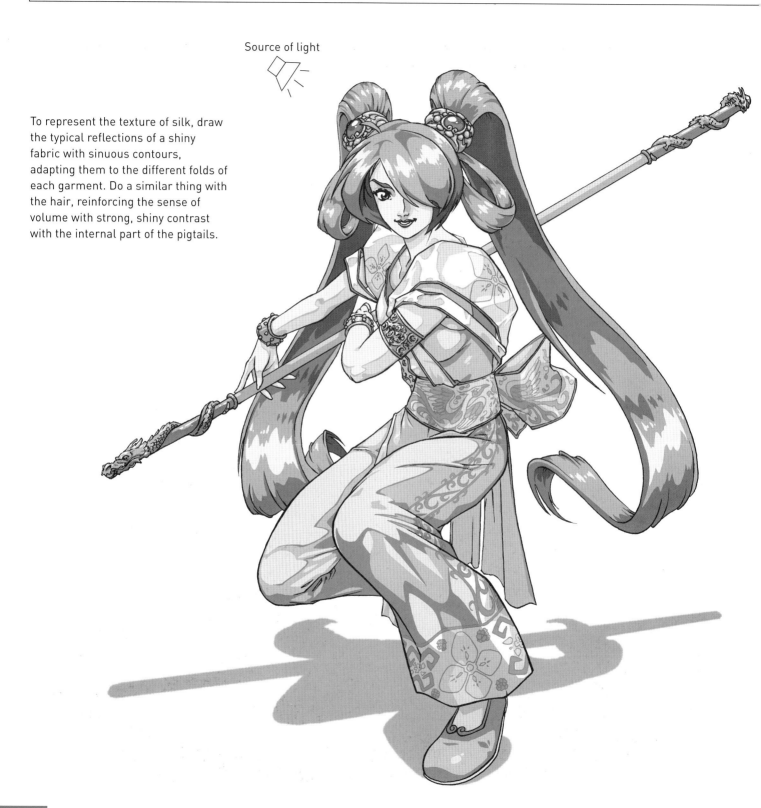

The costume looks even prettier when you use shades of a happy color like pink. Replace the black lines on the design motifs with colored lines. Now the effect of silk in the clothing recalls ancient China, where kung fu originated.

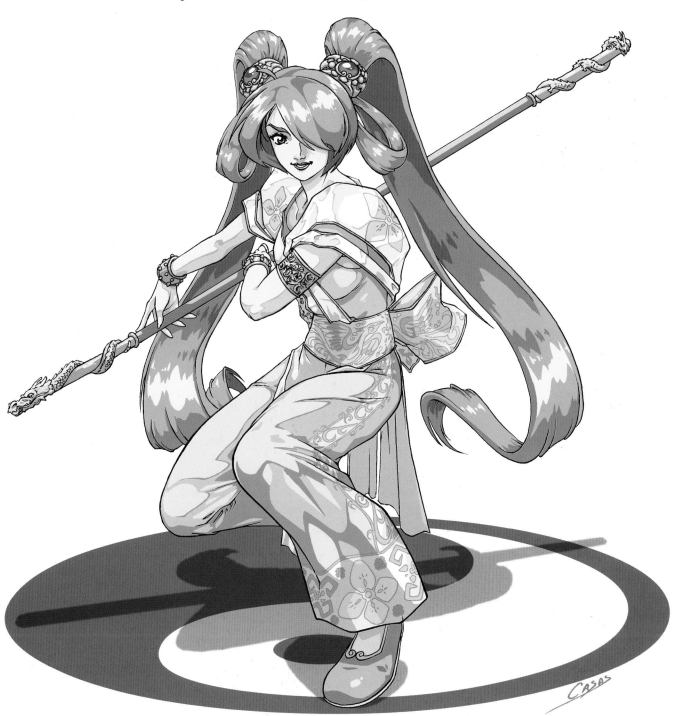

WRESTLER

Catch-style arena wrestlers are partly modern warriors and partly actors; show and performance are what usually matters in this type of combat. This is obvious when we look at the wresters' extravagant clothes, which can combine anything from colorful tights and masks or boxer shorts to a superhero cape. But there are also many variations within this type of show. We can find both gruesome fights between real wrestlers, as we do in many countries, and fake ones like the ones on television, with wrestlers acting as heroes or villains or whatever their stage-wrestling persona demands.

1. Shape

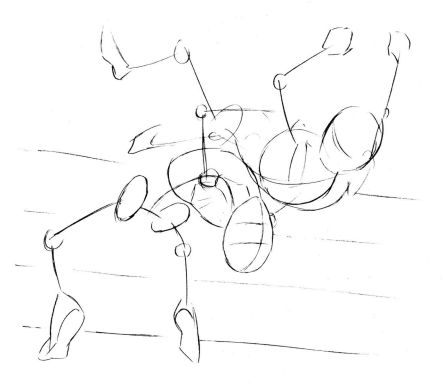

Draw the poses of these two figures by using the ground as the reference point. Then sketch the standing wrestler. His back should have a pronounced arch, and the legs should be wide open. The second figure should be on the same plane as the chest of the standing character.

2. Volume

Now do the same thing the other way around. Begin by sketching the figure above, which will be foreshortened. Underneath this one, draw the part of the standing wrester's chest that can be seen, and continue drawing the rest of his body.

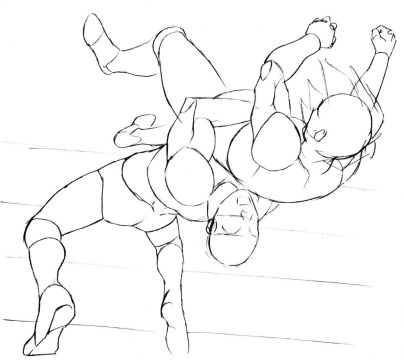

The shading contours will help highlight the anatomical details of the two characters, who are very muscular. Draw a few marked lines around the contour, and then draw the profile of the muscles. The shadows below the wrestler in the foreground need to be more pronounced and highlighted.

Source of light

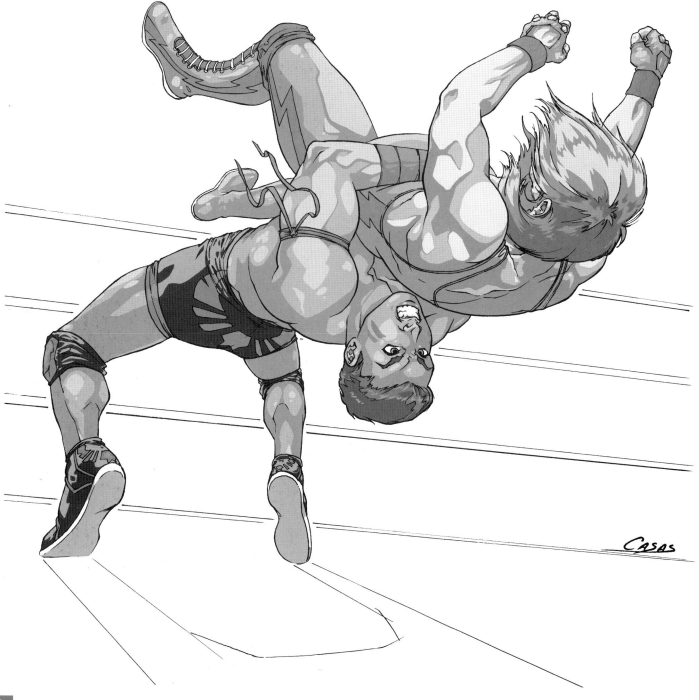

For a clean background that focuses attention on the wrestlers, draw in a few light lines to represent the boxing ring. Even the contour of the shadow on the ground is just a few intersecting lines. Make the clothing bright and theatrical.

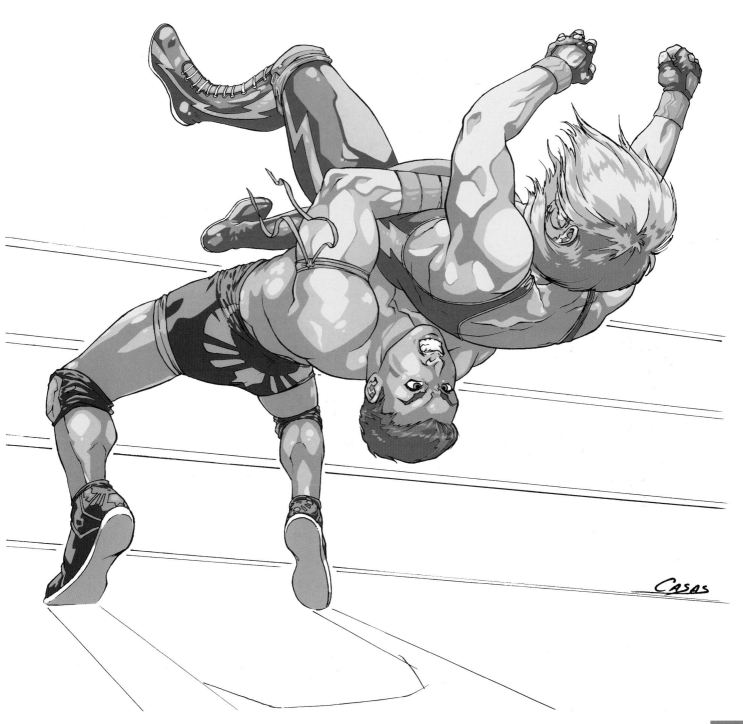

SUMO

Sumo is a contact sport that reflects the strong Japanese connection with roots and tradition. In Sumo, two wrestlers face each other in a type of combat whose purpose is to move one's opponent outside a circle on the floor. The circle is marked by a huge cord of braided rice grass known as tawara. The elements of Sumo are carefully controlled: the place of combat, the sand on the ground, and the process before and during combat. A fight is preceded by a ceremony, and the preparation of Sumo wrestlers, or rikishi, is both physical and spiritual because they are respected as guardians of the ancestral tradition. This martial art requires not only physical strength but also great technique and concentration.

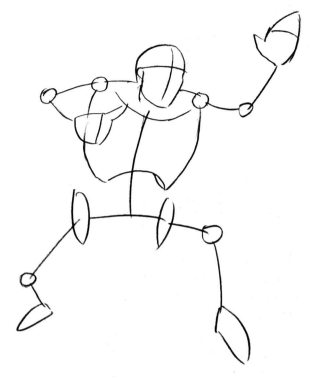

Draw the base of the figure, paying special attention to the considerable size of chest of the Sumo wrestler (rikishi) and to the position of the legs, which are moving forward.

2. Volume

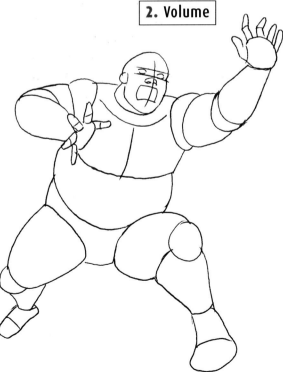

Draw a voluminous torso and a very thick pair of legs. The marked foreshortening effect reinforces the idea of forward movement.

The chest is a compact block that is huge but solid and strong. The rikishi is not an obese person. He, in fact, has powerful muscles over his wide structure. You must clearly define the musclature.

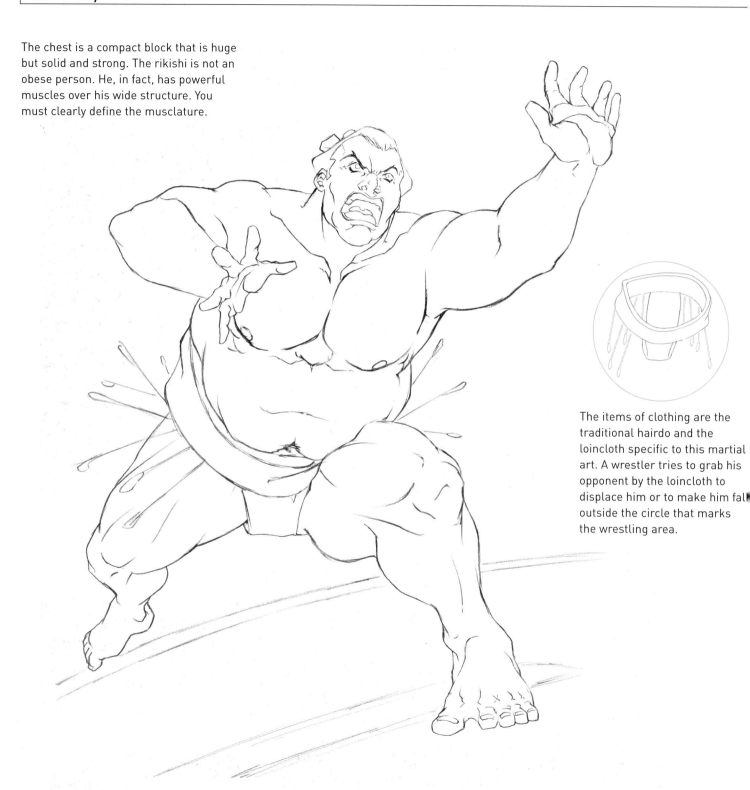

The items of clothing are the traditional hairdo and the loincloth specific to this martial art. A wrestler tries to grab his opponent by the loincloth to displace him or to make him fall outside the circle that marks the wrestling area.

Source of light

Use the outlines of the shadows to highlight the volume of the rikishi's powerful muscles. The inside part of the body is covered by a large shaded area, which makes it apparent that the light comes only from above.

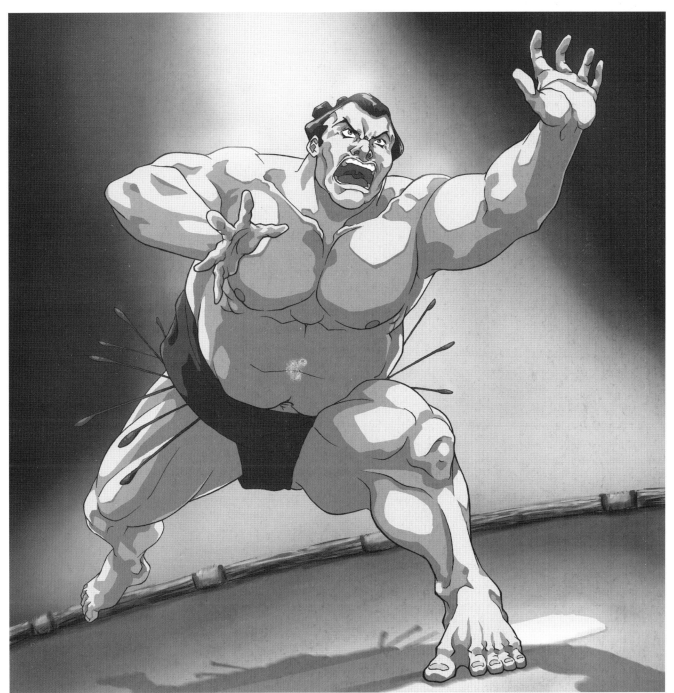

When coloring the figure, pay special attention to the
fact that there is a light bulb above the wrester's
head. Make the shadows coincide with the various
flat colors outlined on the figure.
Keep the colors somewhat naturalistic, except the
unlit parts of the body, which should be darker than
usual for both realistic and theatrical effect.

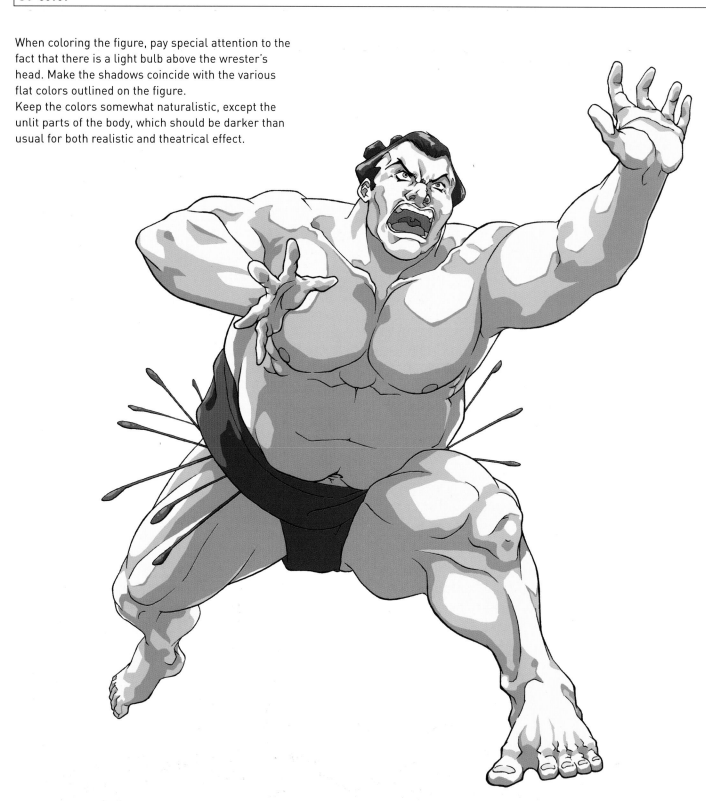

6. Finish

Finish by drawing a silhouette in shadows on the ground directly under the rikishi, and add some specific bright spots that will look like sweat. Add a textured tawara at the edge of the ring.

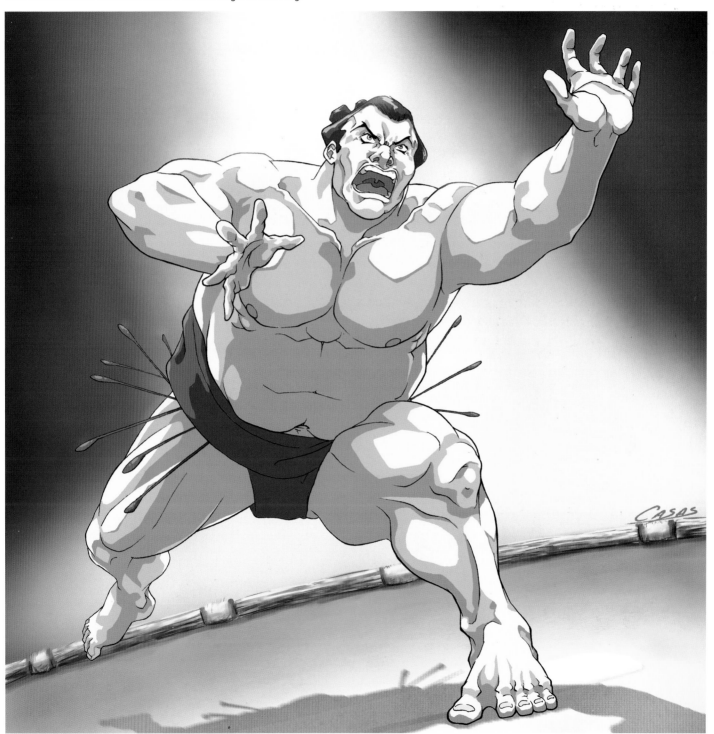

BOXING

Stories of boxers always carry a message of personal improvement; they are not simply stories about two people wearing gloves who hit each other until one of them falls down and is unable to get up again. The combat is about the boxer showing what he has learned and how he has improved throughout his tough training, both in his physical condition and in his strength. But, above all, the boxer must have toughened his personality to be able to give everything he can in just a few minutes and to withstand the blows of his opponent without giving up. If we are able to show all this in one image, we will have caught the spirit of sports-related Manga, and specifically boxing Manga.

1. Shape

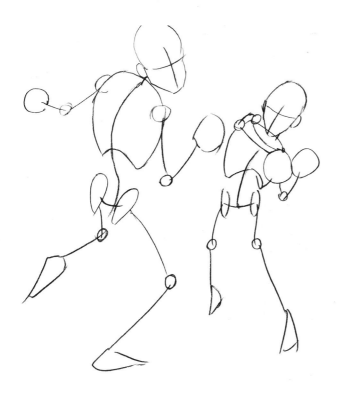

To capture the moment of the actual blow, place the figures at a diagonal angle, with the character who hits entering the space of the character who gets hit. The fighter who advances does so at the same time as he leans on his forefoot in order to lend more momentum to the blow.

2. Volume

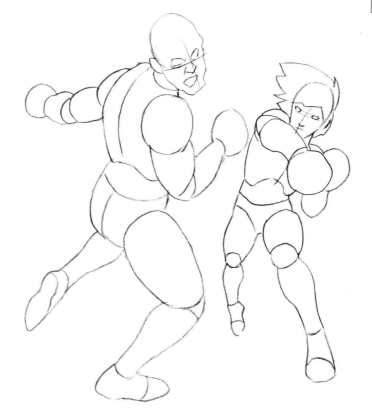

Besides controlling the position of the legs and the way they bend, take care to show the difference in size between the two boxers. The one who receives the blow not only looks larger because he is closer, but he is, in fact, bigger in size and volume.

The position of the feet and the play between the legs with respect to the body weight is fundamental in making this scene work. The boxer who hits is about to lift the foot that is to the left and behind, and he has displaced his weight and momentum forward, firmly leaning on the foot in front and projecting the fist towards his opponent. The boxer who is hit loses his balance, and his legs fail him.

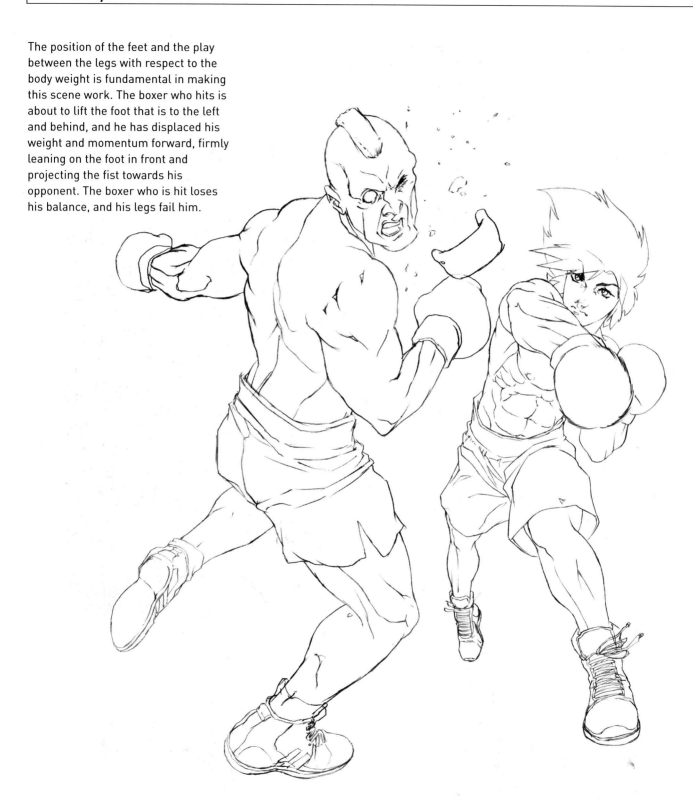

4. Lighting

The illumination comes from powerful arena floodlights, which is why the shadows of the boxers should be well defined—strong overhead light makes intense shadows. Represent the well-developed muscles by locating shadows close to the outlines of their musculature.

Source of light

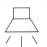

Color the background, in which the central flood of light is the most important element; add round spotlights. Also put in some mist to create a hazy atmosphere, and adjust the textures of objects and details. Keep the colors somewhat realistic.

Not only are there shiny spots on the boxers' bodies representing light reflected from skin covered in sweat, there are also water droplets flying from the hit man's head. Note the trunks are white and black, implying a test of good versus evil, and good is winning.

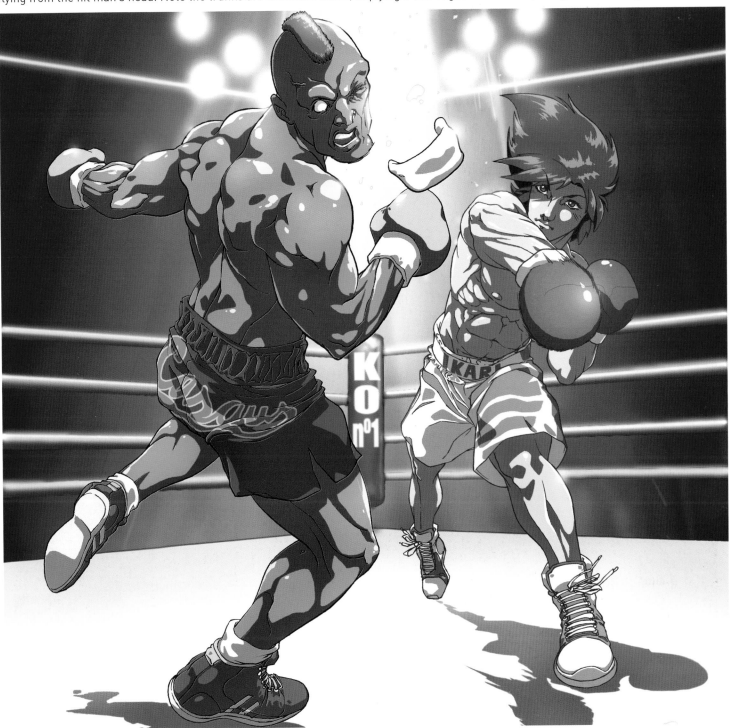

KICKBOXING

Kickboxing is a martial art that can be best described as an Asian version of boxing. It has specific rules for one-on-one combat that takes place in a ring; the technique, centering on the use of both the fists and feet as weapons, depends on rigorous training. A kickboxing match has several ritual aspects: it is a practice with roots in traditional martial arts that are still common in various Asian countries. As such, kickboxing is part of their cultural identity, and those who practice it are respected figures. Due to the importance of legs in this combat, we should draw our characters covering themselves with their arms and attacking with their legs, which fits perfectly with the spirit of kickboxing.

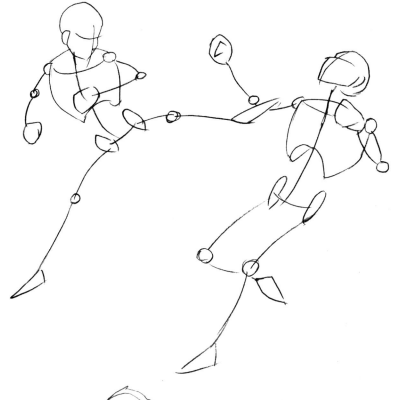

Sketch two figures at different heights. One of the kickboxers lifts himself in a vertical leap to hit the other one with a high kick. The kickboxer who receives the kick loses his balance, which should be made apparent by the incline of his vertical axis.

2. Volume

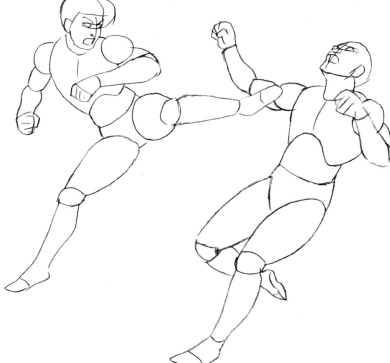

The position of the attacker's leg is the result of bending it after landing the blow. As such, draw a foreshortened leg from the groin to the knee. The volume of the falling character is visibly different from—and larger than—that of the attacker. This makes him seem more threatening and implies that there is more merit in being able to bring him down.

Draw heavy, well-defined musclature, including the "six-pack" abdomens on both figures. Add elements such as the belts and the bandages on their wrists and ankles; these help identify the characters as kickboxers. The hairstyle of the fighter on the right and the ornament on his head let us know that he is a fighter wearing a ritual garment. Note that they wear no shoes.

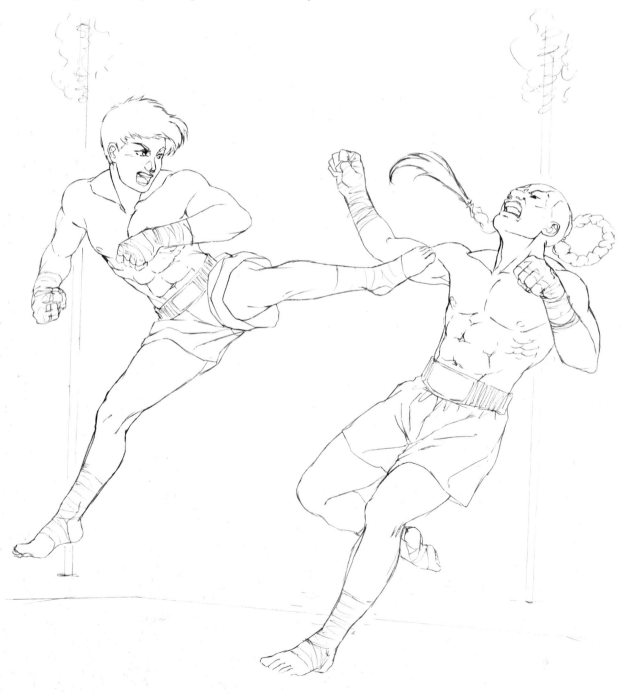

Source of light

The illumination comes from torches that give off powerful light behind the characters. This is why wide, defined shadows are drawn on their clothes and bodies. Because the back lighting is intense, place strong reflections on the skin to represent the boxers' sweat. Note the flying sweat and spittle.

Source of light

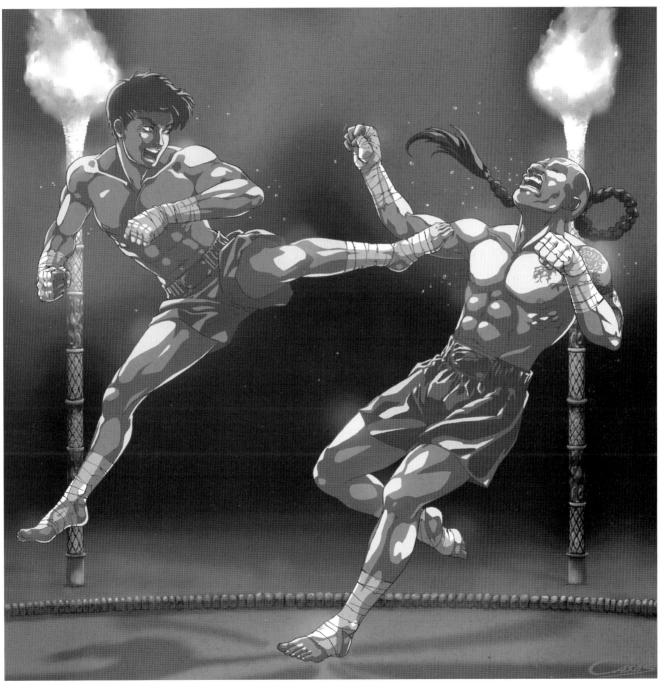

For the background, just draw a circle on the ground and two poles with torches. Color gives more importance to the background. Show that the torches produce strong light and heavily illuminate the smoke clouds. Blacks and golds (darkness and light) predominate.

Add more shadows on the ground to give the impression of other light sources, as if more torches were surrounding the combatants. Color their bodies and clothes in a somewhat limited palette of earth tones.

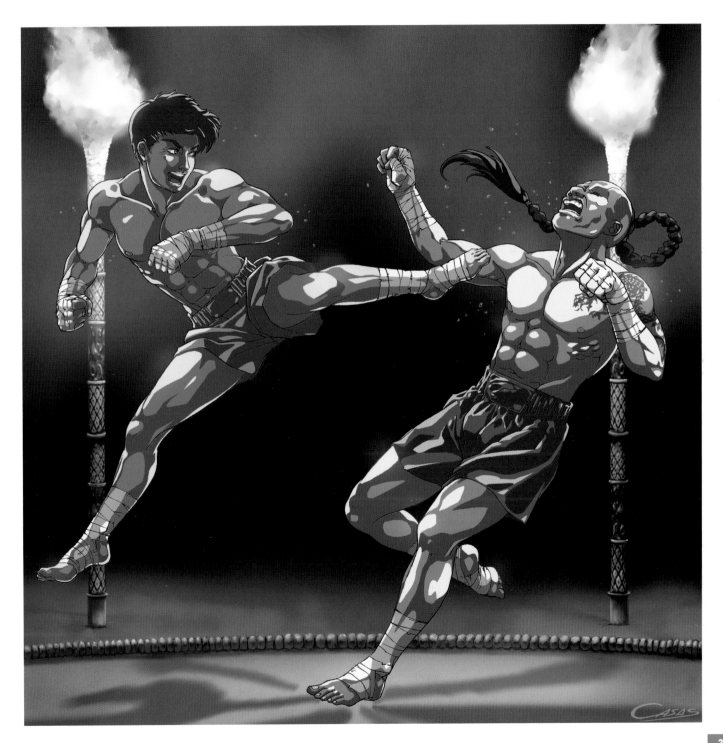

NINJA

Warriors of the shadows, specters of the night, mystical killers, ninjas are part myth, part superstition—and part historical reality. During the Japanese middle ages, a turbulent period, it was necessary to organize a force of spies and mercenaries. The feudal lords used these agents, trained to infiltrate and kill, in a civil war that affected a great many small owners. With the unification of Japan, and the arrival of modern times, ninjas stories eventually became legend, and ninjitsu (the discipline and the training used by ninjas) became a sport. Taking into account that there is still espionage, it would be too naïve to think that ninjas have disappeared.

1. Shape

Focus on the image of a dog in an alert position, and sketch it this way. The ninja is crouching and passes an arm over the animal's back.

2. Volume

Draw the figures at a slightly low angle, showing their volume as seen from beneath. This has to be taken into account to draw the back and legs of the wolf dog.

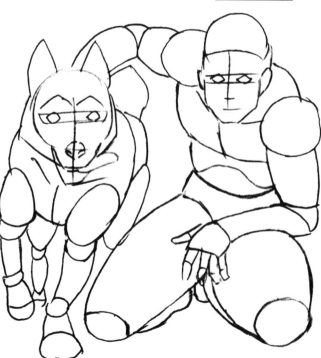

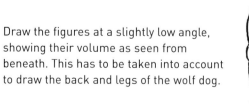

The ninja is resting on his knees in front of us; therefore, the legs are hidden behind the upper part of the legs and the knees. These seem large due to the effect of the foreshortening.
In order to draw the animal accurately, refer to photographs of such dogs. Simplify the characteristic features of the dog, and you will be able to draw it with a few strokes.

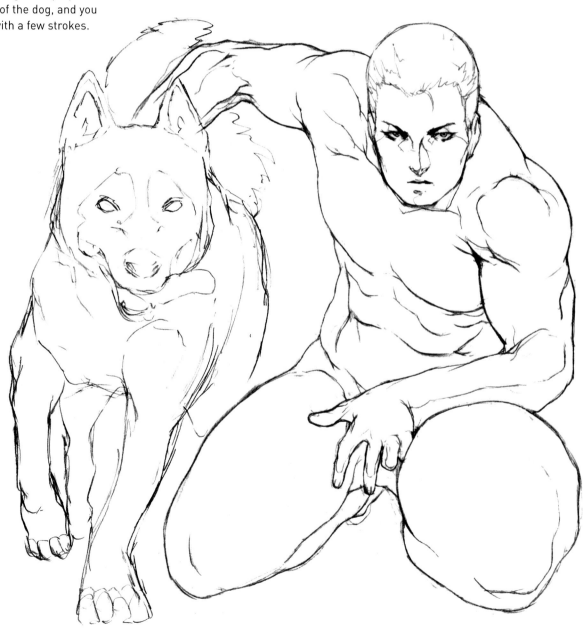

4. Clothes

The ninja's costume and paraphernalia are easily identifiable because people have a clear image of this character's stereotype. Make sure to adhere to the stereotype; while details can change, the loose garments, masks, and wristbands are obligatory.

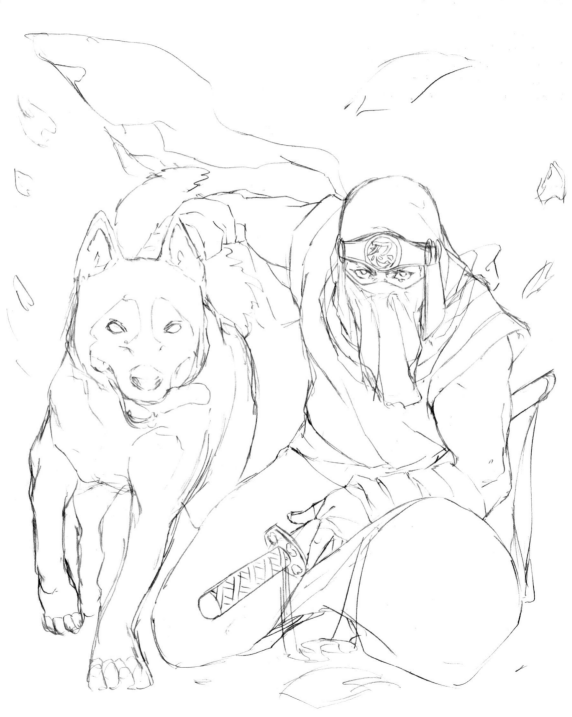

Source of light

The play of light and shadow is important because ninjas remain hidden in the shadows. Design ninja garments to blend with the darkness in most cases. In this case, though, it was the artist's choice to make the clothes light colored and the scene illuminated.

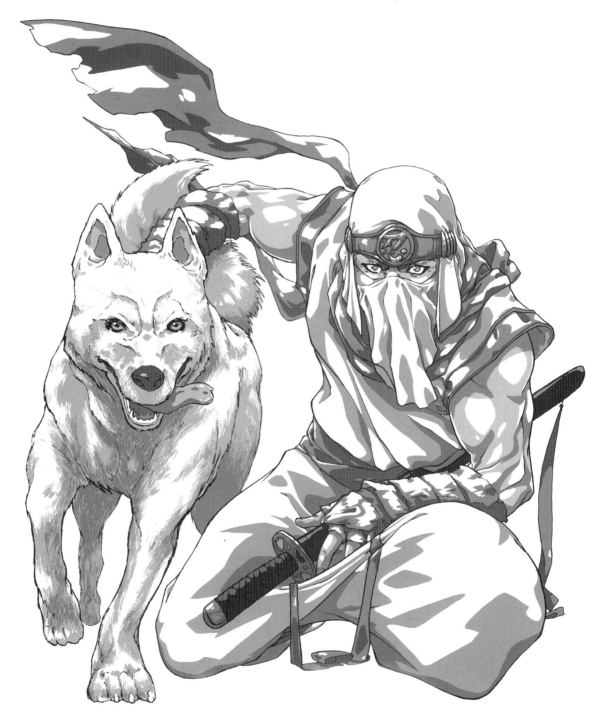

The ninja here may be on a mission in a region where there is a lot of snow. The colors complement the pale gray of the wolf dog's coat.

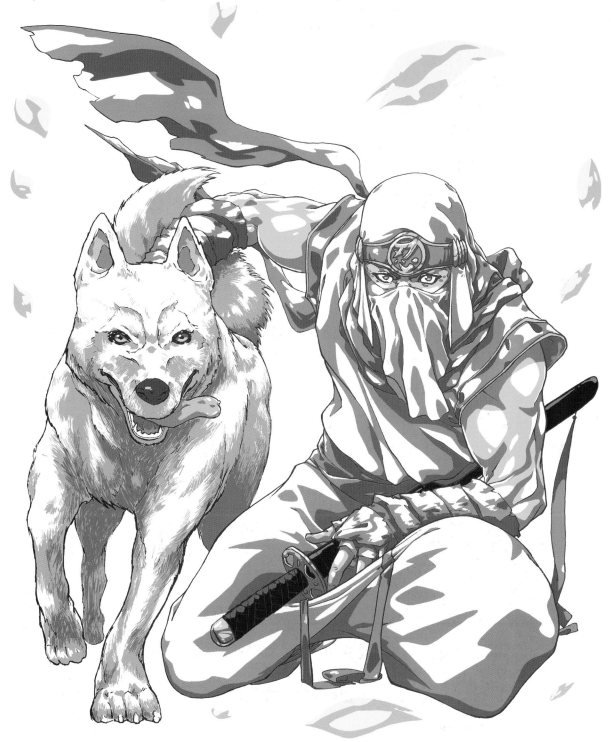

HEROES

SAMURAI
SPACE OPERA
COWBOY
MEDIEVAL
NOMAD

SAMURAI

The Samurai is another exclusively Japanese character, the equivalent of the Western medieval knight. Samurais were the product of violent times when armed men fought wherever necessary. The Samurai, a kind of soldier with privileges and lands, was a noble warrior with the right to carry a sword and armor onto the battlefield. The main privilege of the Samurai, though, was the right to carry a sword in civilian life, the sword being the symbol of his social level. He used the Japanese saber, or katana, famous thanks to its amazing blade, as light and sharp as a knife's. Samurais dedicated their lives to the discipline of wielding this weapon. Theirs became a spiritual way of life. The Samurai Code emphasized duty and sacrifice, even above the Samurai's own life, and obedience to the feudal lord and to the Emperor.

1. Shape

Sketch the internal structure of the figure in a simple pose, with the back axis almost vertical, the shoulders and hips parallel. Draw a reference of the perspective. Make sure the axis matches the perspective.

2. Volume

Keeping in mind the shoulders-and-hip axis, and with the feet in perspective, overlap the shapes that are foreshortened.

Choose a relaxed pose for the Samurai. Lower the perspective slightly in order to highlight the confident, sideways stance of the character.

Make a type of free-spirited, adventurer Samurai, adding items such as the neck scarf and the ribbons tied as wristbands to the kimono.

To draw the ribbons blown by the wind, first draw the reference lines. Then make the secondary lines, and finish the shape of the ribbons.

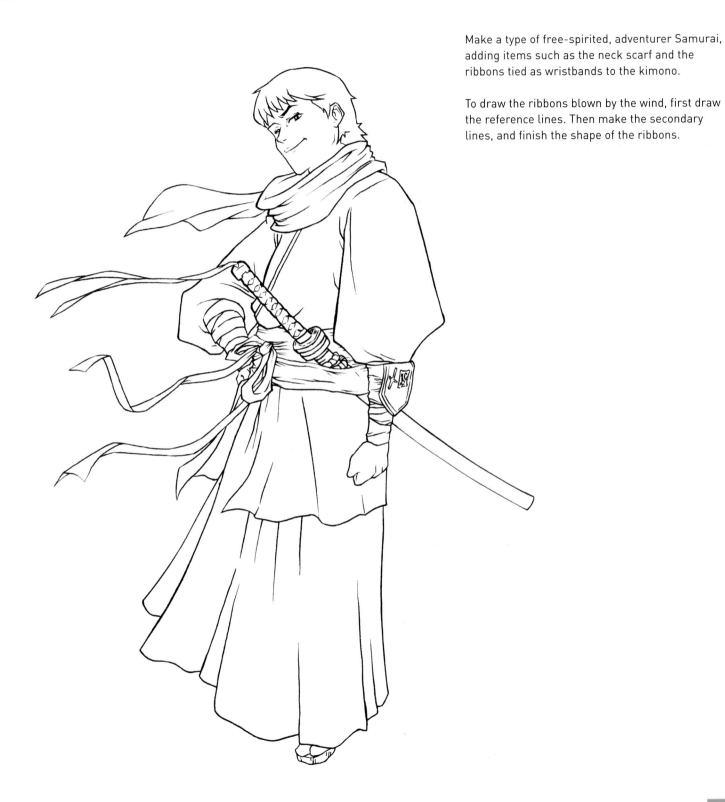

Draw in the outlines of shadows to give volume to the kimono, including large, regular patches that fall vertically on the heavy fabric.

Source of light

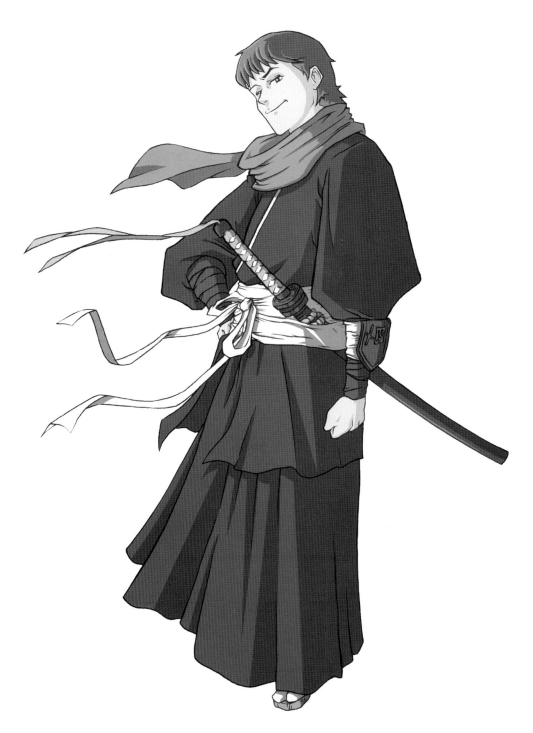

6. Color

As with the head, model the whole figure with shadows and the nuances of light reflections, highlighting the important details. Color the typical kimono in traditional black, but make the scarf—a mark of individuality—a vibrant color.

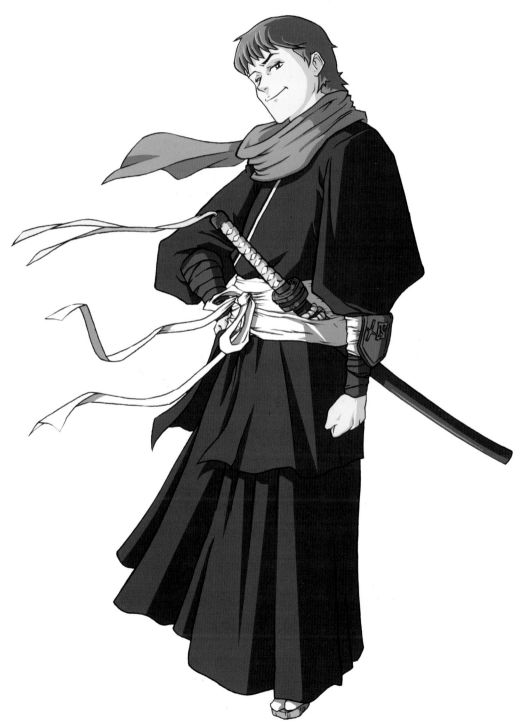

SPACE OPERA

The term space opera refers to adventure stories that occur in space. They have an old-fashioned flavor because they're inspired by old science-fiction novels. These novels, the precursors of modern comics, were basically short and very imaginative stories in which the role of the classical hero was reinterpreted, and the traditional scenario, usually adventures with monsters and princesses, was replaced with space and its creatures. In this way, planets became kingdoms populated by peculiar beings very similar to those in *Gulliver's Travels*. In these stories, the main character is an antihero, a cheeky devil who acts for his own benefit. He's a fortune hunter and outlaw who seems to have come from a pirate story set in space.

1. Shape

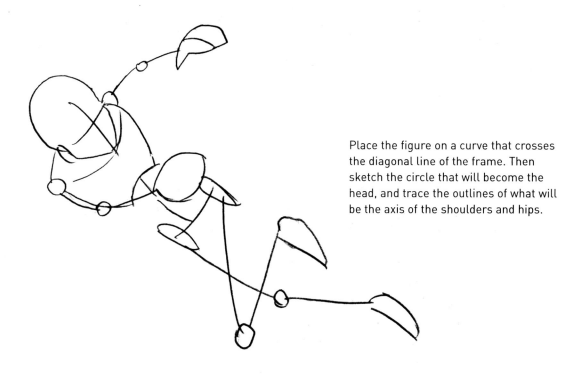

Place the figure on a curve that crosses the diagonal line of the frame. Then sketch the circle that will become the head, and trace the outlines of what will be the axis of the shoulders and hips.

2. Volume

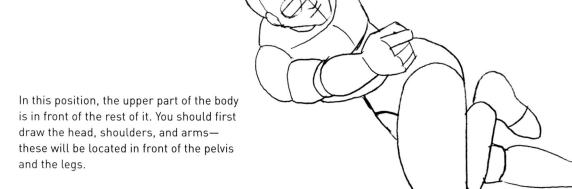

In this position, the upper part of the body is in front of the rest of it. You should first draw the head, shoulders, and arms—these will be located in front of the pelvis and the legs.

The main difficulty in drawing the space hero is how to represent the head when viewed from this perspective. This is a slanted view of the figure. So draw the upper part of the figure's anatomy, exaggerating the foreshortening of the parts that are moving forward and toward us.

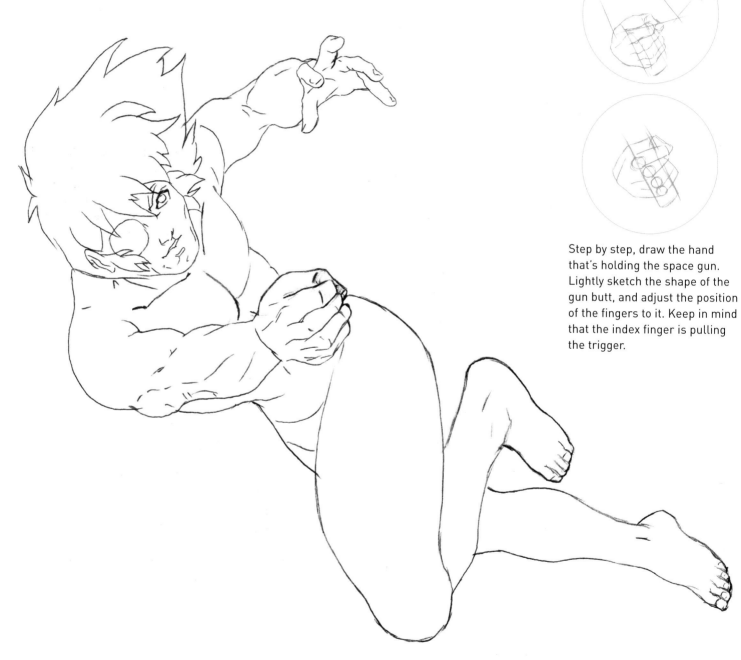

Step by step, draw the hand that's holding the space gun. Lightly sketch the shape of the gun butt, and adjust the position of the fingers to it. Keep in mind that the index finger is pulling the trigger.

Although our hero must spend his life traveling from planet to planet on his spaceship, the wardrobe has nothing to do with what is expected of a normal astronaut. Instead of pressurized suits, space adventurers wear tight-fitting clothes. A belt or strap across the chest is the only special equipment.

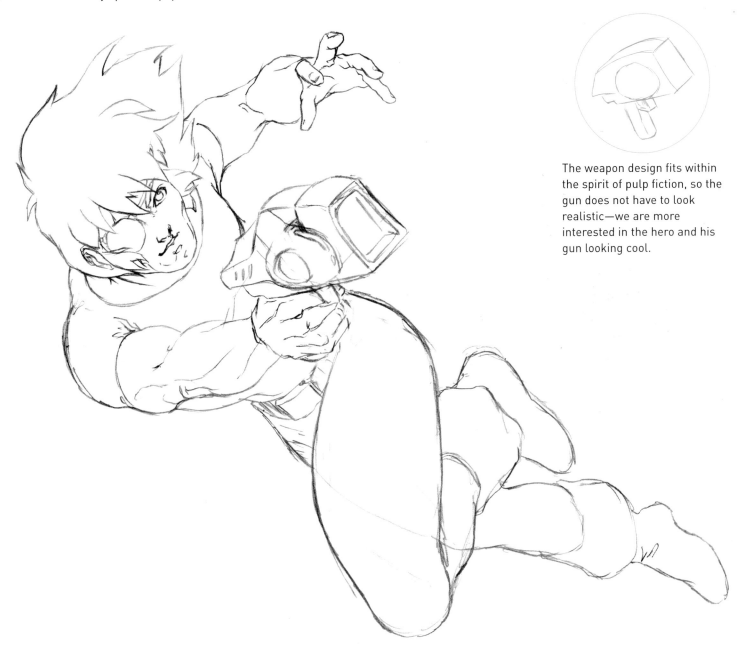

The weapon design fits within the spirit of pulp fiction, so the gun does not have to look realistic—we are more interested in the hero and his gun looking cool.

Make it seem as though the light is coming from the ray of energy emitted by the gun. Place shiny spots and on the torso and legs; on the shoulders, arms, and head, draw denser shadows.

Source of light

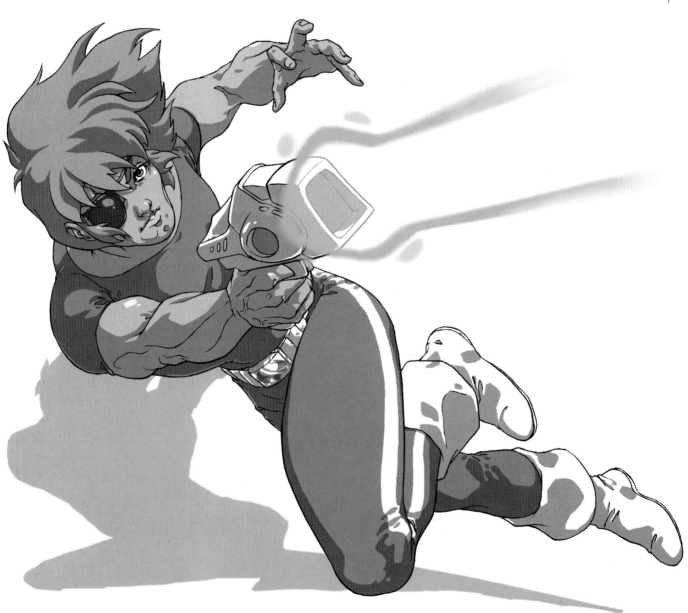

Draw the deformed silhouette of the character as a gray-colored spot. Color the suit in dramatic, pulp-fiction colors.

COWBOY

Westerns make us think of action-packed stories, lonely heroes, and rural landscapes. It does not necessarily have to be this way, but the typical image *is* the gunman with nerves of steel, who survives in a hostile world thanks to his quick-draw and sharpshooting talents. We have taken some liberties by drawing an attractive young man with long hair. However, we consider it a given that you are familiar with the classic Colt revolver, a firearm often used in western movies. With the desert as a background and a wide-brimmed hat in the picture, we have enough elements to create an Old West atmosphere.

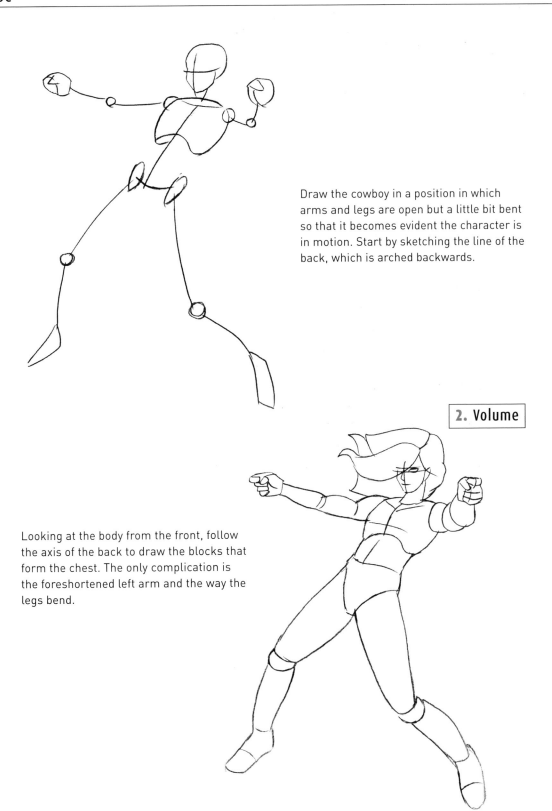

Draw the cowboy in a position in which arms and legs are open but a little bit bent so that it becomes evident the character is in motion. Start by sketching the line of the back, which is arched backwards.

2. Volume

Looking at the body from the front, follow the axis of the back to draw the blocks that form the chest. The only complication is the foreshortened left arm and the way the legs bend.

Redraw the pose of the head, which does not seem convincing. Sketch the new version on a separate piece of paper, and after you're sure it works better, substitute it for the first version.

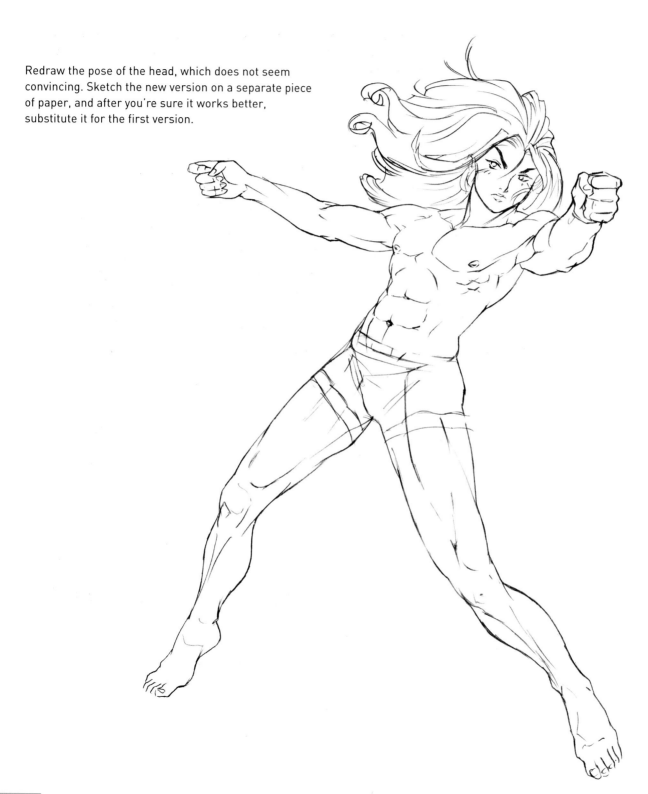

4. Clothes

The jacket floats in the air forming folds that follow the movement. Show this to make the image more dynamic and help characterize the cowboy as a gunman from the Wild West. Make some corrections in the sketch of the revolver so that it does not look so shallow in profile: give it some relief on the cylinder, and make the end of the barrel more solid.

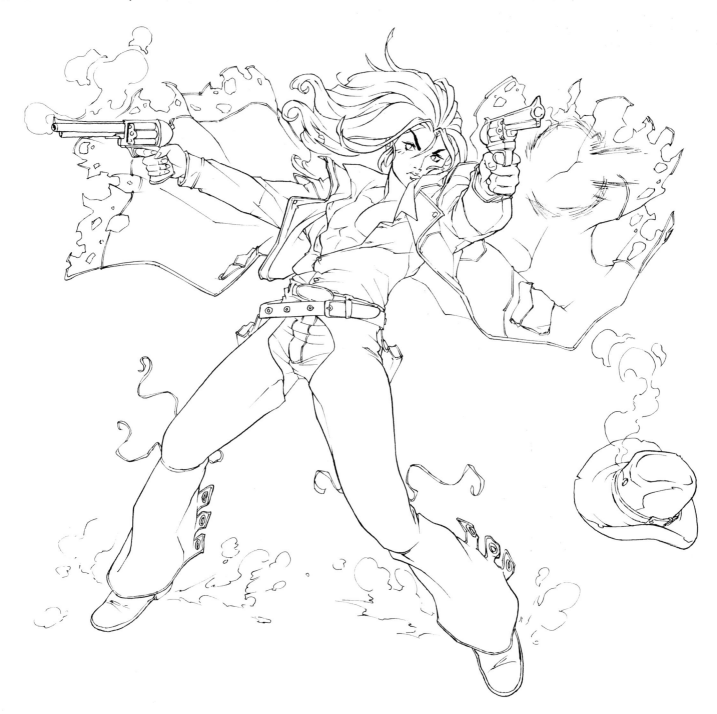

Source of light

So far, not bad. This time, draw the folds of the tattered raincoat with shadowy outlines. Also make a shadow extending from the figure's feet.

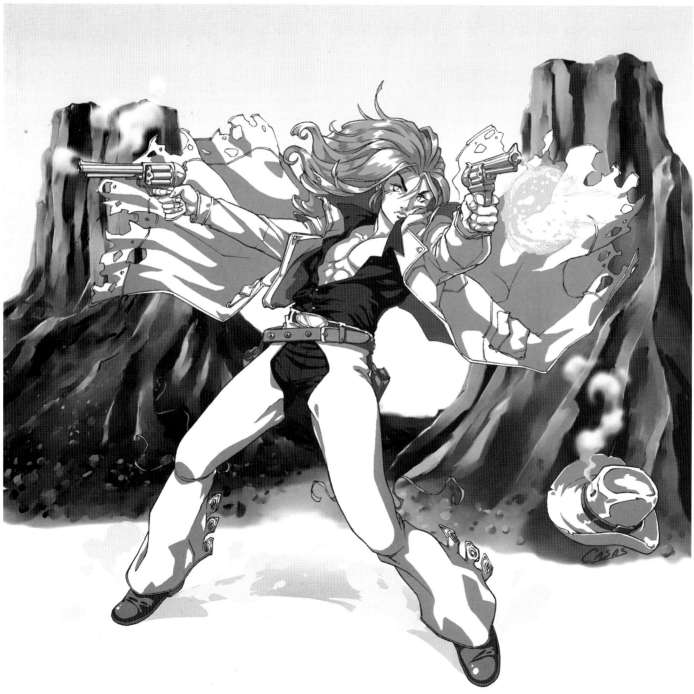

Give the cowboy light, chamois-colored clothes that complement the desert background. Add a cloud of dust near the gunman's feet and the image becomes more dynamic and is more complete.

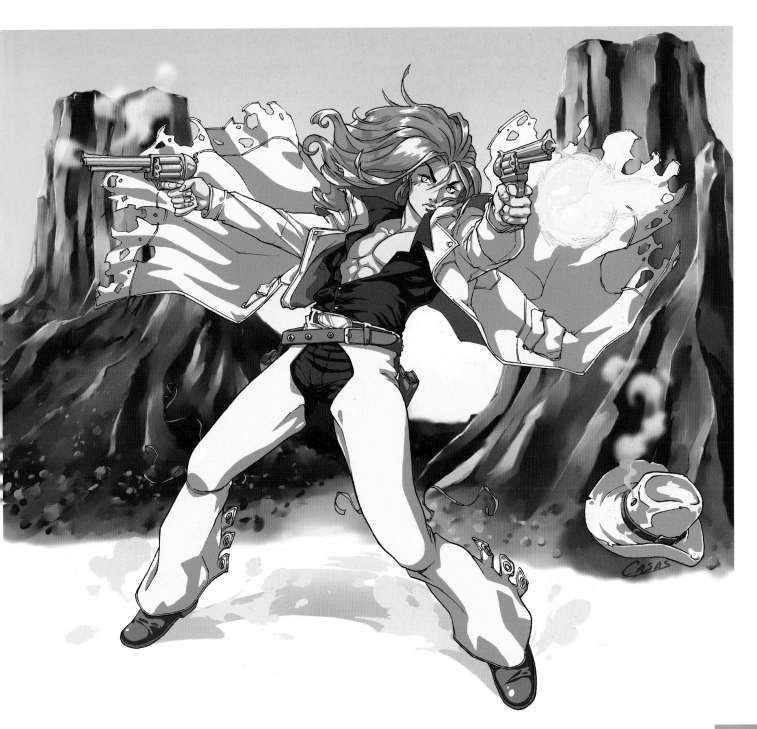

MEDIEVAL

Medieval fantasy stories often fall in archetypes: good in absolute terms against evil in absolute terms—the sword against magic. As a general rule, there are different races of characters, and each race has a determining role in the story: humans are numerous, often with leading roles but capable of assuming any role; dwarves are tough warriors, sophisticated archers, and magicians; and goblins or small beings can be thieves or they simply support the others. The forces of good are identified with light, compassion, and courage, while the forces of evil are connected with darkness, oppression, death, and degeneration. Here, we will draw a magical warrior elf.

1. Shape

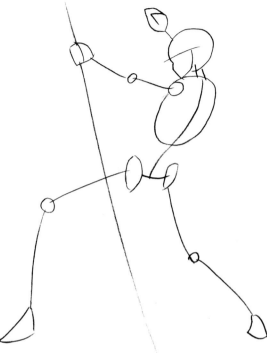

Sketch the hero practically turned backwards, with one arm holding the sword (draw a reference to it with a long line) and the other arm lifted, casting a spell.

2. Volume

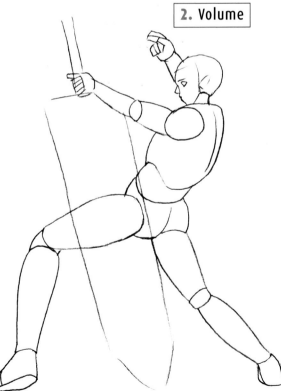

When drawing the figure, make sure the position of the legs shows that he is leaning backwards. Also flesh out the enormous sword.

This large elf is drawn basically as a person with a few modifications. Draw a slim, athletic, and fit character, with well-defined muscles and long elfin ears.

The elongated or oblique eyes and the pointed ears are two details that give this being a more elflike appearance.

The elf's armor is pure fantasy. The pieces are much larger and more sophisticated than they would be in real medieval armor, although it does has a basis in reality—it's modeled after a cuirass and the pieces adapt to the figure.

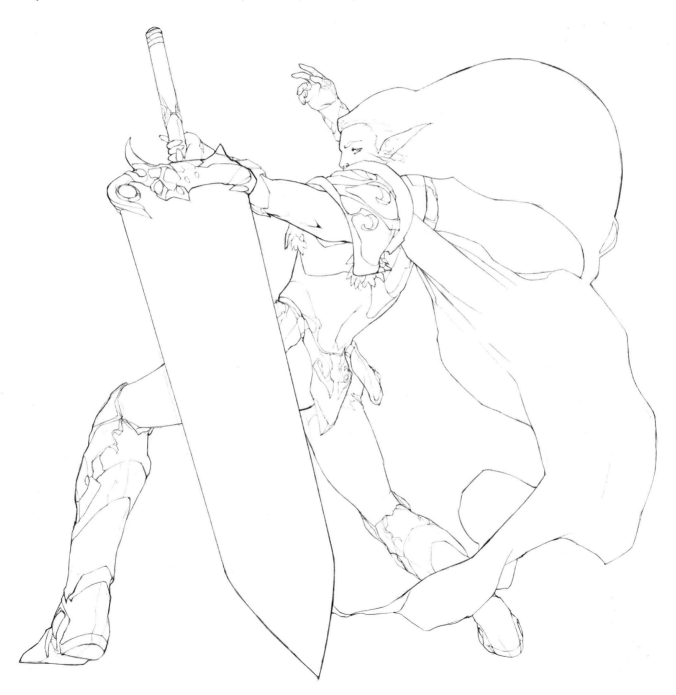

Source of light

The lighting is from the flash of the magical effect, which produces high-contrast shadows. Give more volume to the cape with blocks of shadows.

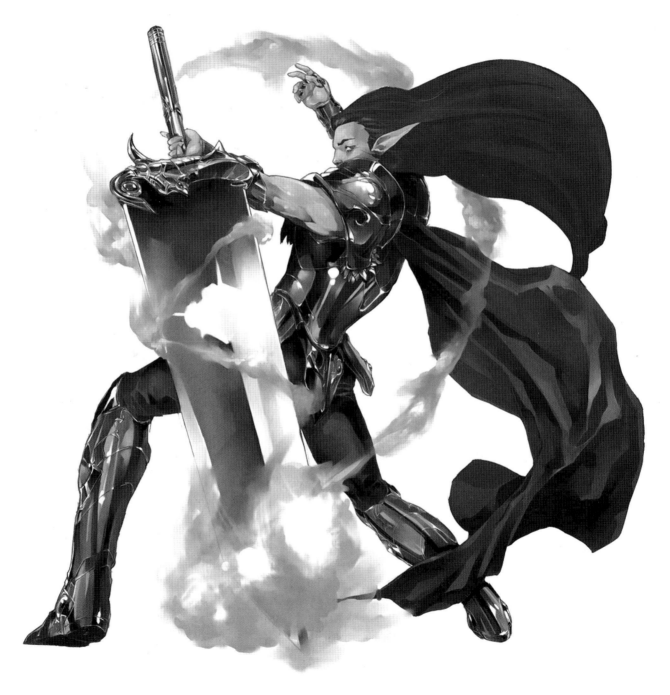

Depending on how we want to highlight the armor, we can make it look matte, opaque, or shiny. The latter will endow it with greater importance, due to reflections of the fiery light. Color most elements of the scene in blacks to underscore the warrior's toughness.

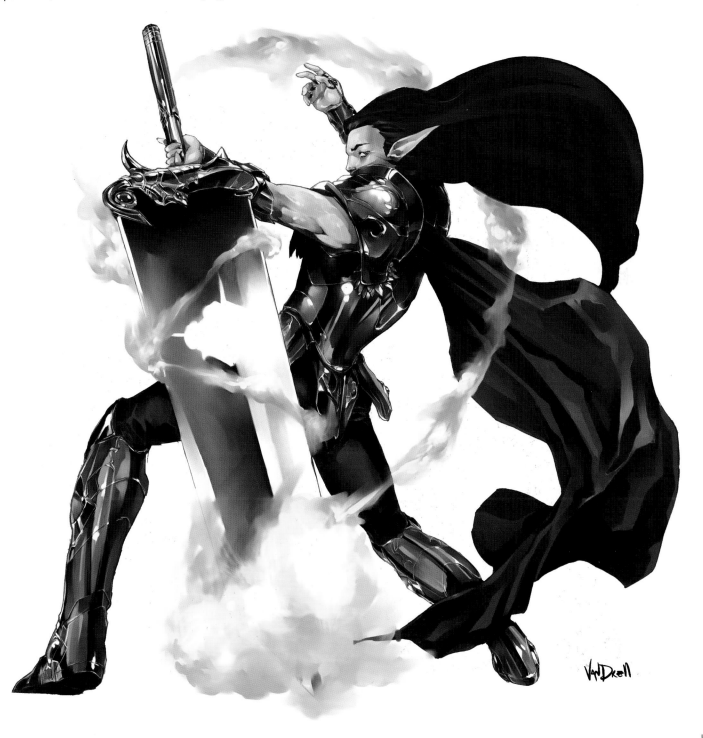

NOMAD

Stories about post-apocalyptic futures have common starting points: due to a war or natural disaster, civilization disappears, and man becomes mindless. Survival consists of stockpiling whatever people find from the recent past, not caring about anyone else, and even worse, not helping anyone else. It's survival of the fittest; skills with guns or martial arts are all that separate most people from criminals, who wander freely. There are few governments, and even fewer law enforcement agents. Some small populations find a way to organize and preserve some means of survival. These small islands of hope are threatened by thieves, who are the villains. People who need help turn to this kind of tortured hero who wanders alone.

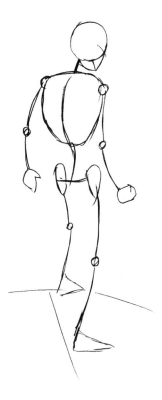

Build the base of the figure and its vertical symmetry axis. Above it are the shoulders and the hips, held in such a way that the figure seems to be in a static, but not rigid, position. The face doesn't show.

2. Volume

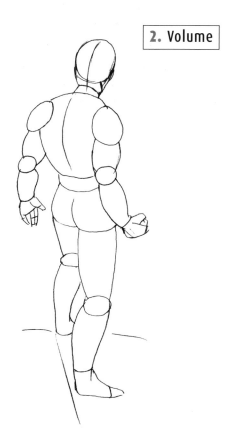

Finish the figure by giving it some volume. Draw a synthesized version of a rounded set of muscles that will adapt to the figure's pose and size.

To create a nomad who is a surviving hero, draw an anatomy that will focus on his virility, that is, a lean but powerful figure with a wide back.

When you draw the muscles, start by sketching a simpler version in order to model it, and then add the details with higher definition.

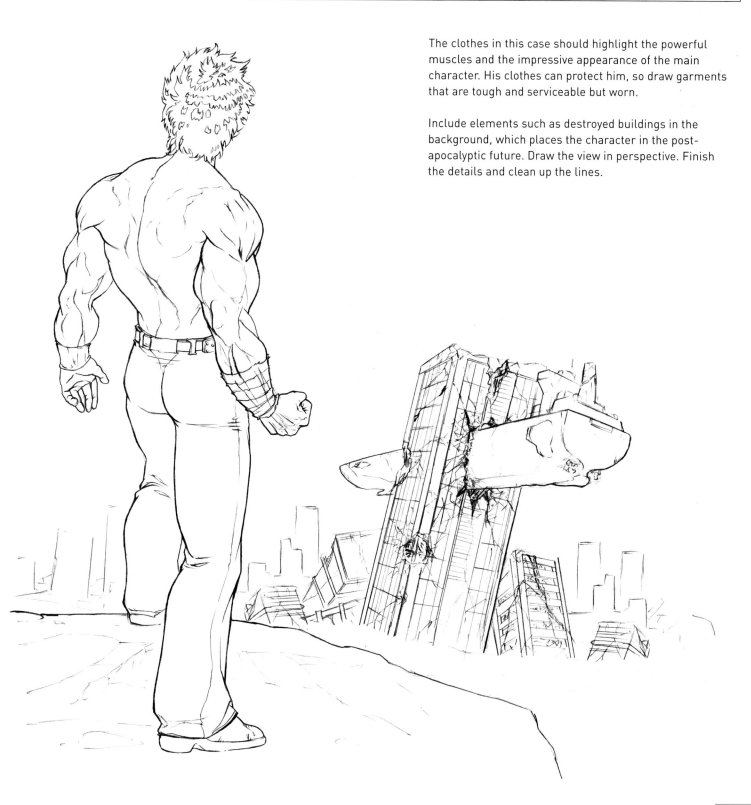

The clothes in this case should highlight the powerful muscles and the impressive appearance of the main character. His clothes can protect him, so draw garments that are tough and serviceable but worn.

Include elements such as destroyed buildings in the background, which places the character in the post-apocalyptic future. Draw the view in perspective. Finish the details and clean up the lines.

Source of light

The illumination highlights the nuances in the figure's form, which is why we use the outlines of the shadows to help us better define shapes.

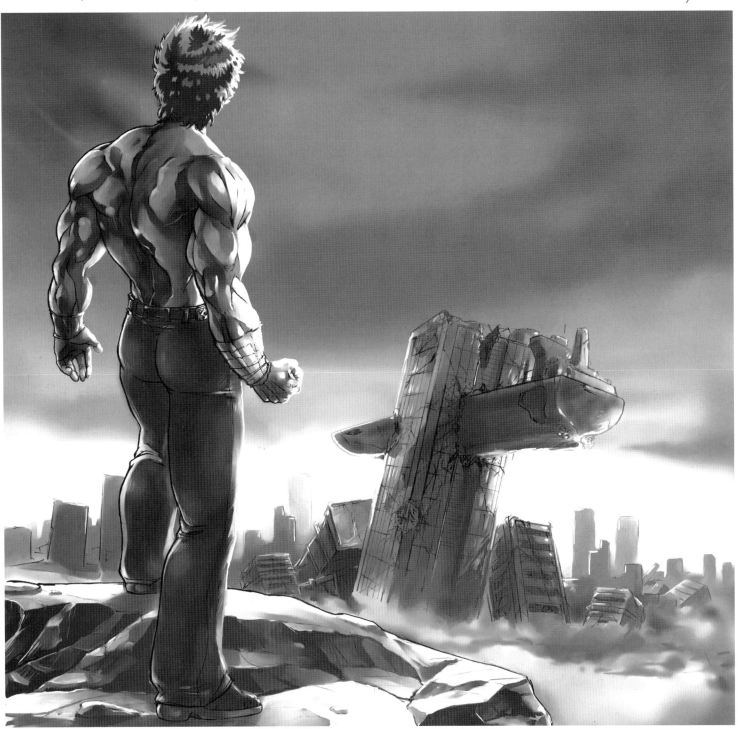

Color the background in a toxic reddish haze, framing the character in the desolate setting of these stories.

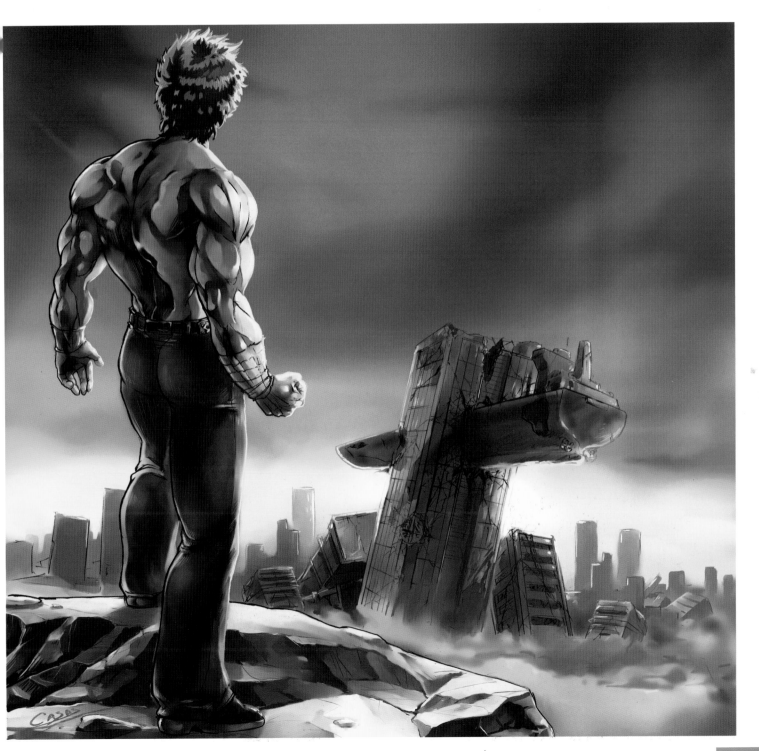

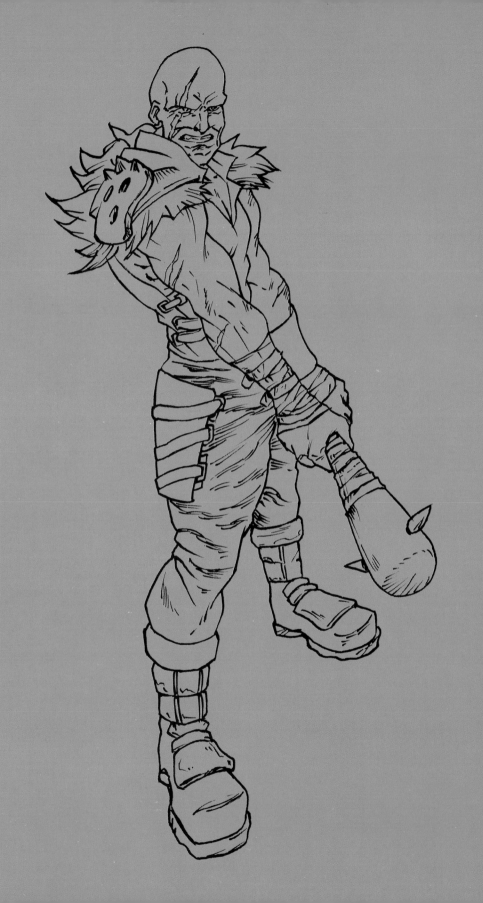

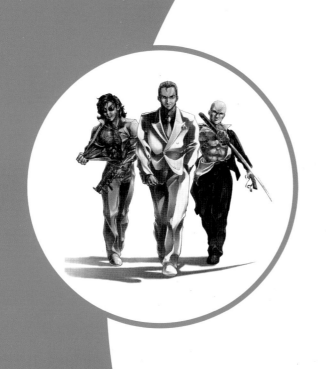

VILLAINS

SD MAD PROFESSOR
ASIAN GHOST
GANG MEMBERS
SPY
ROMANTIC GOTHIC
ALIEN WARRIOR
SORCERER
EVIL EMPIRE'S GENERAL
EVIL GODDESS
GANGSTER

SD MAD PROFESSOR

Villains play a leading role in adventure stories. A villain is the perfect opposite of a hero: the villain may be an egocentric character, often evil and pitiless, who takes pleasure in the pain he causes. The hero is in charge of preventing the villain from getting his way. So we could say he gives the hero a reason to exist. Nowadays, there is no real archetypal villain; he is simply the antagonist to the hero. He tends to be a violent person who uses brute force or a smart manipulator, such as a mad professor, who uses others to achieve his goals. He usually tries to eliminate the hero and dominate the world. The professor creates machines that help him, though his pride often leads him to underestimate the hero and, thus, lose.

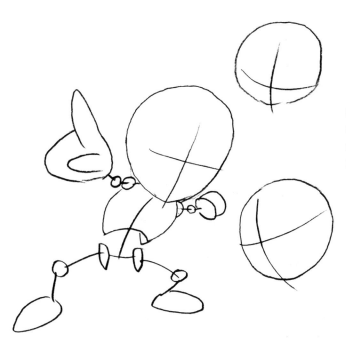

Sketch the character's pose, looking for the right perspective. First draw a series of lines or axes where you will place the figure's extremities.

2. Volume

Exaggerate the foreshortening effect, especially that of the hand pointing forward, with an index finger that gets increasingly bigger as it reaches the fingertip.

Draw the professor with the usual white gown, and add some freaky details, such as the bionic eye that gives the impression this guy is a little crazy. Make the robots look sort of cute, rather than like the threatening weapons they actually are.

4. Lighting

Source of light

The shadows should be projected in the opposite direction from the light and toward the internal parts of the clothing.

Clothe the figure in plain garments and plain colors. Add some colored shading effects to represent the propellers of the menacing little robots. Add a swatch of energetic color as background just behind the professor.

ASIAN GHOST

As in Japanese terror movies, Asian ghosts are much more tangible than the typical manifestations of strange phenomena and diffuse lights that Western society considers to be ghosts. Asian ghosts interact with us, appearing at any time and in any environment, even using modern technology such as elevators, cell phones, and videotapes to terrorize us. This is an outgrowth of Shintoism, which is practiced in Japan; it is a religion that sees spirits as another element of nature. The Japanese think it's normal to live with spirits. Japanese folklore is a catalogue of spirits, both good and bad. The typical destructive spirit that appears in terror stories is the spirit of a woman who died hating others and seeks revenge.

Sketch the composition as a close shot, since the whole figure will not be seen. Show only the trunk, the shoulders and arms, and the head.

2. Volume

The hair volume is important for the composition of this scene, which is why you should reference it with simple lines that present its outline. Fill out the figure's volume.

The ghost's facial expression is the key for the message we want to communicate. Draw the eyes carefully so they appear to be glaze over with hatred and have a lost-but-threatening expression.

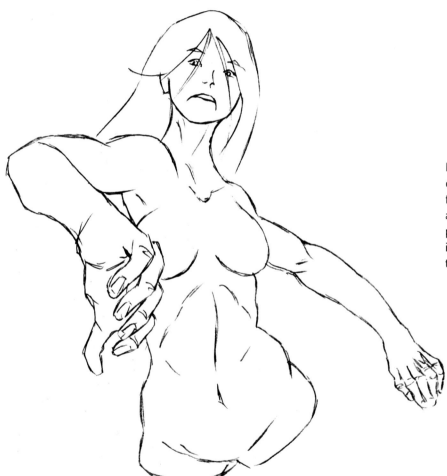

In order to draw the hand that's coming toward us, sketch the foreshortening of the stretched arm, ignoring the hand. Then place the hand in position in order to continue defining the final line.

4. Clothes

Now draw in full detail the shape of
the hair and its movement, as well
as the way the locks of hair overlap,
some moving ahead of the others.

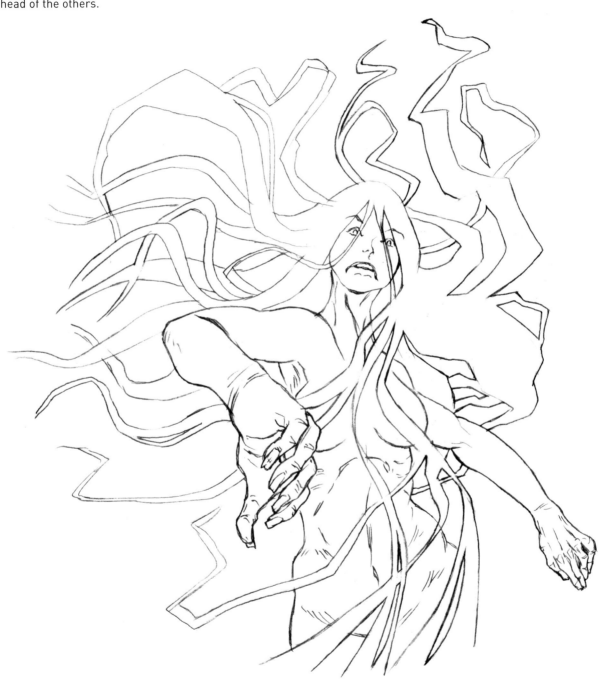

We want to show that the ghost appears suddenly. Therefore, the dark background helps to express the ghost's entrance onto the scene, as well as our surprise at seeing it.

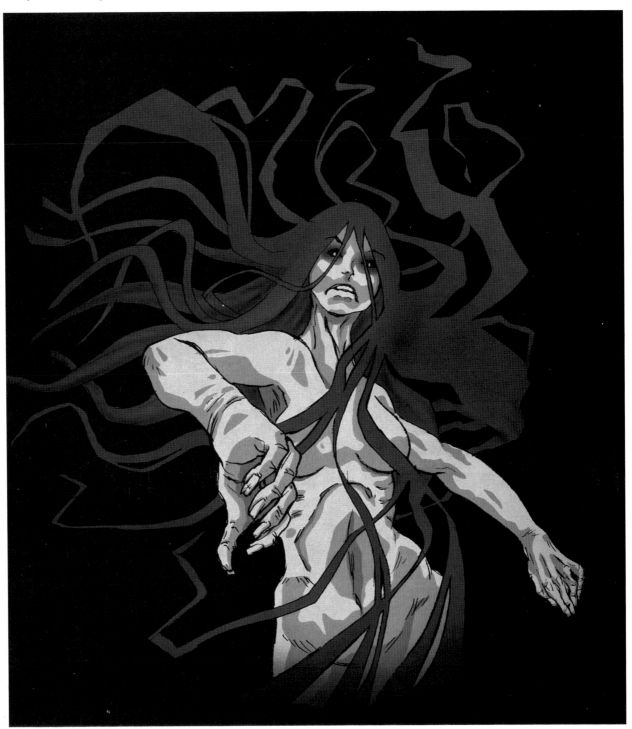

Finish by drawing the last lighting effects, which create a chilling shadowy atmosphere. Color the figure an almost phosphorescent green, which invokes thoughts of decay.

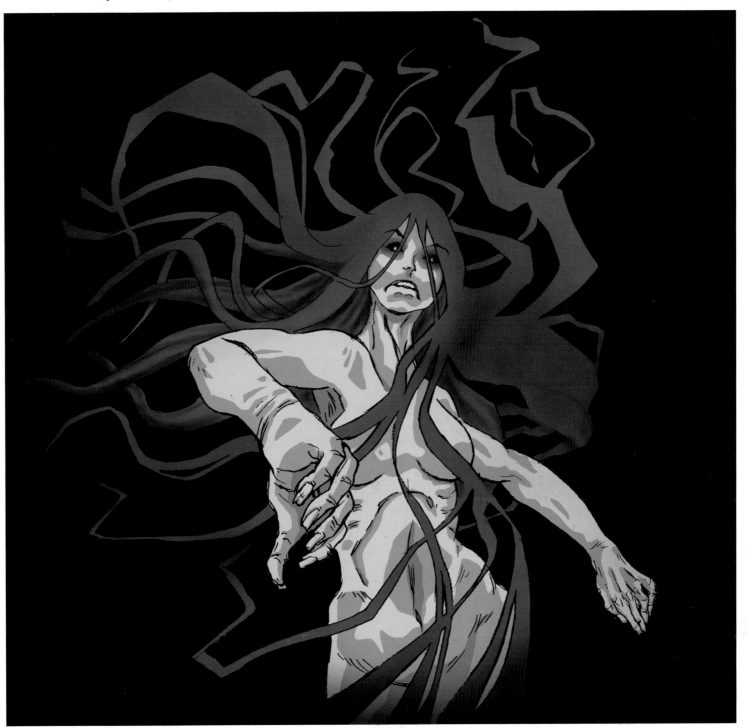

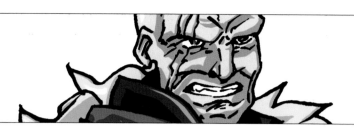

GANG MEMBERS

These thugs or paid killers are secondary chartacters, ideal for representing a threat or obstacle that the hero must overcome and resolve, an essential feature of Shonen Manga (adventure Mangas for teens). The so-called Punk or postmodern killer is the most extreme version of the paid assassin, based on movie villains like Mad Max who populate the chaotic, post-apocalyptic future, in which these killers form a true army, pillaging and sacking towns that cannot defend themselves. Because the gangs are anarchic, the leader is usually the strongest and cruelest of these psychopaths; he rules by fear, using extremely cruel tactics on his victims, and on his own followers when they make a mistake.

1. Shape

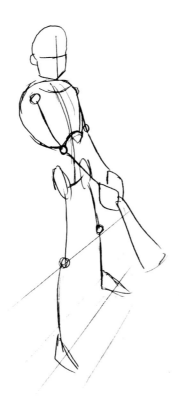

Draw the figure, locating it over the reference points for the ground; this consists of drawing perspective lines under the figure.

2. Volume

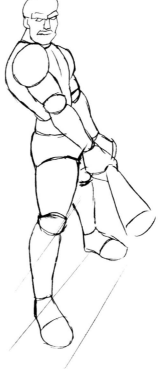

Complete the character's general form, and give volume to the figure. Since the character holds a club, sketch one in now.

Even if this is a regular human being, draw the killer as an exaggerated version of a bodybuilder. His chest and back are enormous, and his figure is lean. The head is small.

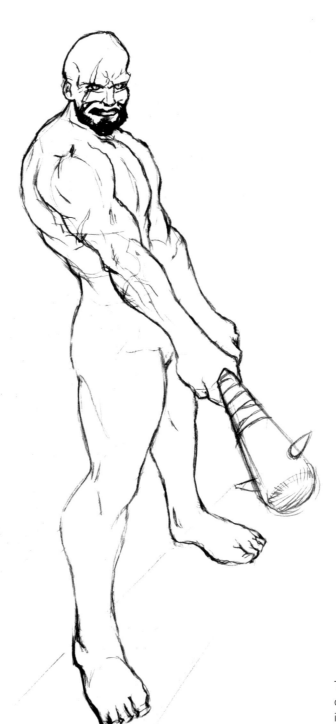

To draw the hands that hold the club, first sketch the hand that is in back. The second hand goes in front.

The costume is an essential part of this character's identity, both as a group member (we might even say the gang members wear a uniform) and as a reflection of his own personality. Different gang members might have different hairstyles.

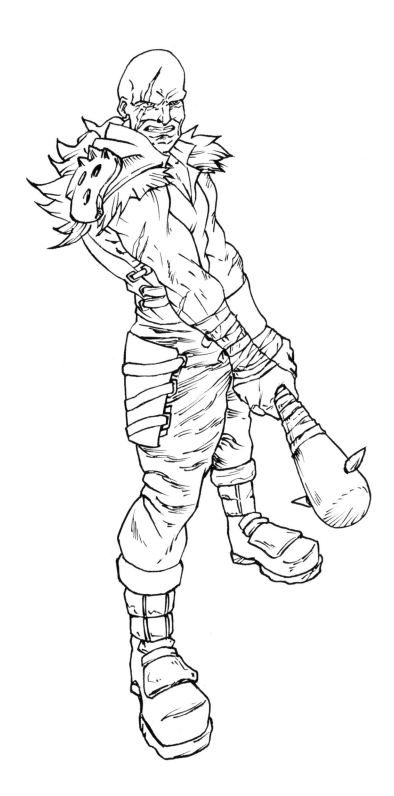

The light that falls over the figure from above creates shiny spots on top of the head and at the end of the club, besides projecting a silhouette on the ground.

Source of light

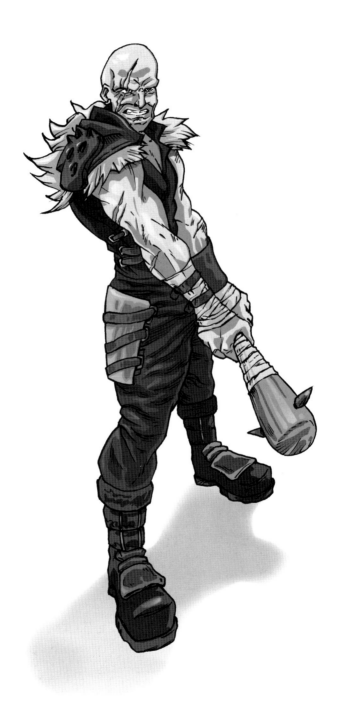

Now give the image an effect similar to that of an airbrush in the shiny areas. This is how you model the volume—the shiny areas blend with the tone of each surface. Note the almost animalistic colors and costume details.

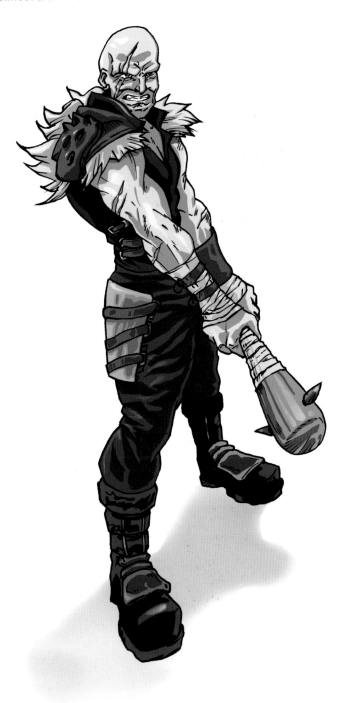

SPY

Professional assassin-spies are sinister characters of dubious morality, but they make good protagonists, even heroes (or antiheroes with a dark, unpleasant, side). Professional assassin-spies are specially trained in the martial arts, and in weapons and infiltration. They have to be sharp, agile, and able to improvise in complex situations. They can be mercenaries, special agents working for a particular government, or elite members of some secret organization. They are exceptional individuals—living weapons. To add some sex appeal to our design, we have chosen to draw a girl and have opted for a less violent design. We will substitute the usual weapons for an action pose on a cartoon background.

1. Shape

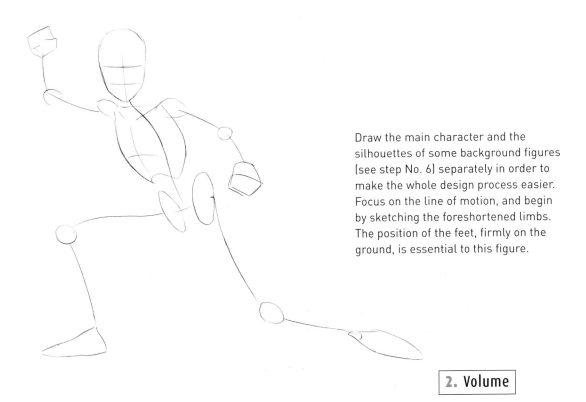

Draw the main character and the silhouettes of some background figures (see step No. 6) separately in order to make the whole design process easier. Focus on the line of motion, and begin by sketching the foreshortened limbs. The position of the feet, firmly on the ground, is essential to this figure.

2. Volume

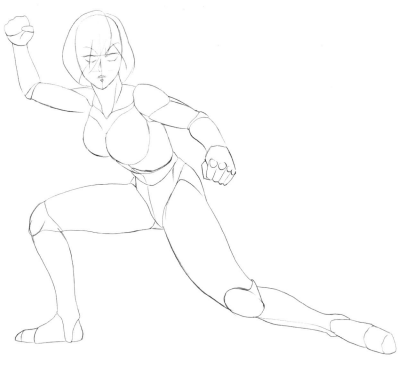

Finish the foreshortened elements, focusing on the arms. Now do the rest of the anatomy; it's best to first fit in the torso and then add the other elements.

Be careful when designing the position of her knees and feet, especially the leg on the ground, which the character is leaning on. This character is slim and elegant but at the same time quite robust and athletic. With a female character, be careful when delineating her anatomy: she has to look strong, with the muscles in tension, but not too muscular.

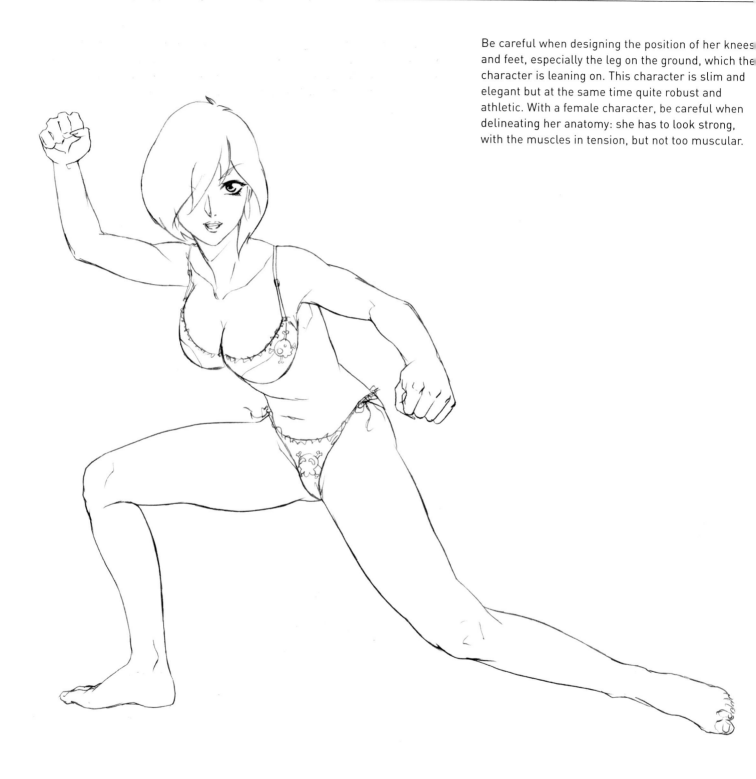

This assassin is an elite agent who is, therefore, equipped with the latest weapons and electronic gadgets. It is important that her costume reflect this. Despite being quite tight, the costume should look like a well-equipped uniform. The scarf around her neck lends a feminine touch.

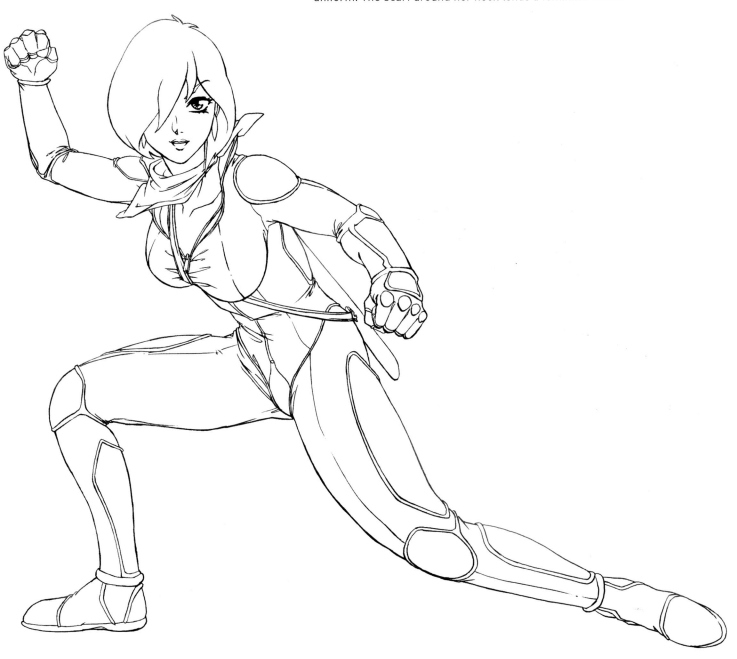

Source of light

Use shadows to mold the volume of her sinuous shape. To this end, use a subtle, natural-looking light from above. Contrast between the tonalities of each texture differentiate the elements of the drawing. Note that the costume, for instance, has much more contrast than the skin.

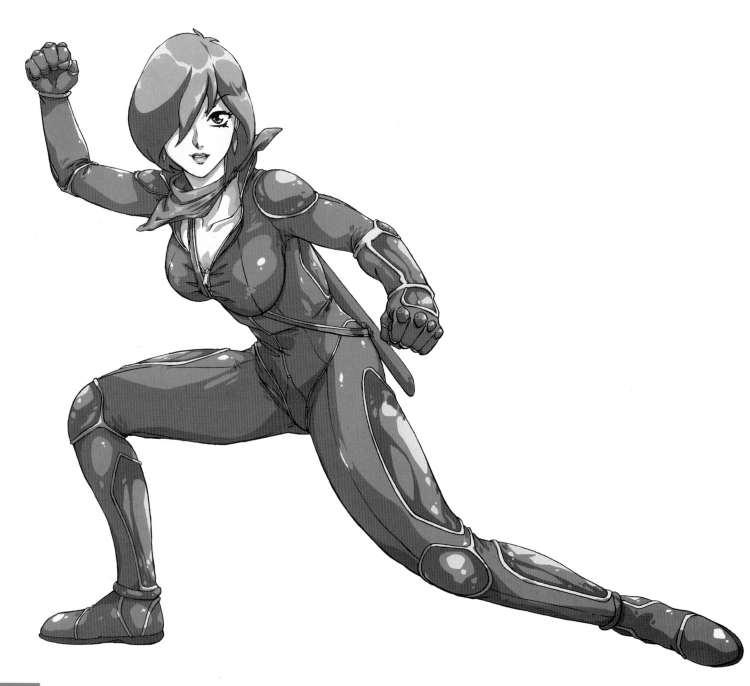

Here, contrast is the most representative feature of this design's chromatic range. Combine the sobriety of the gray with the strength and luminosity of the reds. For the background, add some silhouettes you sketched in step No. 1.

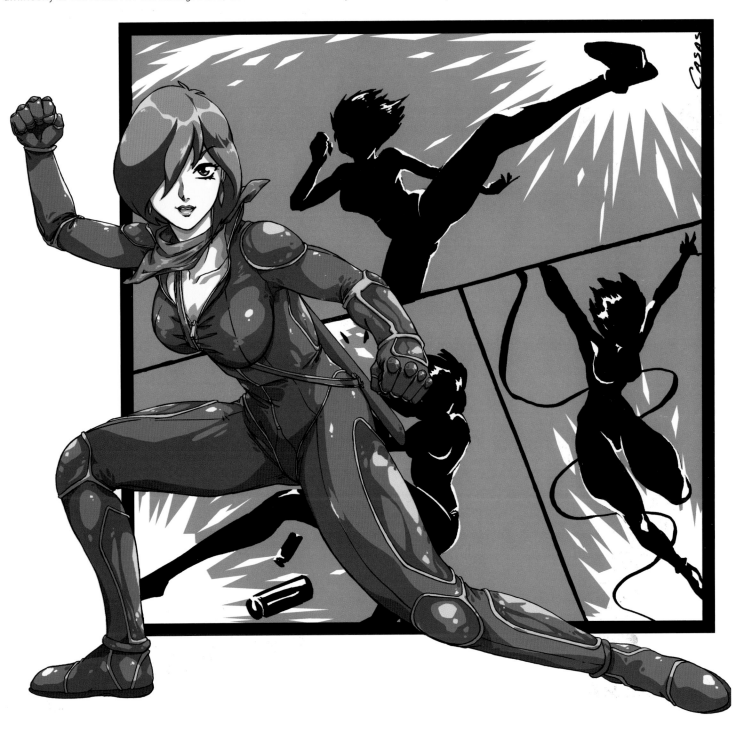

ROMANTIC GOTHIC

Gothic-sinister settings are reminiscent of romantic moments with a delicate aesthetic. Whether it's because of Victorian poetry and horror stories, such as Dracula or Frankenstein, or because of the mixture of fatal attraction and melancholy that characterize stories where human beings fall in love with monsters, ghosts, or other similar creatures, such stories are dark and intense, and passionate. It may just be as a result of the certainty that the story will inevitably have a dramatic conclusion, but the monster tends to appear to us just as another victim of love, unable to escape his destiny.

1. Shape

Draw the characters in their theatrical poses, as if frozen in a time and context full of intensity.

2. Volume

Follow the atmosphere of the setting, and draw slim and elegant figures.

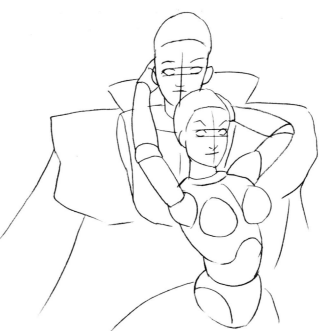

When drawing characters of this period, show listless figures with delicate features.

The eyes are of great importance; they are a mirror of the characters' emotions. For this kind of scene, draw very elaborate eyes.

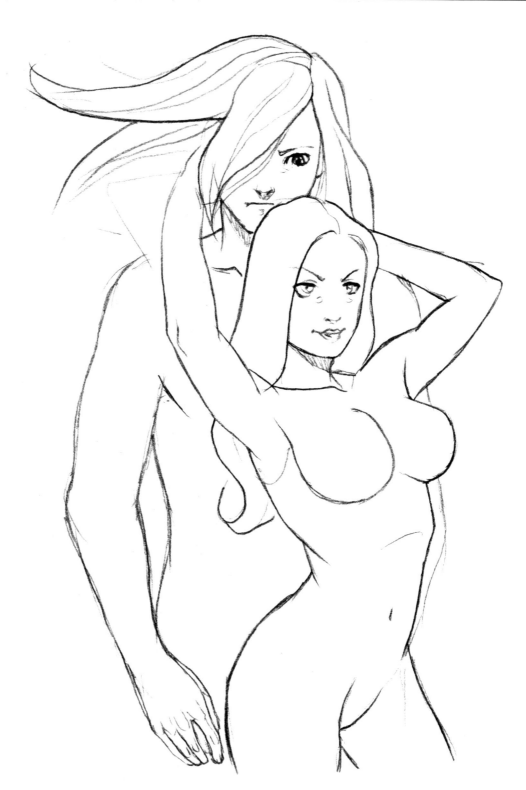

Vampire films and other stories from the 17th and 18th centuries can be used as a source of inspiration for this genre's costumes. Long suits and dresses, frills and other garments, with lots of pleats and folds are common.

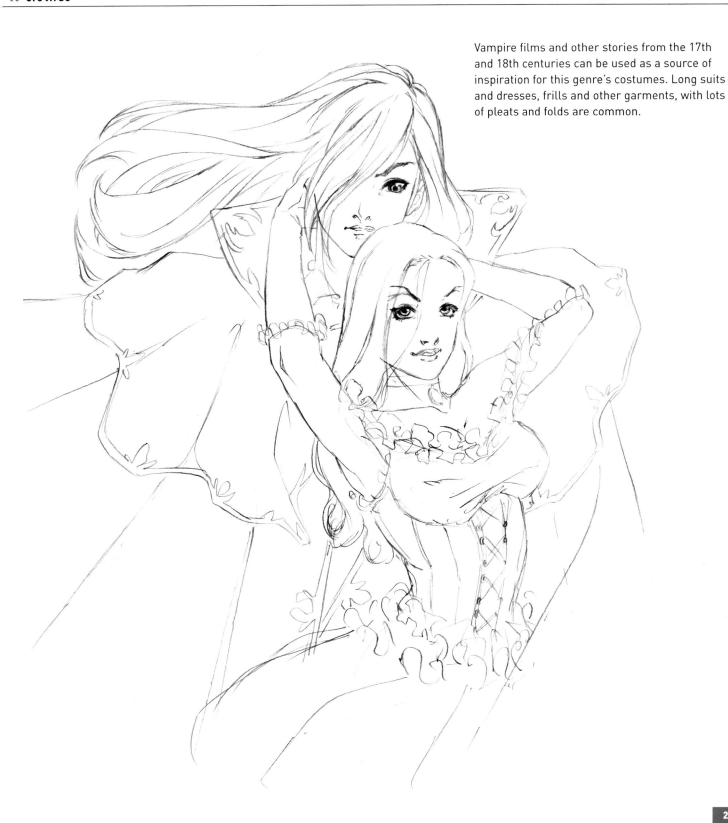

Source of light

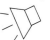

Gloomy lighting is most suitable for this type of scene, but without strong contrast between darkness and light. This is characteristic of expressionism, in which light and shadow are clearly distinguishable.

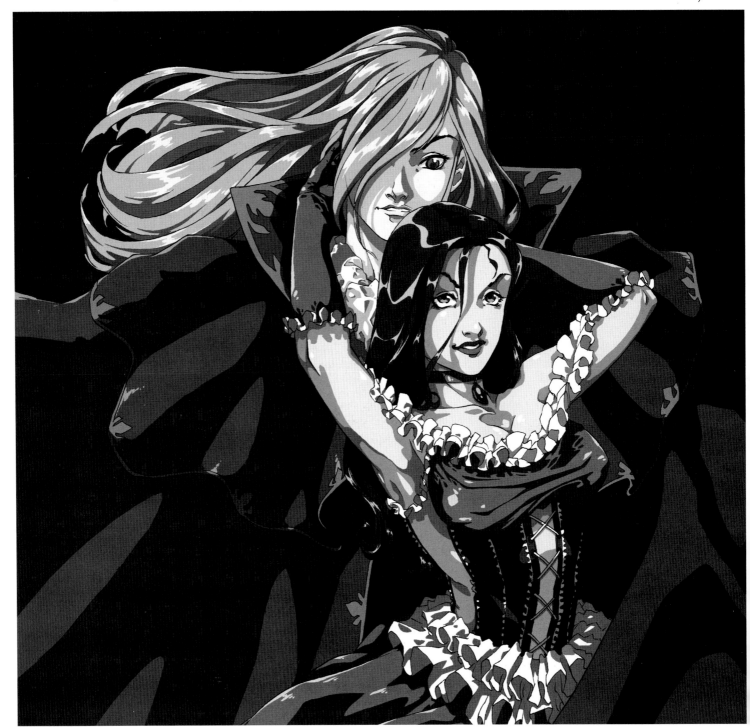

Complete the scene by creating an appropriate atmosphere around the characters. The woman's dress has garish colors and many details, while the man's cloak is in sedate colors and rich-looking fabric.

ALIEN WARRIOR

We tend to imagine aliens as sophisticated and highly civilized beings, assuming an advanced technological level is necessary to build spaceships that travel very long distances. But not all aliens need to be big-headed scientists. If specialization reached extremes in a society full of violent planet conquerors, the living warriors would be killing machines. If there were a caste of warrior hunters living amongst an advanced race, they might have a fierce physical appearance. Considering that evolution could preserve the natural talents of these warriors, we would have a fighter who combines a strong physique with the instinct of a predator; and the tradition and dedication of a medieval warrior with the sophistication of alien technology.

1. Shape

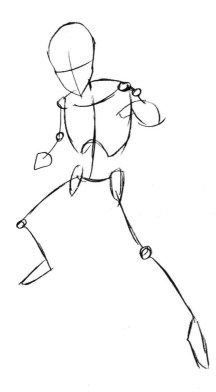

Sketch reference lines to locate the axis and the perspective. Above them, draw the axis of the shoulders and hips, then sketch the location of the feet on the ground.

2. Volume

Create the foreshortening effect that corresponds to this scene. With the aid of the same guides, apply the effects to the chest and pelvis, in addition to the limbs.

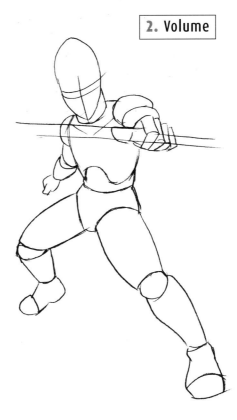

This is a humanoid creature, and the anatomy will be different than ours, but with similar mechanics. Add some details that show these differences.

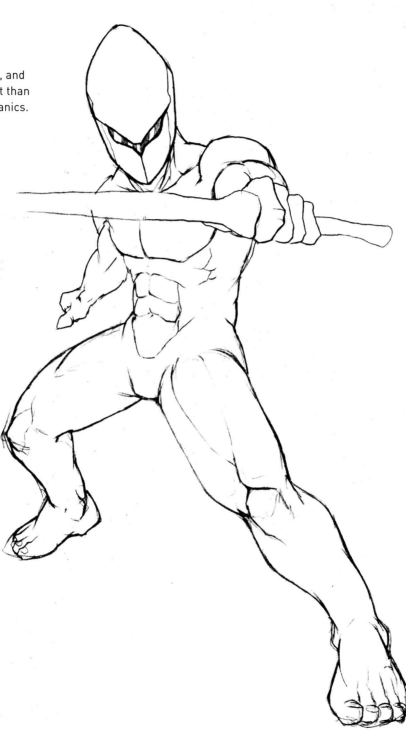

It is not worth creating the face, since it is totally covered by the helmet. You can give the helmet an organic feel, which gives it the sensation of being a face that stares at us ferociously.

4. Clothes

The alien's costume is very different from an advanced space costume with a breathing device. Construct armor with thick metal plates, reminiscent of medieval armor.

When you draw the armor, adapt the pieces' shape to the body's volume. Then make it look solid, fleshing out the details and cleaning up the lines as you go.

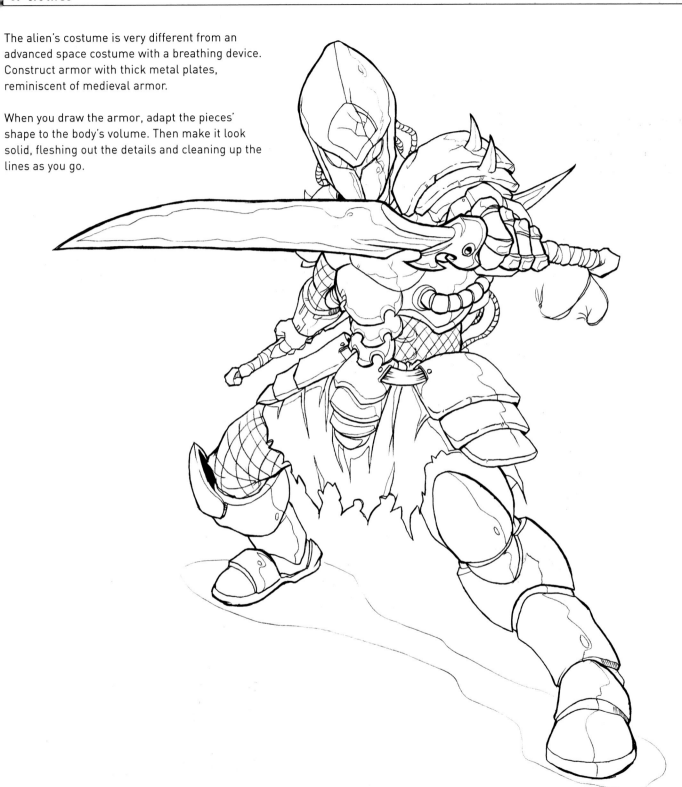

Use shadows over its body to highlight the muscles in the parts where skin shows, or use shadows to describe the regular surface of the armor pieces. Add some reflective spots on the metal parts.

Source of light

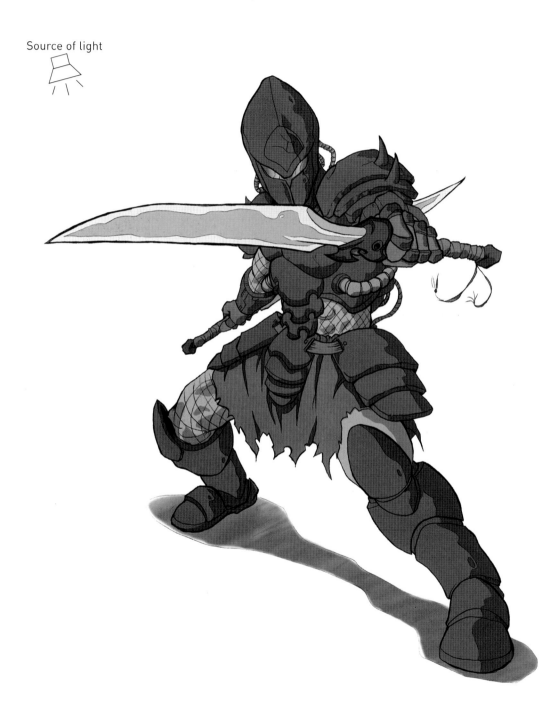

The alien is a warrior who adopts colors that will allow him to pass unseen in the environment where he wants to act. Use subtle colors for both the shadows and the background.

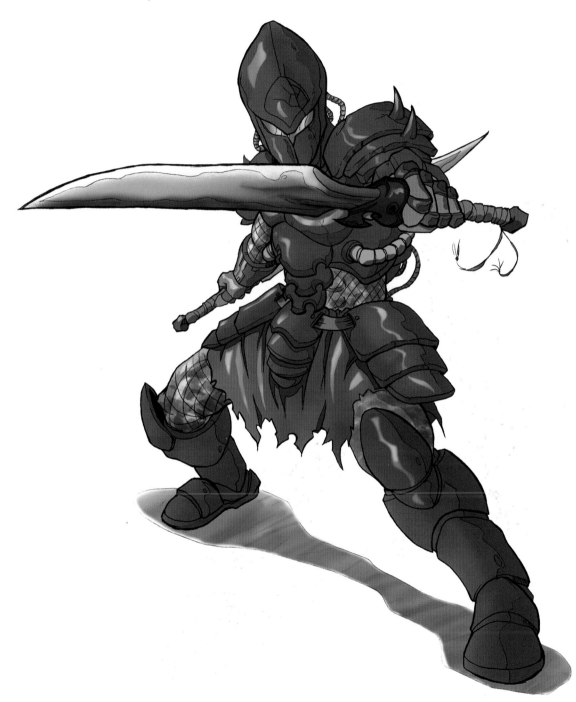

SORCERER

A sorcerer is, by definition, a king of wizards or magicians who usually deals with dark creatures and offers them bloody sacrifices in exchange for supernatural powers and immortality. In general terms, this often leads them to becoming monstrous beings themselves and to loosing their humanity, which reflects the darkness of their souls. In this case, we are going to draw an Asian sorcerer who, in trying to mock death, has become transformed into a kind of ghost. This terrifying creature needs to consume the body of a young girl for his reincarnation so that he will be able to continue spreading evil in the world.

1. Shape

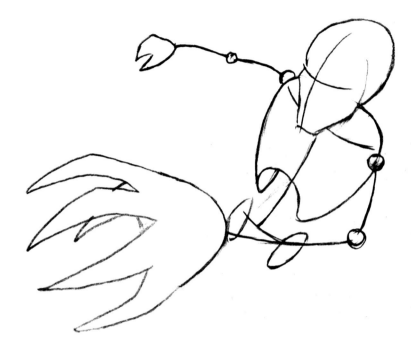

Sketch the different parts of the body: the head, the torso, and the arms.

2. Volume

The perspective of this drawing is that of a sharp lung, where the eye of the observer goes from the foreshortened hand to the other in the distance, passing by the head. The foreshortening is very pronounced and gives the image a lot of movement.

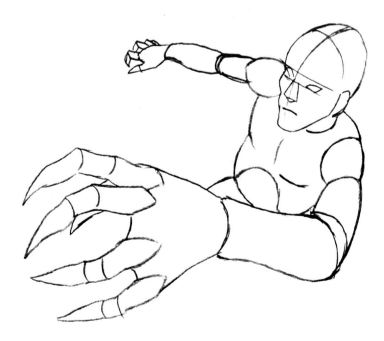

3. Clothes

In order to draw the sorcerer's costume, look at
actual kimonos and similar clothes. Draw a very
simple sketch of it in order to have thorough control
over its shape and a sense of motion. Then add the
details, and draw the folds properly.

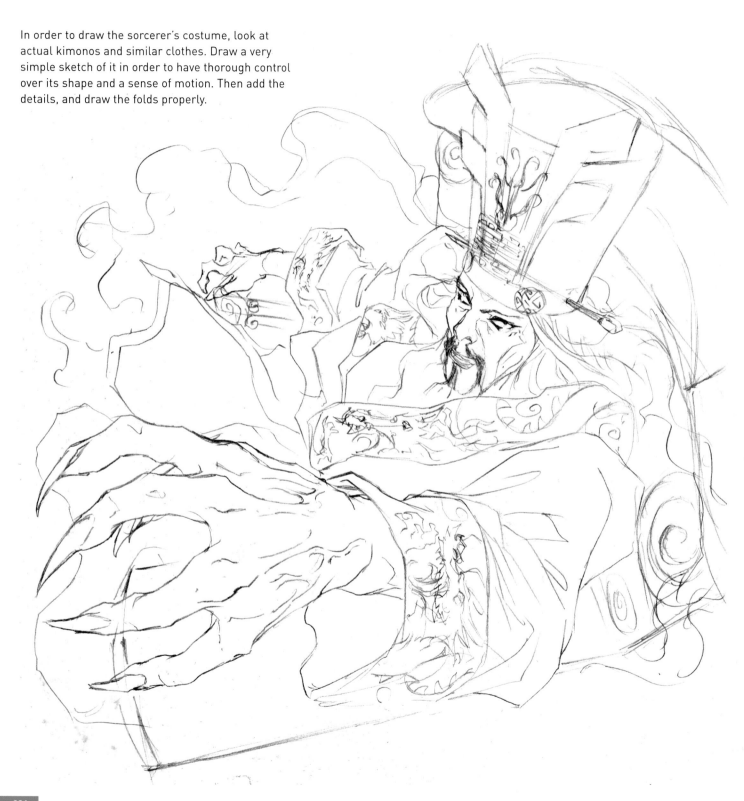

Source of light

The background light clearly comes from a supernatural origin—try to communicate this sensation. In order to highlight the marked features of the sorcerer, try to mix some expressionist effects with the different light and contrasts.

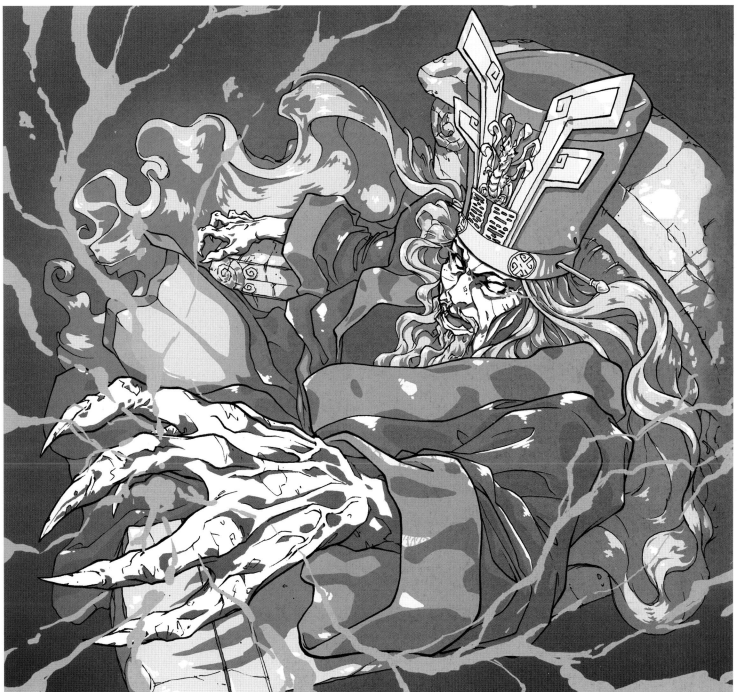

5. Color

Color the figure and, at the same time, sketch the folds and shadows of the costume, which is the main feature of this drawing due to its complexity. Use intense, saturated colors.

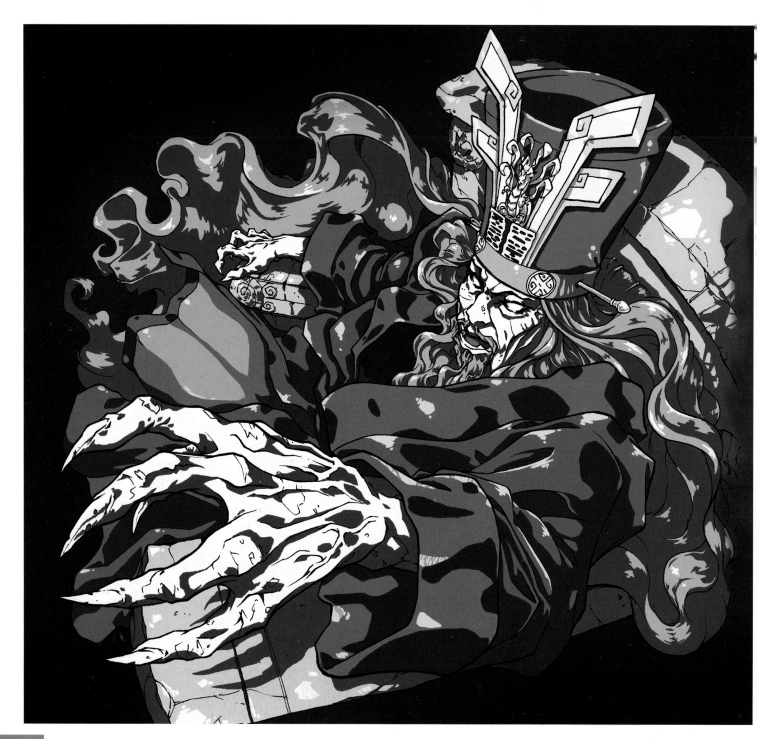

6. Finish

Take into account that we are dealing with an Asian sorcerer, so draw a face with characteristically Asian fantasy features, such as the long moustache and an elaborate hairstyle, as well as this character's long fingernails.

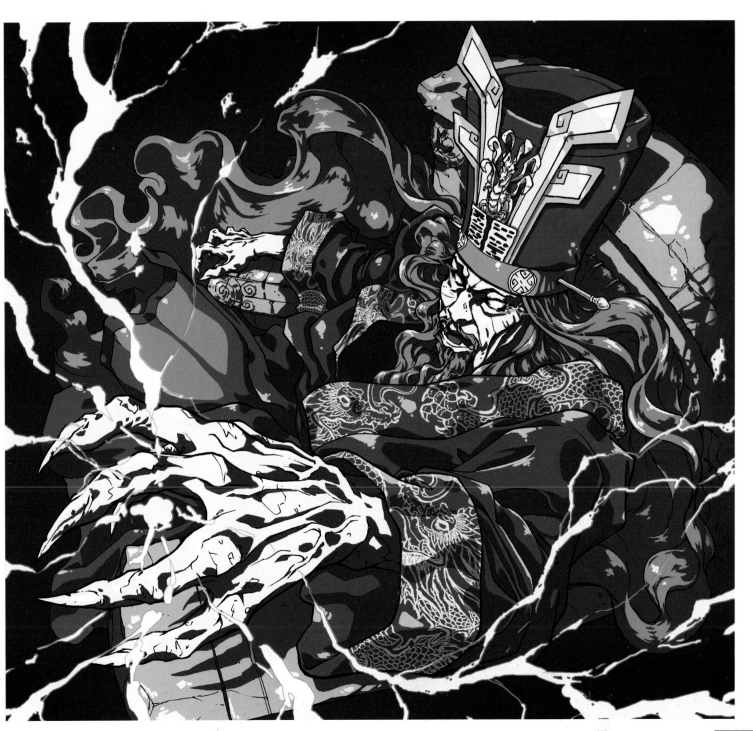

EVIL EMPIRE'S GENERAL

What would become of our heroes if there weren't an all-powerful Evil Lord? In stories about oppressive kingdoms or empires that threaten to invade the lands inhabited by heroes, or that simply wish to destroy for the sheer pleasure of it, there has to be an evil leader, a terrible figure who will direct the other enemies of justice and goodwill. The general, king, or emperor of evil, whatever the character's name or title, is generally a tyrant who governs over his troops with an iron fist, through fear and by the law of the fittest. The ambition of the Evil Lord knows no limits, and his powers are so vast that the heroes don't have much recourse against him. They are constantly looking for ways to defeat him.

1. Shape

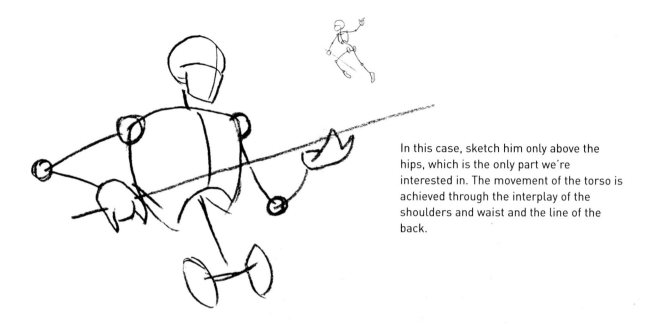

In this case, sketch him only above the hips, which is the only part we're interested in. The movement of the torso is achieved through the interplay of the shoulders and waist and the line of the back.

2. Volume

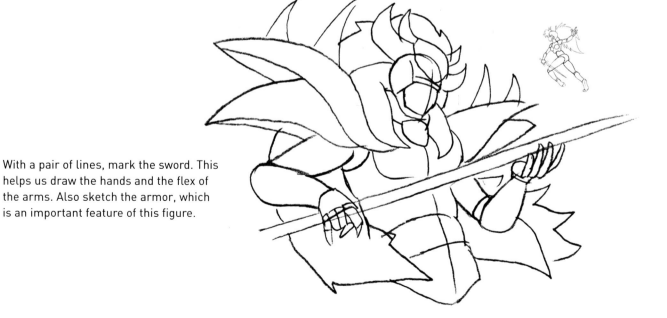

With a pair of lines, mark the sword. This helps us draw the hands and the flex of the arms. Also sketch the armor, which is an important feature of this figure.

For a more demonic and aggressive attitude, deform the anatomy with bestial details, being careful to integrate everything with the armor, as you can see on the gauntlets and the head. Draw the base, which will help you create somewhat organic armor. Try to add traits from other cultures or times (medieval, Asian) to the armor to give it as much depth and texture as possible.

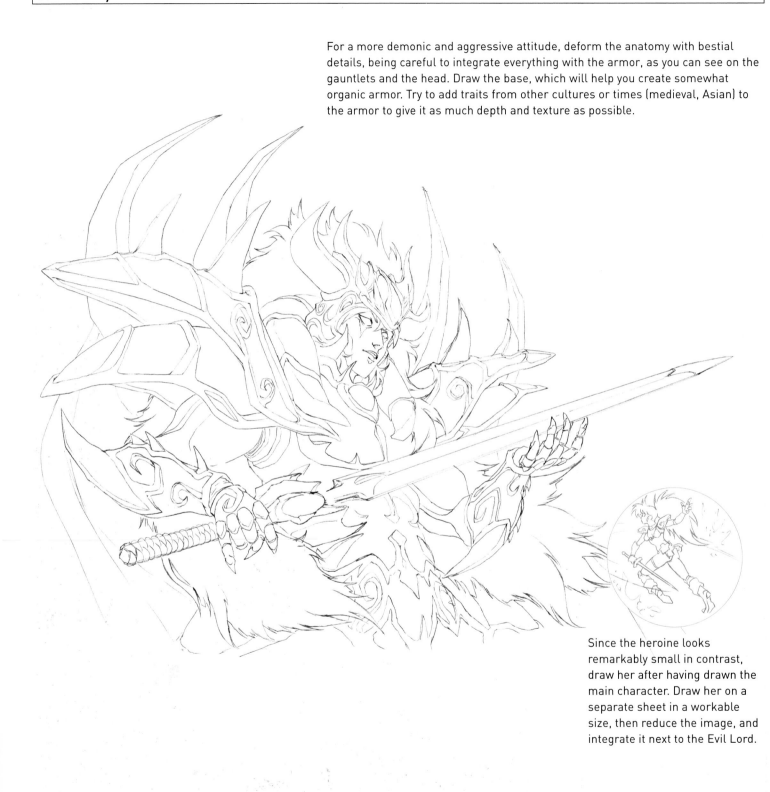

Since the heroine looks remarkably small in contrast, draw her after having drawn the main character. Draw her on a separate sheet in a workable size, then reduce the image, and integrate it next to the Evil Lord.

4. Lighting

We want to achieve a dark
environment, broken only by the
light that emerges from a single
point. Such light must be
highlighted and potent. Then add
some shiny spots both on the main
parts of the armor and on the face
of the Evil Lord.

Source of light

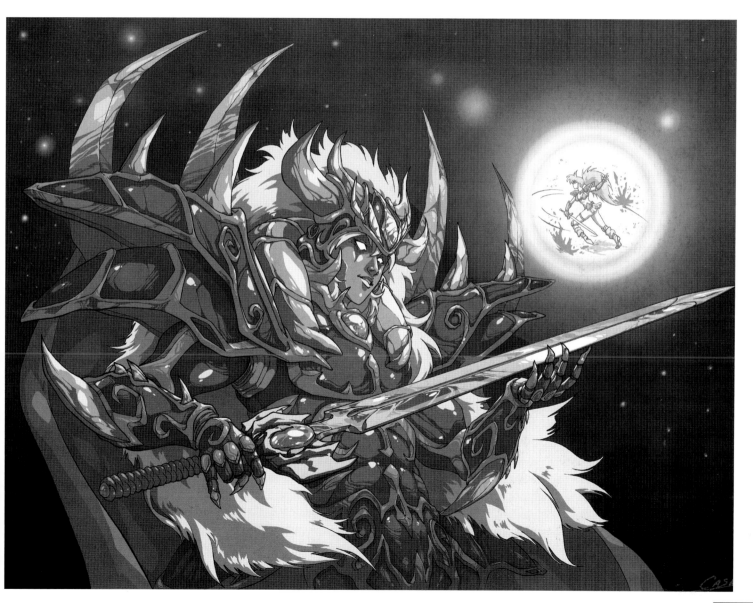

Use an intense blue color as background—the
scene should look as if the figure is in outer space.
The background is very dark and has many stars.
Focus on the galactic qualities, then color the
figure and integrate it into the image.

6. Finish

The red tones on the armor evoke the bloodthirsty and violent stance inherent in this character. Darkness is all-important in this scene, therefore shade the figure in blue to complement the reds.

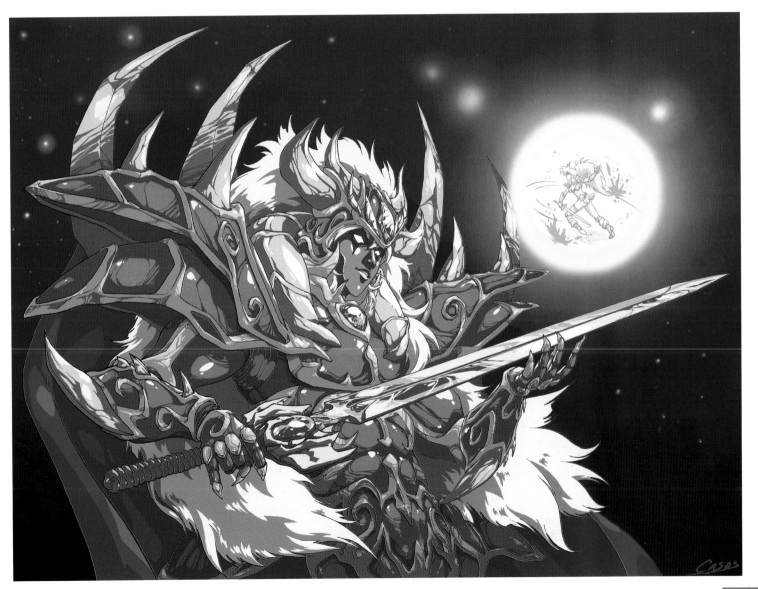

EVIL GODDESS

Next, we are going to draw one of the most powerful villains: the Goddess of Evil. As the name indicates, this is a deity, or in other words a supreme being, capable of bringing to life her desires by her own will. The Goddess of Evil's domains exist in a different dimension and she usually has demon servants to help her conquer the world of the mortals. In this case, we are going to draw a goddess who does not reveal her real form, rather she appears in the pleasing form that her mortal vassals recognize. They cannot imagine her terrifying real self.

1. Shape

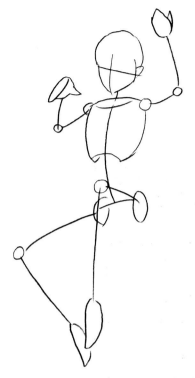

Draw the figure of the character leaning on the sword by sketching a straight line referencing the position of the sword.

2. Volume

Make a complete sketch of the figure of the Evil Goddess, and give shape to the sword.

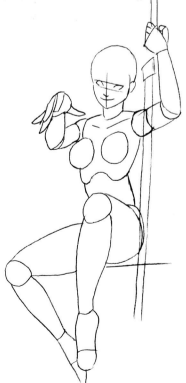

Move on to defining the body of a female by softening the line of her contour so that it gives the impression her flesh is soft. Be careful to draw the folds around certain parts of her body properly.

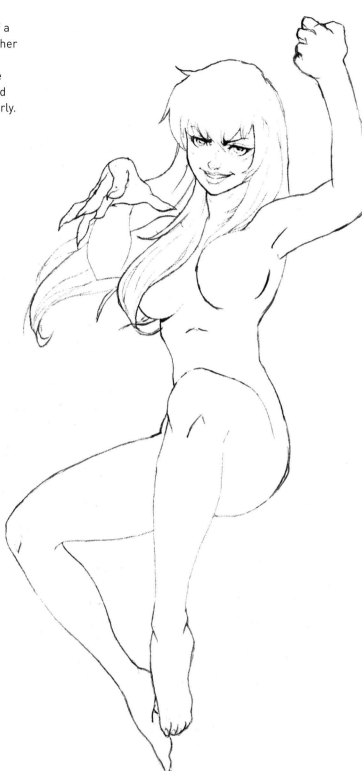

Pay special attention to the hand holding the sword. Sketch the grip, and adapt the position of the knuckles and fingers to its shape.

Abundant, long hair helps give presence to the figure of the goddess. Play with shadows so the contours of the figures merge with one another.

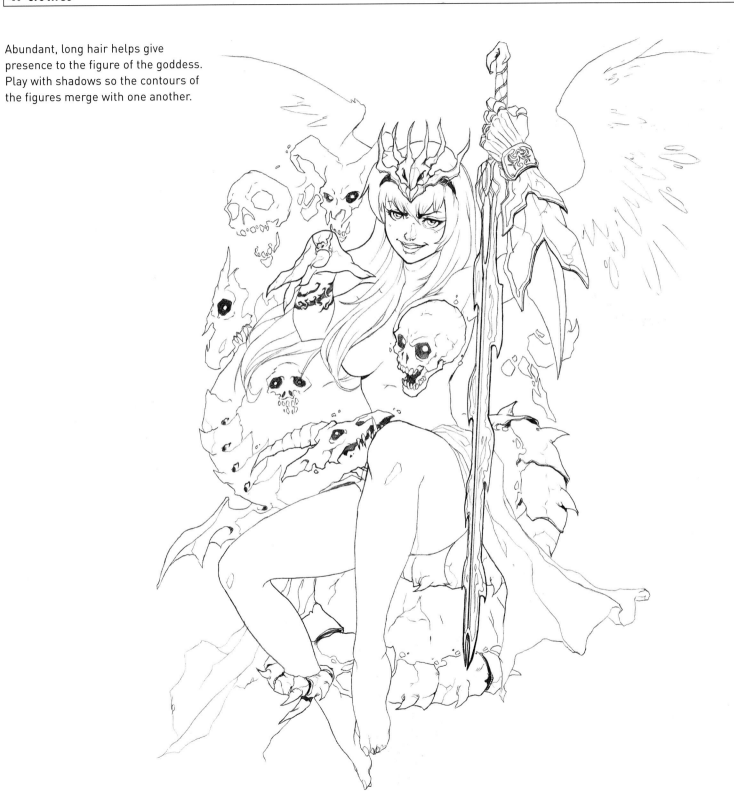

All the lighting in this scene is intended to highlight the deep shades in the background. To this end, try to create a sense of darkness to amplify an atmosphere of evil.

Source of light

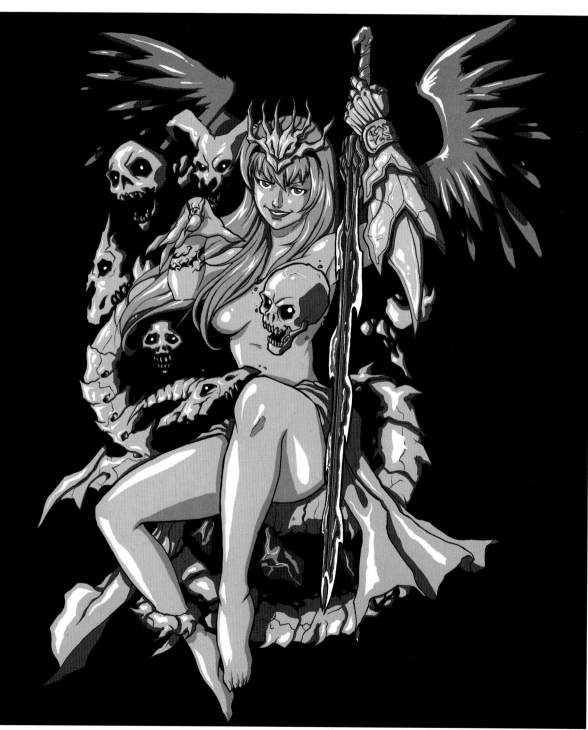

As can be seen in the drawing, it is easy to associate absolute evil with dark tones. Note the predominance of black and blue shadings.

GANGSTER

Japanese gangsters, or yakuza, are similar to the classic mafiosa gangsters we all know from films: they form a criminal organization heavily dependent on seniority and inspired by the military's structure. Thus, the gang master, or oyabun, is something of a general in the mafia gang. He, in turn, has secondary bosses and subordinates, who are the newcomers, or soldiers; these constitute the lowest ranks. Japanese gangsters combine Japanese business sense and respect for tradition with their use of violence and modern technology. Because of this, we can find yakuza members armed with katanas who decorate their bodies with traditional tattoos alongside biker thugs dressed in the latest fashion.

1. Shape

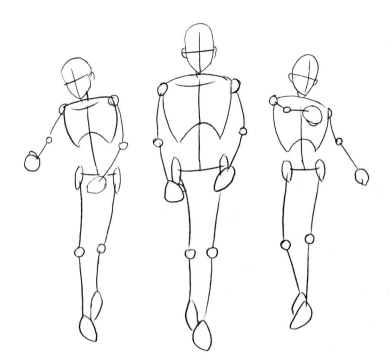

In this ensemble, be very careful to balance the space allotted in front of and between the three figures.

2. Volume

Use a standard perspective here, with very normal proportions and few foreshortenings.

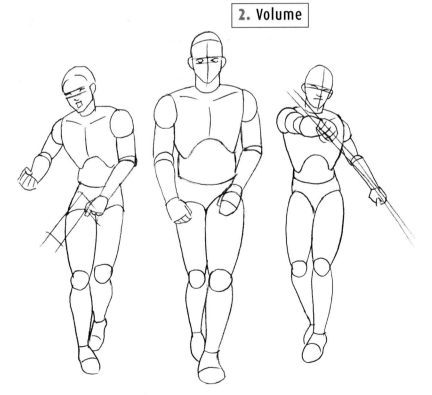

Complete the drawing, taking into
account that the features and height of
each characters is distinct.

4. Clothes

Clothing is essential in order to reflect each character's job. Differentiate between the leader, who is the character with the highest rank, by dressing him in more elegant clothes. On the other hand, to stress that the one on the left is just a thug, draw some tattoos on his body.

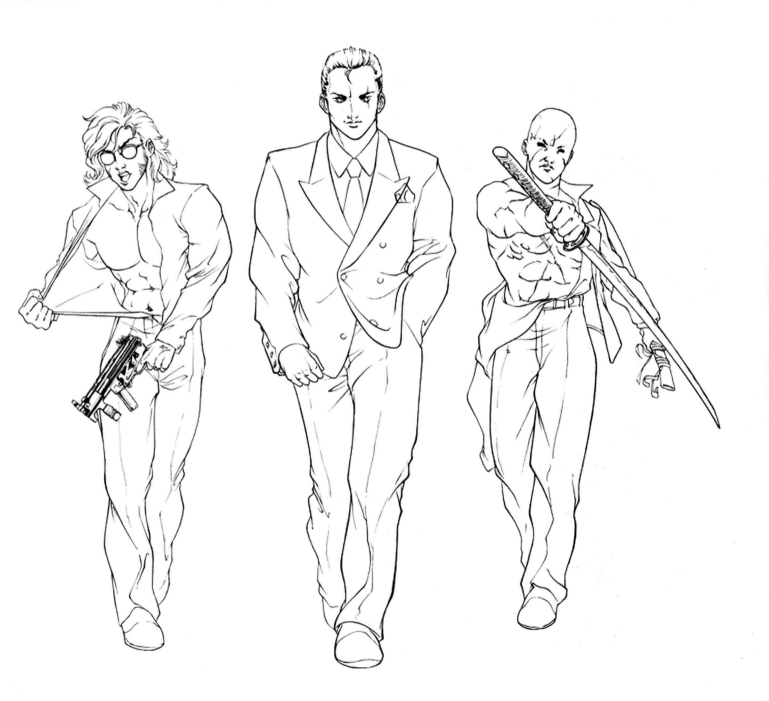

This step requires very detailed work with shadows in order to model the clothes of the different characters properly. Use large shades to mark the shape of the folds.

Source of light

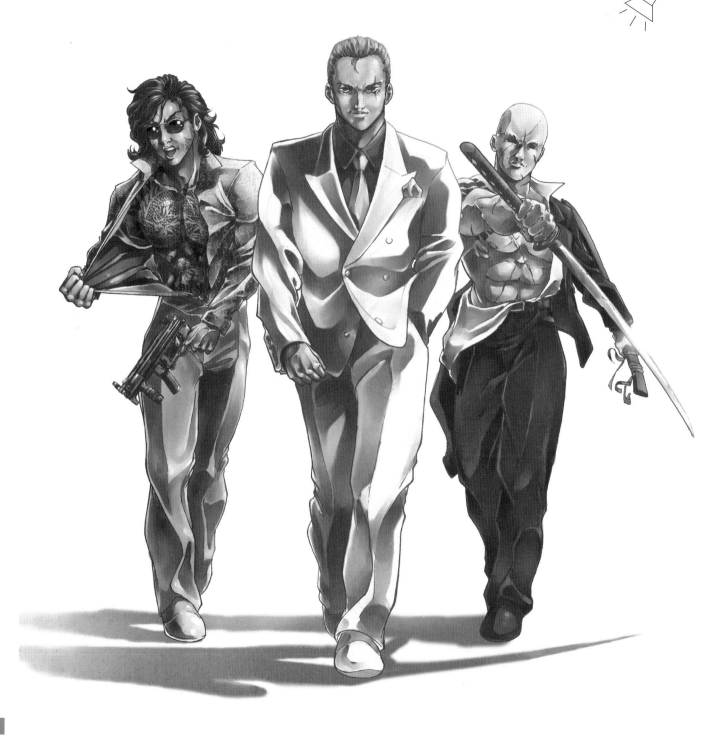

To color the figures, try a very limited range of colors with a common tone that pulls together the composition.

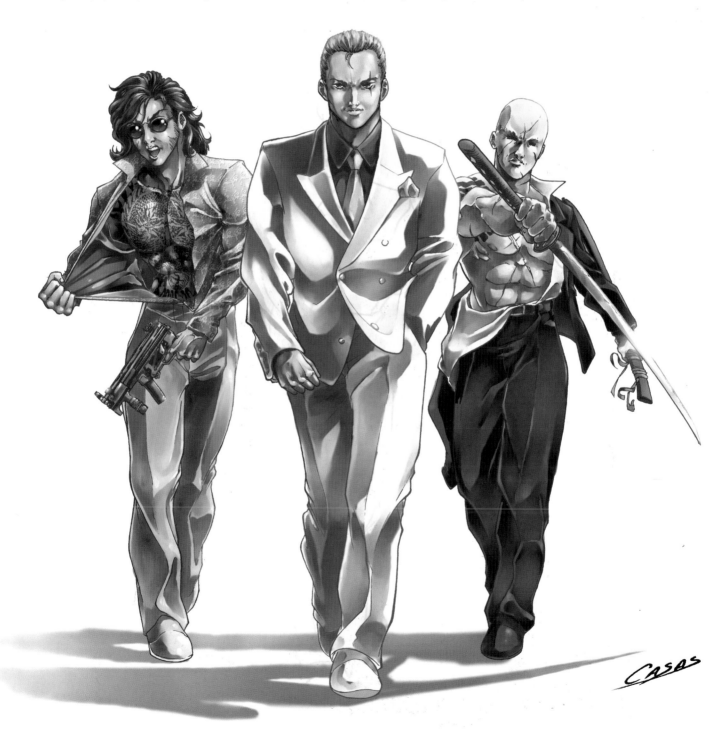

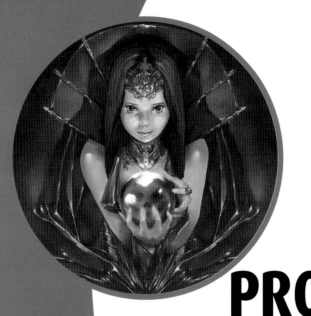

PROFESSIONAL

WITCH

We want to avoid the idea of the old, deformed witch, with her huge aquiline nose and purulent spots. Instead, we will represent a young, sensuous, and tempting woman who is charming enough to captivate us, but whose look warns us of the danger we are running into. The witch is a woman who deals with demons or spirits from other dimensions. She can be a good witch who deals with nature spirits, or she can be a witch who deals with magic or evil, a disciple of creatures from the underworld. Besides casting spells and preparing potions and beverages, witches are famous as experts in the arts of chiromancy and divination, sometimes reading bones and runes, or tarot cards and the crystal ball.

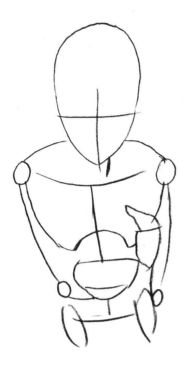

Sketch the figure of the woman leaning forward: draw a curve as the back axis, to which you attach the head and shoulders and the hip axis.

2. Volume

We don't need to see the legs, so draw the figure in a midplane attitude. Indicating that the arms are slightly outstretched is complicated: First draw the hands, and then connect the arms to the shoulders, showing where the elbows fall , and controlling the foreshortening.

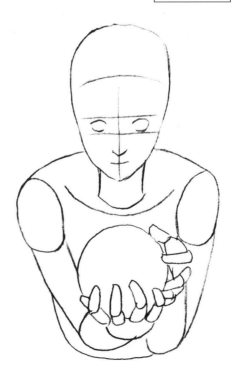

In order to characterize the witch, think of a brunette with long, loose hair and eyes full of mischief. Her penetrating gaze is an important feature in making the scene work.

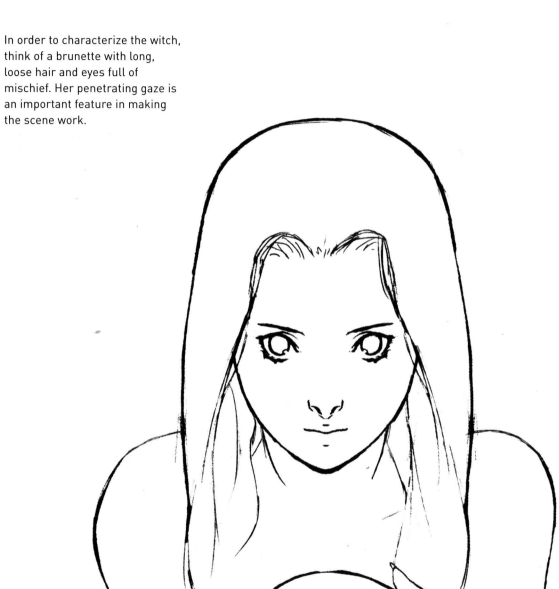

When drawing the hands cupping the crystal ball, start by sketching the sphere, and imagine its volume in order to place the palms in contact with the surface. Then finish the fingers other details.

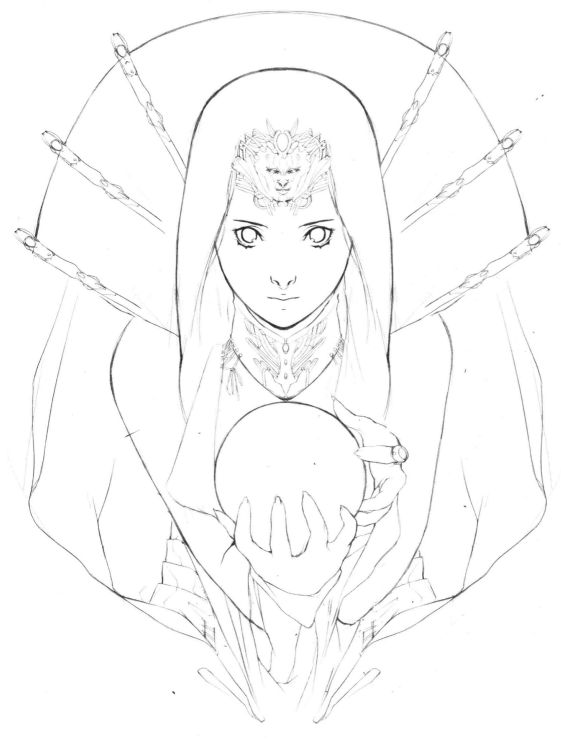

The witchch's clothing reveals her nature and highlights her charm because she is a woman who uses seduction as a weapon. The costume design has something sinister about it; you can underscore this with necklaces and other jewels—a frightful face peers out from the headpiece.

Give the illustration a more pictorial look; do not reinforce the lines very much. The shadows in the scene and the background contribute to the charged environment. On the crystal ball, note the bright reflected light and the shadowy, skull-like face.

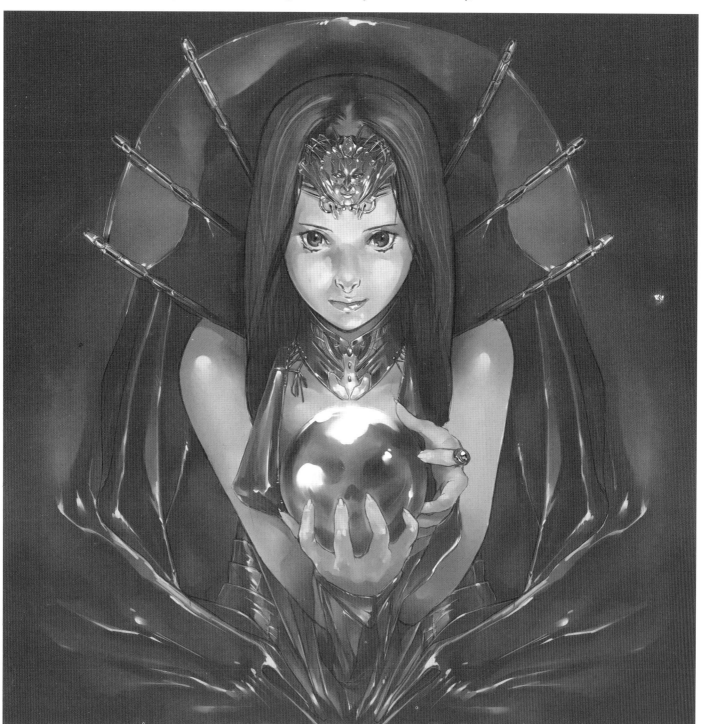

Focus on the penetrating look of the eyes and on the sphere, and you'll snare the audience in the witch's enchantment. Color her clothing and the background in dark witch's colors and blacks.

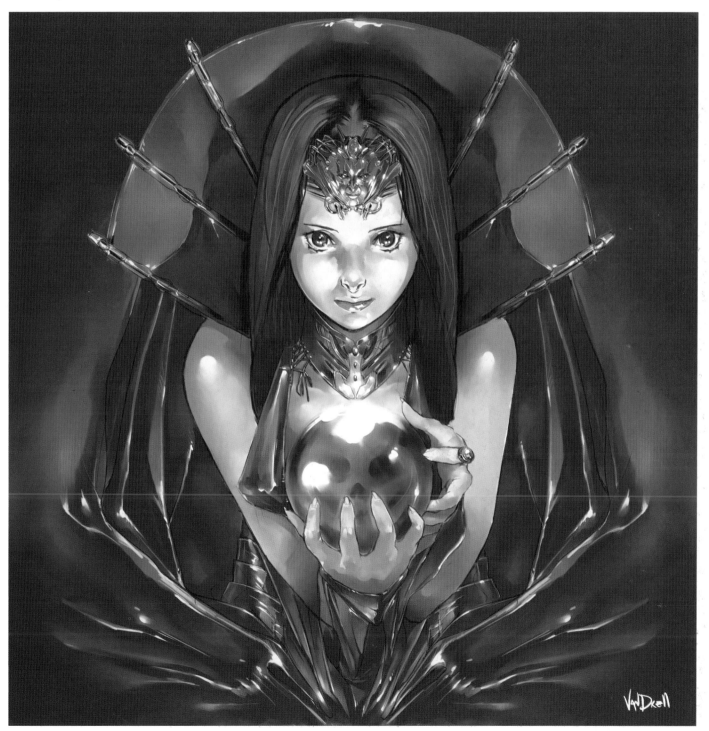

DRAGON

Fantastic monsters have the advantage of not needing a logical explanation or a credible origin; they are what they are. In this way, we can create a giant fly with butterfly wings, a basilisk can turn people into stone with its glaze, or a dragon can spit fire. We can design the most terrifying or funny versions of each species of monster. In this case, we will draw a fierce-looking dragon with a huge body, but with a nicer and kinder expression than the stereotypical perverse, ill-tempered dragon. We could say that the way we draw its face is rather comical, seeking a certain contrast between the warmth of those ridiculously curious eyes and the imposing enormity of the creature in its lair.

Simplify the basic forms of a kind of lizard, just to see if you are capable of imagining a dragon.

2. Volume

Draw an oval for the main body mass. Add the head and neck, and finish with the tail and the limbs.

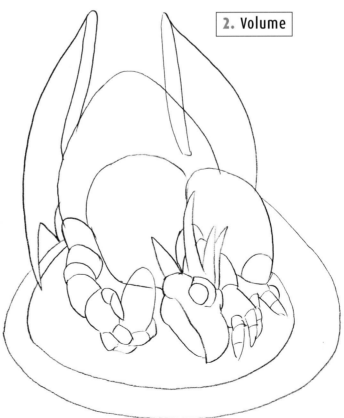

The dragon is an invented creature—it doesn't exist, but we believe that it's similar to a reptile. Refer to images of dragons in illustrated books and in movies.

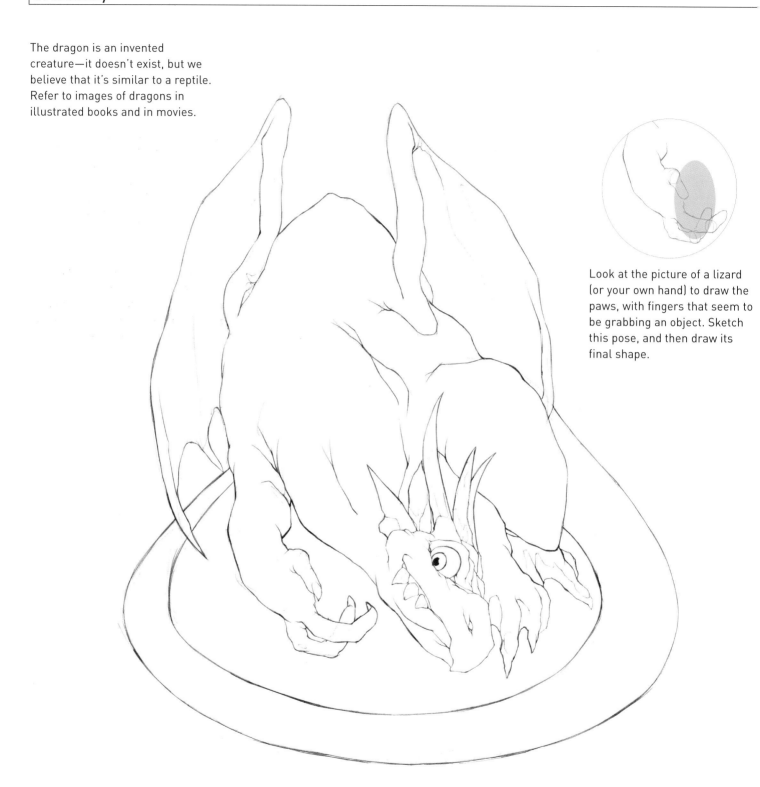

Look at the picture of a lizard (or your own hand) to draw the paws, with fingers that seem to be grabbing an object. Sketch this pose, and then draw its final shape.

The dragon has no clothes, but the warrior figure that goes with it does. Instead of making the dragon's claws grab an object, wrap them around this small character protectively.

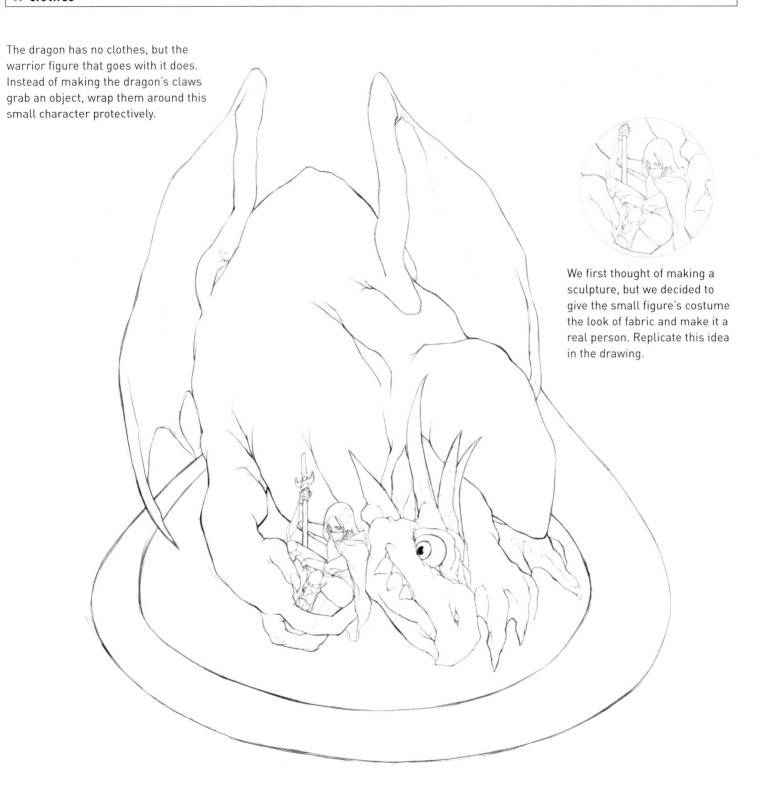

We first thought of making a sculpture, but we decided to give the small figure's costume the look of fabric and make it a real person. Replicate this idea in the drawing.

5. Lighting

Draw shadows with a continuous, curving outline to show that the dragon's volume is rounded and chubby.
For the warrior's figure, the shadows should obscure the details of its body under the cloak.

Source of light

The dragon's color changes according to the surroundings. It is red if it's in the mountains, green if in the woods, blue if near the sky or water, black in caverns, white if it is near snow, etc.

COLOSSI'S FIGHT

Fights among giant monsters are one of Japan's favorite Manga and Anime themes. If we consider the fear experienced by a society threatened with natural disasters like earthquakes and tsunamis, in addition to the devastation wrought by the atomic bomb, it is understandable that giant, destructive monsters count among Japan's most feared fictional enemies. Because of this, one of the main icons symbolizing Japan's desire to overcome threats and to excel is the ultrahero. For the Japanese, the ultrahero is what superman is to North Americans: a sentinel or guardian angel who protects the country and the world. The ultrahero can grow tall, enabling him to face monsters, and he can also throw laser beams.

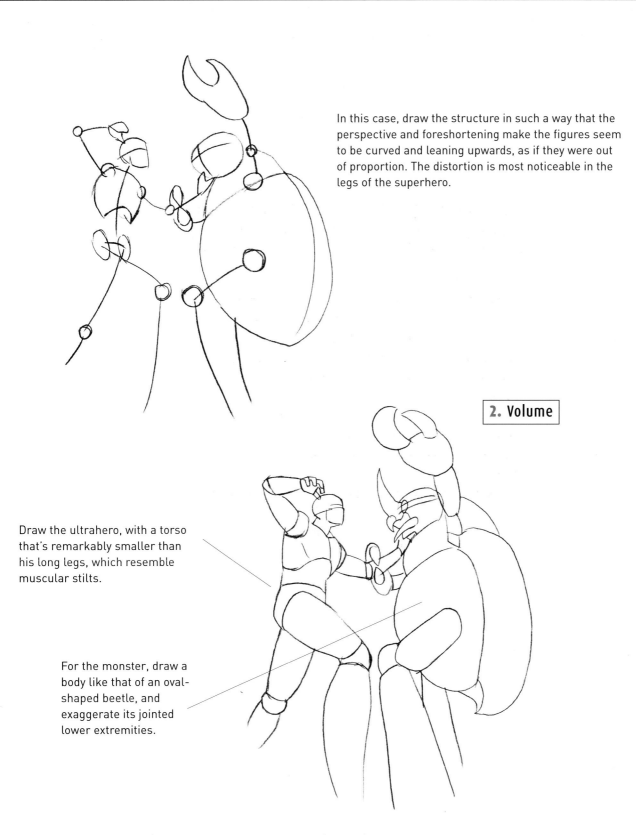

In this case, draw the structure in such a way that the perspective and foreshortening make the figures seem to be curved and leaning upwards, as if they were out of proportion. The distortion is most noticeable in the legs of the superhero.

2. Volume

Draw the ultrahero, with a torso that's remarkably smaller than his long legs, which resemble muscular stilts.

For the monster, draw a body like that of an oval-shaped beetle, and exaggerate its jointed lower extremities.

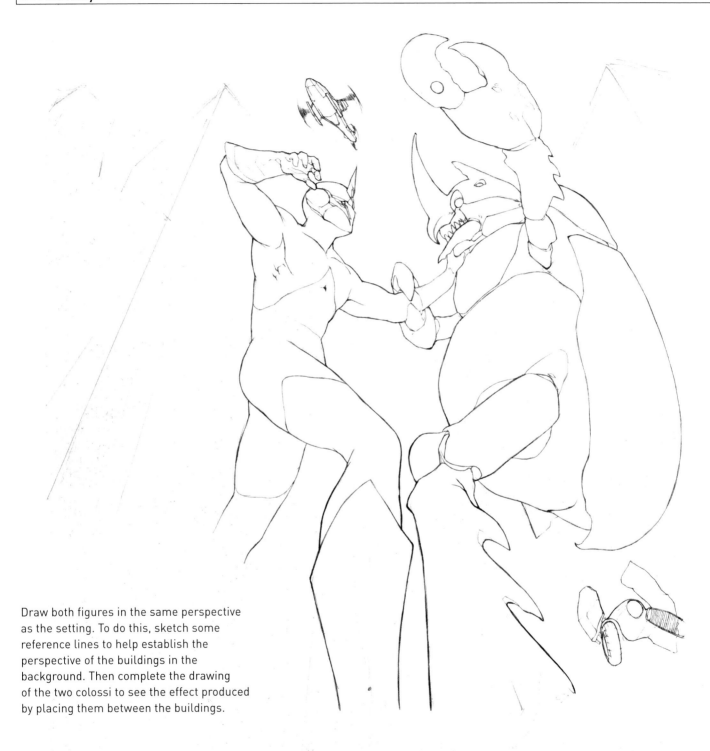

Draw both figures in the same perspective as the setting. To do this, sketch some reference lines to help establish the perspective of the buildings in the background. Then complete the drawing of the two colossi to see the effect produced by placing them between the buildings.

The highlights in this scene are laser beams hitting the ground and the consequent explosions. Therefore, try to originate the light from this activity, and add some shading to help create the right atmosphere. The shadows projected by the figures over the buildings help show that they are practically leaning against them.

Source of light

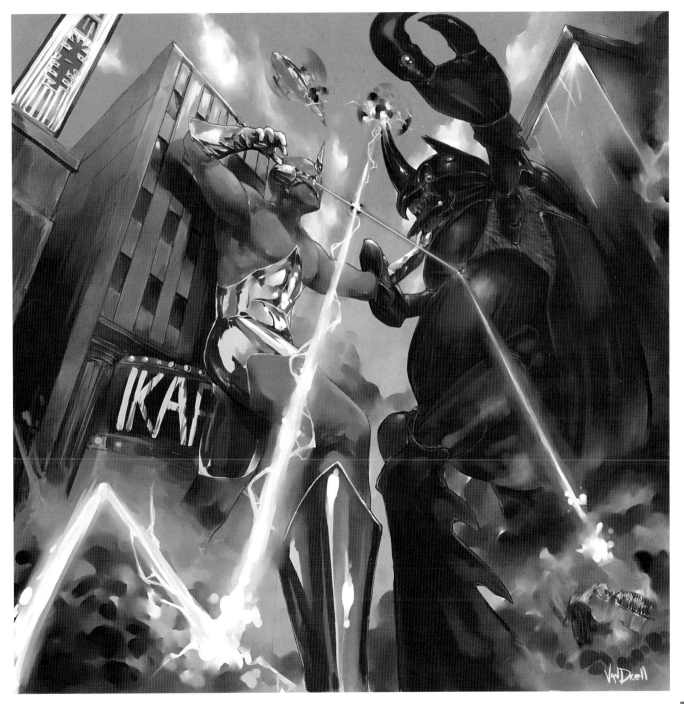

To color the figures, first draw in some rough patches, which will help mold the figure. Add the shading and textural effects progressively with controlled pencil strokes. Finally, draw the details with a series of more defined and strong pencil lines. The heros should be brightly colored (think Superman); the villain, beatle black with brown hairs where its armor meets.

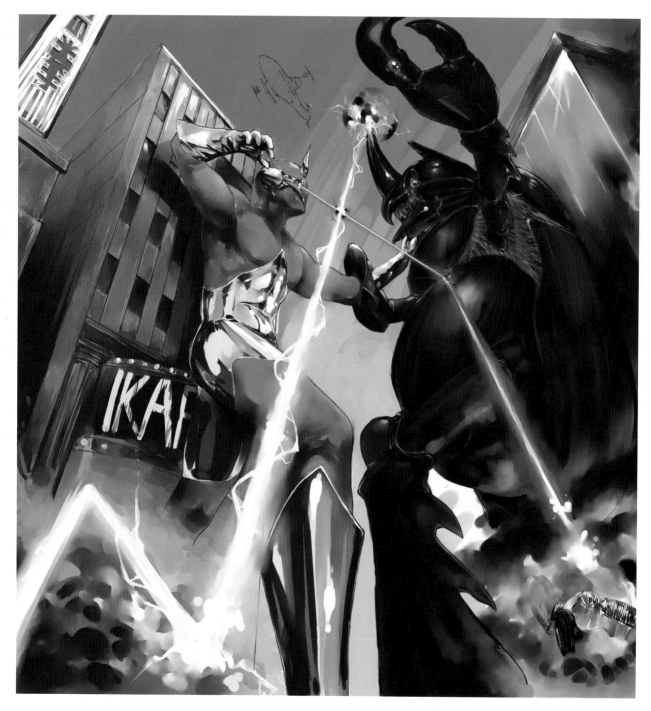

To finish, add background details like the letters on the neon signs, and the blades and reflections of the helicopter. The scene should now be complete and full of detail.

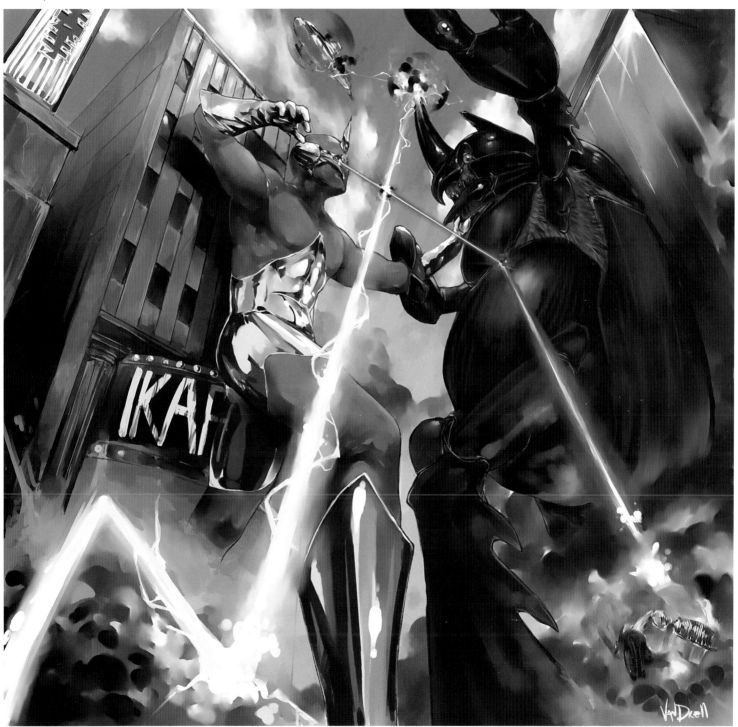

THE SUPER ATTACK

A character often associated with Manga comics is the martial artist who develops superhuman skills and is capable of breaking rocks with his bare hands, flying through the air with prodigious leaps, or manipulating energies through his body. These fighters dedicate their lives to mastering their techniques; they usually wander the world looking for enemies to fight and thus acquire experience in individual combat. Tales of martial artists with special skills have been around for hundreds of years, but lately they've gained in variety and popularity thanks to video games. Fighters have certain skills that depend on their martial art and on each one's character. Each has special attacks personally developed by the fighter.

1. Shape

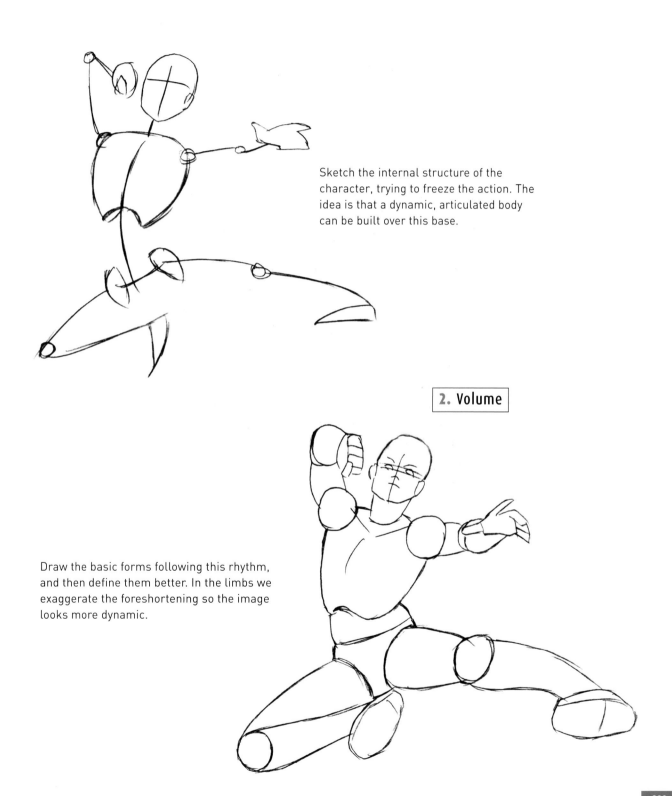

Sketch the internal structure of the character, trying to freeze the action. The idea is that a dynamic, articulated body can be built over this base.

2. Volume

Draw the basic forms following this rhythm, and then define them better. In the limbs we exaggerate the foreshortening so the image looks more dynamic.

The fighters' costume tells us a lot about his personality and his actions. It can have elements associated with his martial art, sportswear elements, or something more casual or even elegant, according to his personality.

We draw the clothing as plain elements, and then we add the main folds and wrinkles, following the direction of the movement.

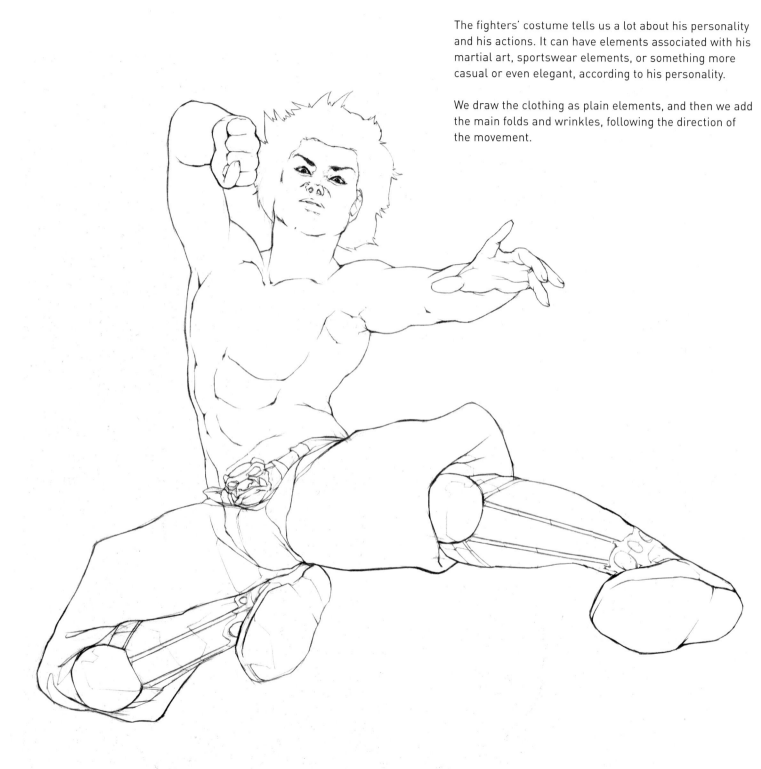

4. Lighting

The object of this lighting is to show on the figure a magnificent special effect that appears when he's performoing his super-attack move.

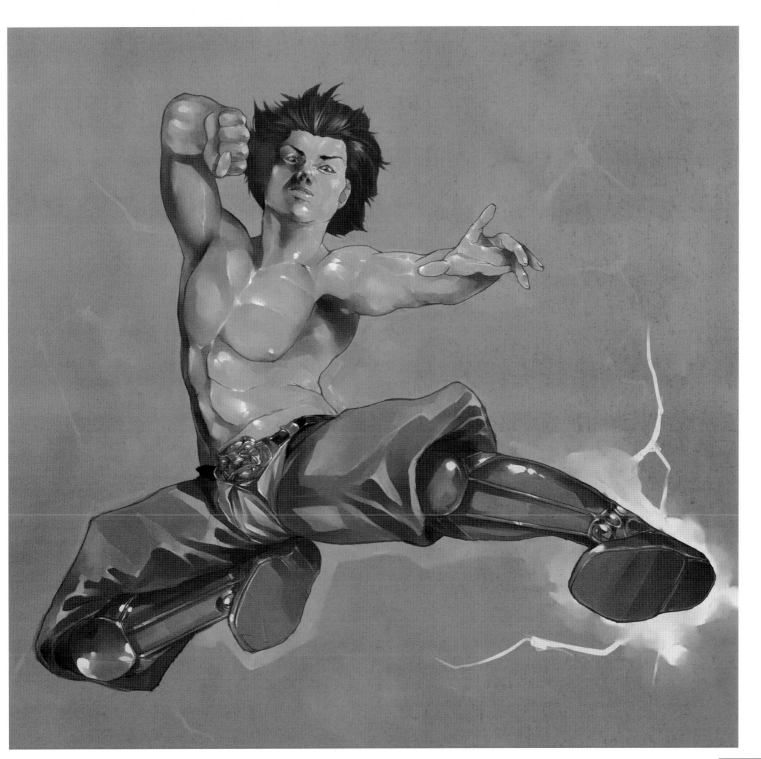

Start by applying plain colors to the figure, and then differentiate each area. Here, we have defined the general tone of the image.

6. Finish

With color strokes, draw an especially intense effect. The character will appear to be manipulating energies in such a way that his spectacular blows are devastating.

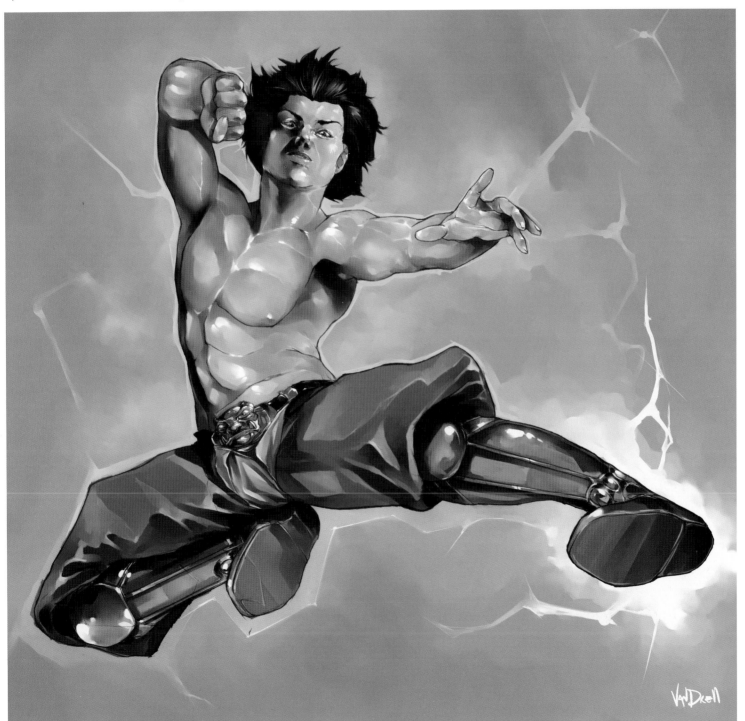

CLASSIC HERO

The heroes of tales and legends have a close relationship with the culture of a region's people. That is why, in part, we talk about icons that represent each one of these cultures. In the same way that these cultures have meeting points, these heroes have a whole set of common characteristics that could form what might be considered the classic hero archetype. The hero usually is a self-sufficient warrior, brave and even bold, but above all, proud of his origins and with a solid sense of honor. These heroes usually have to search for special objects or magic weapons to defeat apparently invincible monsters.

1. Shape

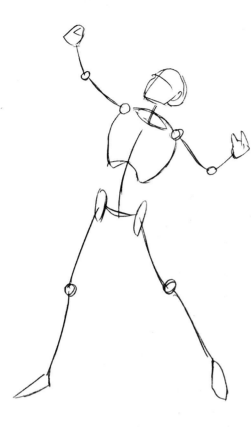

Sketch a standing figure that's holding high a magic weapon with his right hand. To do this, draw the curve of the back, and sketch in the head, the shoulders, hips, and limbs.

2. Volume

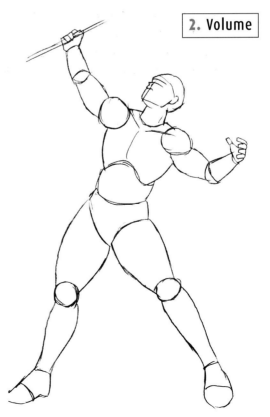

Over this, finish the figure's volume blocks. There is no foreshortening nor are there forced points of view, so just give the body the perspective of the scene.

Curiously, this hero has powerful legs that catch your eye more than his arms or torso. In order to construct a more heroic-looking figure, use proportions that make the head look smaller than the body, and the figure will look taller and leaner.

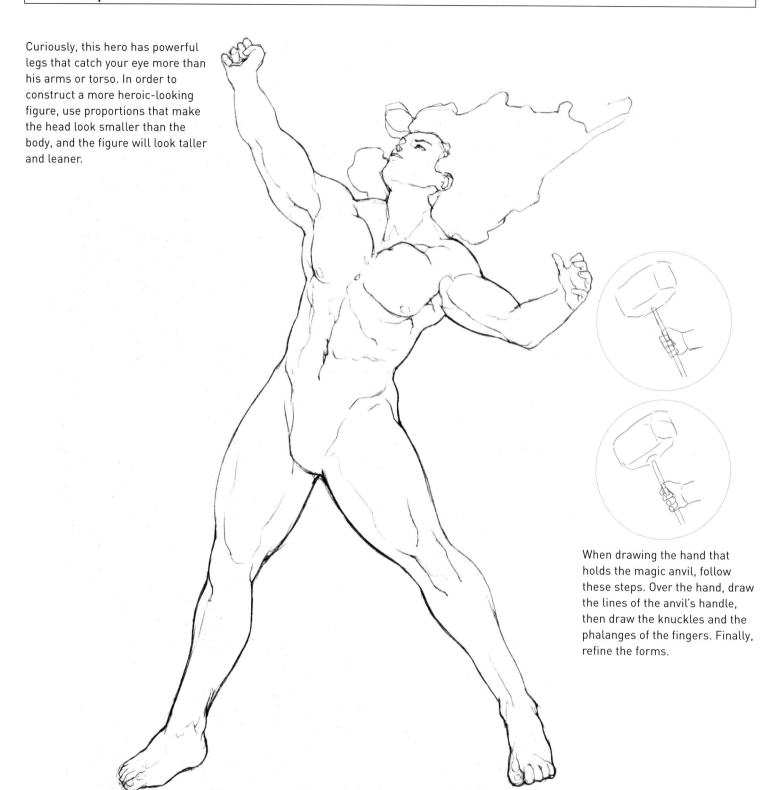

When drawing the hand that holds the magic anvil, follow these steps. Over the hand, draw the lines of the anvil's handle, then draw the knuckles and the phalanges of the fingers. Finally, refine the forms.

Source of light

The ray's flash is a source of light, and it is very close to the figure and very powerful. Mark strong and contrasting bright and shaded areas, differentiating the areas where the light impacts directly from those on the other side that remain darker .

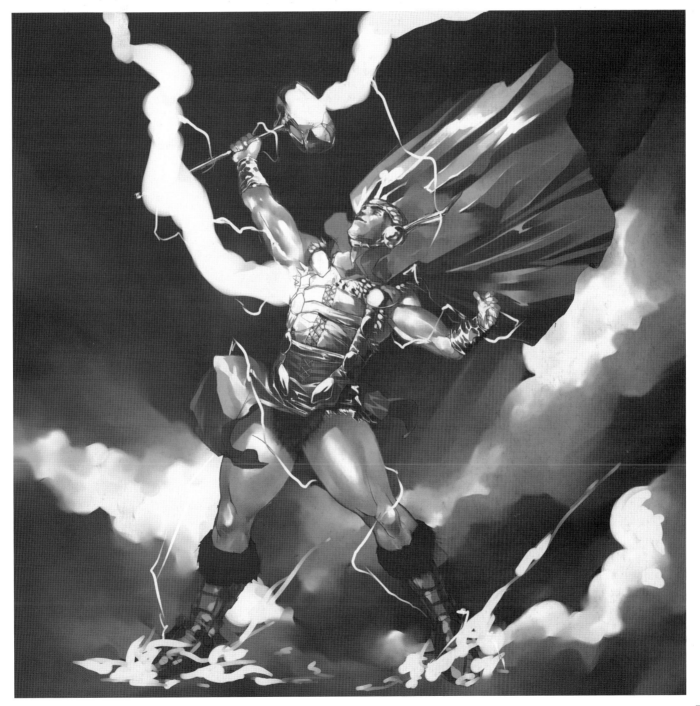

Color the figure, taking into account the strong contrast between bright and shaded areas. This will generate the effect of the beam hitting his chest; thus, some areas should be left white.

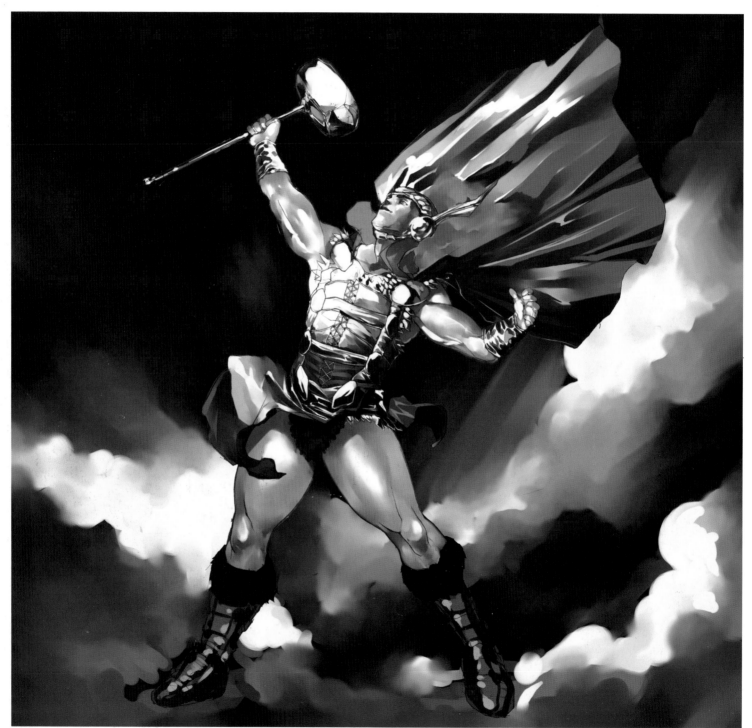

6. Finish

Thanks to the expressive power of light in this image, we give the hero an almost divine power.

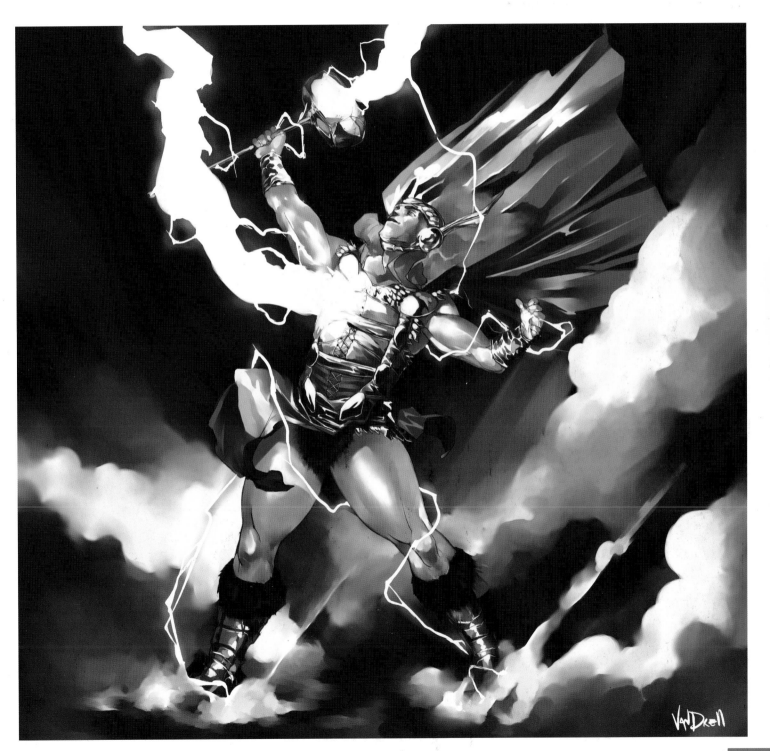

WARLORD

The Warlord is the personification of the violent, individualistic warrior, a force of nature who lives for combat and is never at home outside the battlefield. However, he is also the ideal commander of the troops, who see him as their strongest leader. They know they would not like to run into him as an opponent. Our Warlord should reflect this mix of fear and admiration; he should be a violent, brutal character, but at the same time charismatic and mysterious. What we know is that, physically, the difference between the average human being and this fearsome warrior must be exaggeratedly evident.

To draw many figures interacting is quite complicated. Try to make very clear what is visible in the overlapped figures, and eliminate what will not appear in the image.

2. Volume

The chest and the arms of the Warlord are extremely voluminous, and they seem to swallow up the figure of the warrior he is strangling. Besides controlling the proportions of the characters, sketch the foreshortening from this point of view.

The Warlord is a gigantic figure compared to the other characters, and his anatomical details should be enormous. For instance, he has extremely developed muscles. You should show how those muscles twist when the chest is turned.

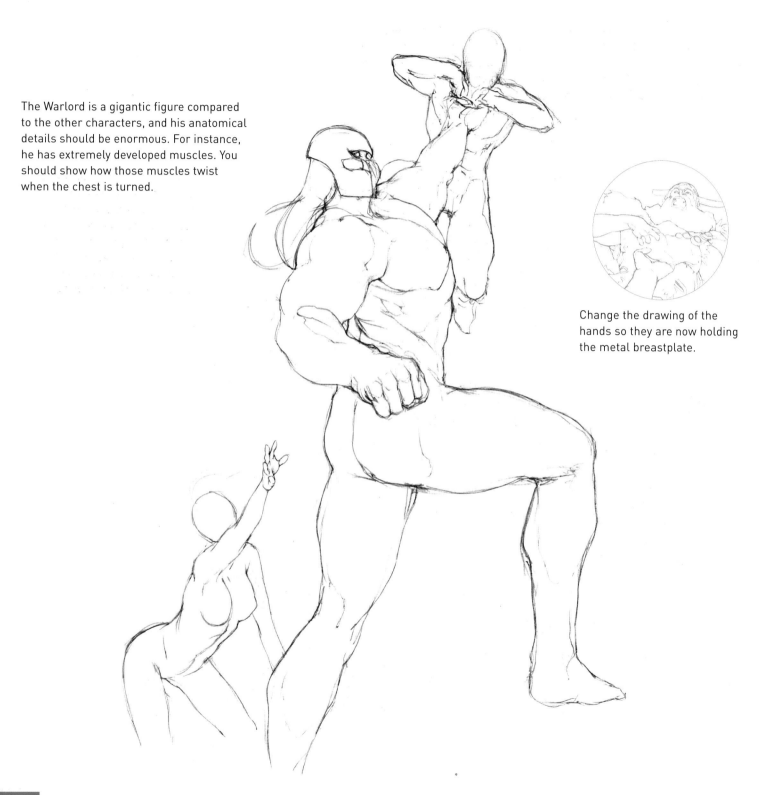

Change the drawing of the hands so they are now holding the metal breastplate.

This illustration has a medieval-fantasy feel. In keeping with this, re-create medieval weapons and armor for a battlefield atmosphere. You can do a free interpretation so that they are better. It is not necessary for the scene to look completely realistic, but it must look consistent; research your subject and carefully examine medieval weapons or at those used in movies.

To draw the fallen bodies and the elements in the background, take a separate page and carefully trace the legs of the Warlord. Design him taking into account the appropriate proportion, then copy it next to the drawing of the main figures.

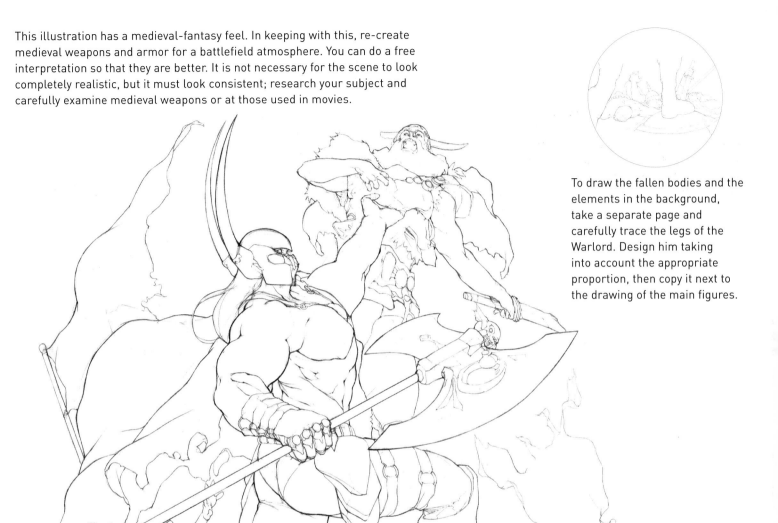

The scene is quite dark and grim in order to create an atmosphere of death and devastation, which suits the Warlord. In the heat of the battle, black clouds darken the sky. The center of attention is the Warlord himself, who must be clearer and more illuminated than the others.

Source of light

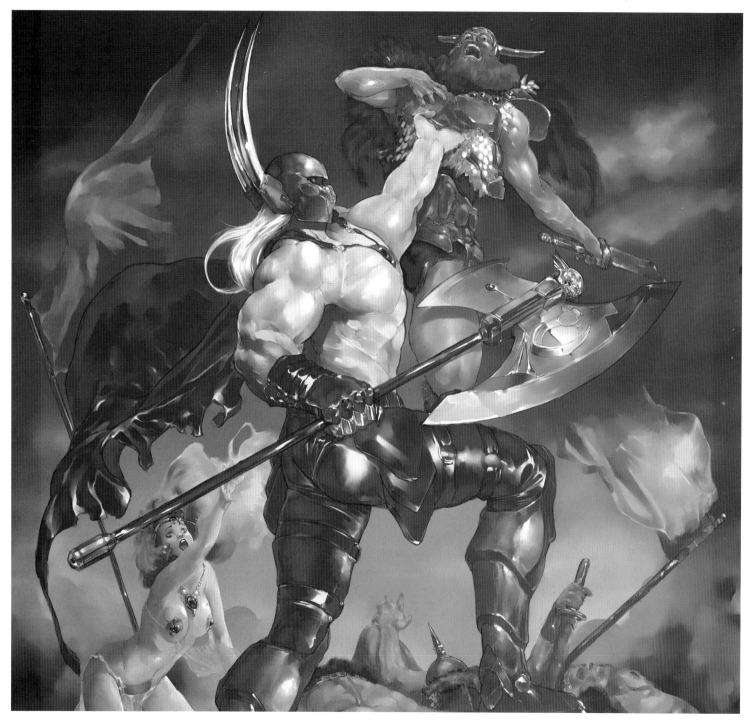

Start by applying some brushstrokes to the skin using gray tones; superimpose darker areas to represent shadows. When we blend the strokes, you should model the volume of the muscles and the lighting.

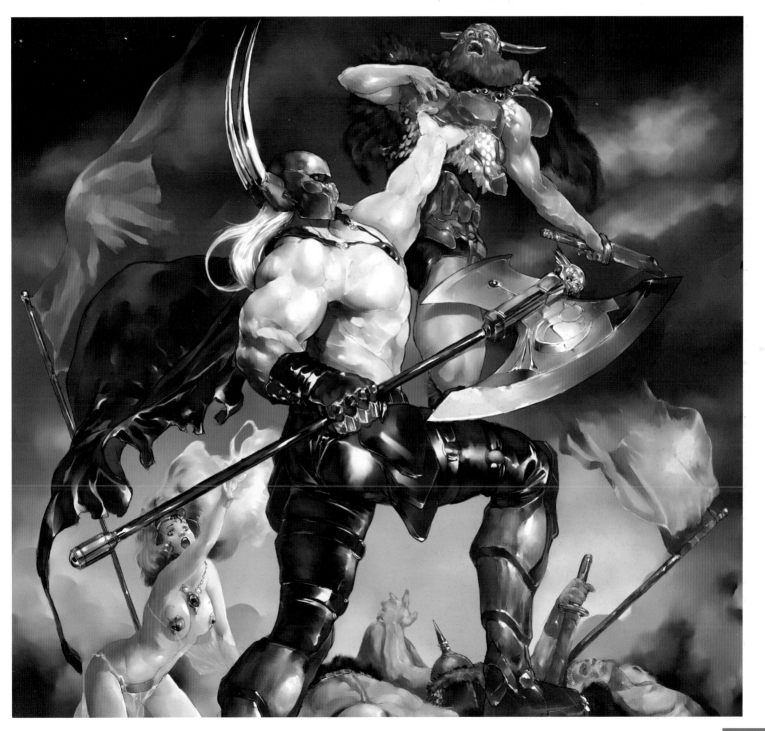

THE LAST LEVEL

This part is born out of the need not to offer more material, but really to give much more to those who have trusted us so far on this journey. Here, we present to you, step by step, the most complex parts of the color processes of our illustrations. To do that, we have chosen a huge set of images that illustrate step-by-step the details of our creative process, focusing on the color steps, especially the more complex illustrations of this book. The selection criteria have been totally subjective and have been done by us, the illustrators, as emblematic of the difficulties that we had to resolve in our own illustrations. In this way, we think that we have made a simple, honest tool to study the color process of an illustration.

Color is, without any doubt, one of the main characteristics of any illustration, and it is often the definition of our work. This is why we have made this section, hoping it might help all of those who are currently trying to step ahead in their personal growth regarding drawing, or in their career as draftsmen or illustrators.

Follow step by step the evolution of the illustrations from the base of color, passing through the definition of volume, until the final tone and the detailed work; discover how to make blends, watch how to place shadows, and how to finish backgrounds in order to reach the last level.

COLORING
TECHNIQUES

WARRIOR PRINCESS
PIXIE
OCEAN FAIRY
WARLORD
COLOSSI'S FIGHT

WARRIOR PRINCESS

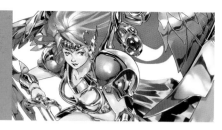

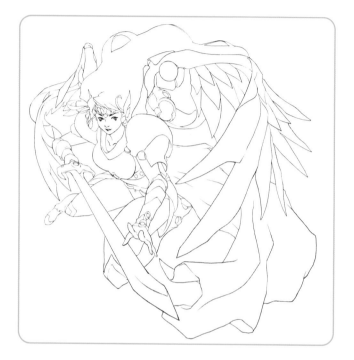

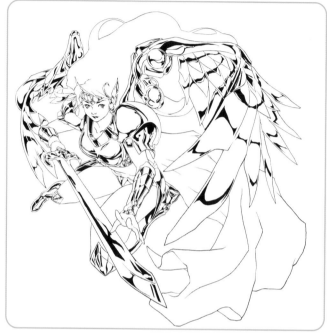

What we are interested in representing in this case are the metallic reflections and chrome effects of the metal parts. To this end, we apply some color marks in irregular and fluid shapes so that we get some contrast with the thin and uniform lines that form the contour of the figure.

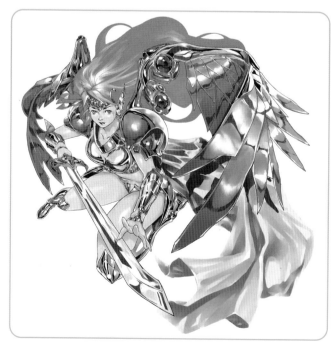

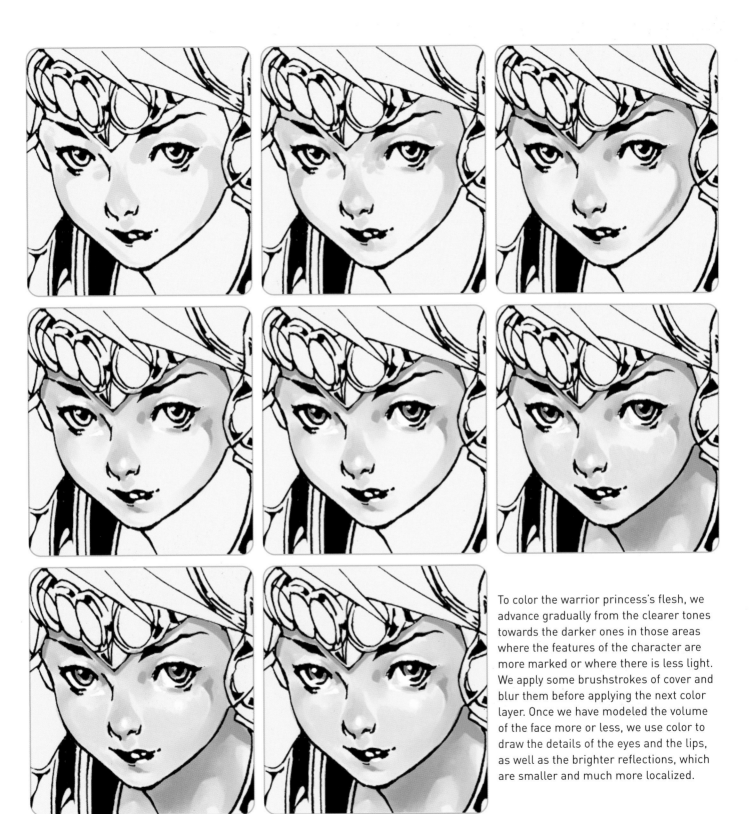

To color the warrior princess's flesh, we advance gradually from the clearer tones towards the darker ones in those areas where the features of the character are more marked or where there is less light. We apply some brushstrokes of cover and blur them before applying the next color layer. Once we have modeled the volume of the face more or less, we use color to draw the details of the eyes and the lips, as well as the brighter reflections, which are smaller and much more localized.

If we replace the black line of the hair with a reddish tone, it will look brighter and more realistic when the drawing is complete. Equally, we shall dye with color the contours of the chrome areas we have drawn.

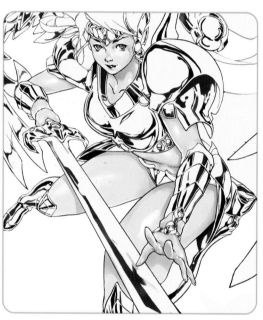

Following the same process as with the face, we have applied some flesh tones all over the body of the warrior princess. The shiny bits help delineate the volume of the legs.

We apply a color base on the different parts of her clothing and hair, and gradually we define the colors of the image more precisely. We then add shading to the shiny spots and shadows in this image.

By applying smooth layers of faded transparent color, we obtain a more subtle effect, which helps define the metallic pieces. We then blend them with the more marked shapes that form the reflections of the chrome parts.

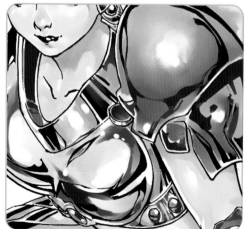

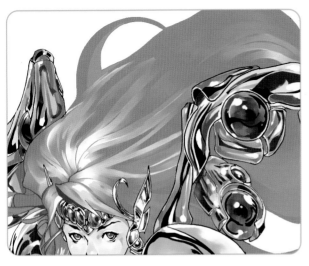

We use the longer brushstrokes that we applied when drawing the shine of the hair in order to define the shape of the locks. We then apply lighter brushstrokes, going from the central part of the hair towar the ends, so that the brushstrokes lose intensity and the background color becomes clearer as we paint.

By blending different layers of semi-translucent spots, we draw the volume of the cloak. The lighting of the image becomes much more realistic once we make the contour line disappear. The shadows that the wings project over the girl's clothing are another effect that contributes to bringing realism to the figure.

Once we have modeled the entire surface of the figure, we add those details that require more definition, such as the internal part of the eyes and the mark on the warrior princess's cheek.

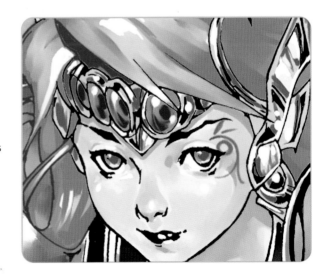

In order to color the hair, we first apply some color marks for the base tones, and then sketch some brighter shiny spots. We then add color brushstrokes to sketch the shape of her long, wavy locks, and gradually paint all the details of the final look .

We apply some color brushstrokes to shape the veins of the leafs and blend them. Then we apply on top of this some more defined strokes, as well as the many other details.

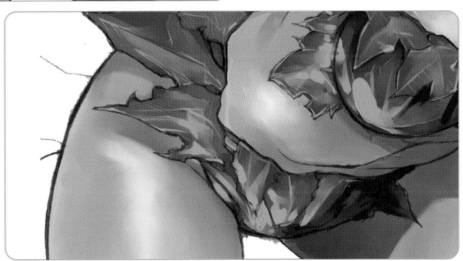

To color the wings, we need to apply broad color brushstrokes to define their texture, and we add and blend the color brushstrokes gradually.

In addition to this, we sketch and draw the circular motifs on the tips of the wings and retouch some of the details, like the reflective spots around the lines that define the wings' veins.

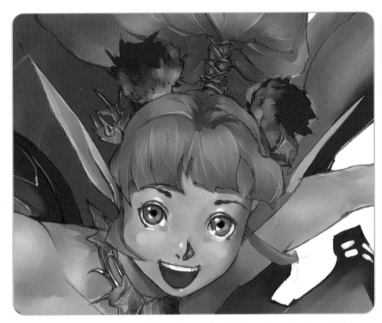

We darken the pompoms that adorn the hair and make them look more like moth antennae by drawing in a little hair.

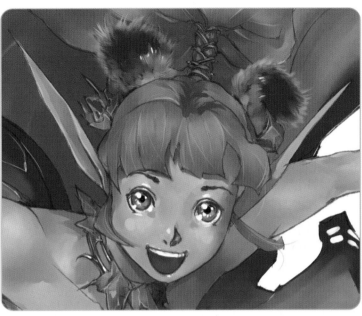

We add a few very intense final highlights to illustrate the light effects of the flames.

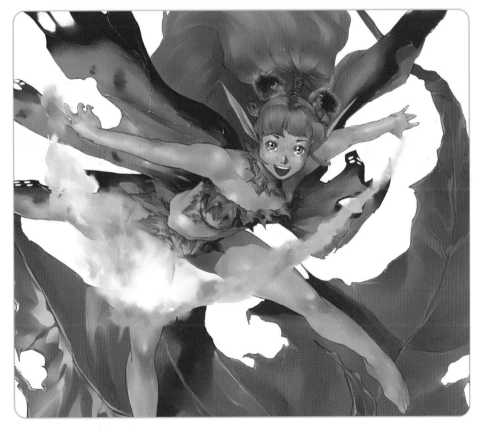

To finish, we draw the flames with color brushstrokes, leaving some white marks so that they resemble a bright blaze.

OCEAN FAIRY

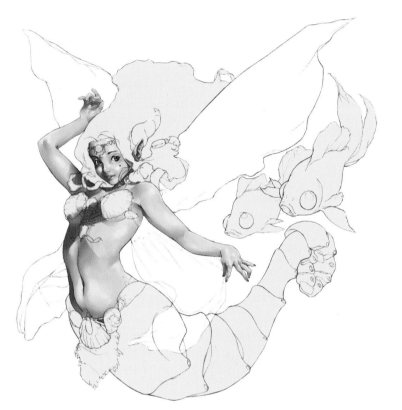

We begin by applying a very thin color base over the skin areas, as well as the first color coating forming the flesh and its shades. Once the figure has been properly modeled, we can sketch in its basic details.

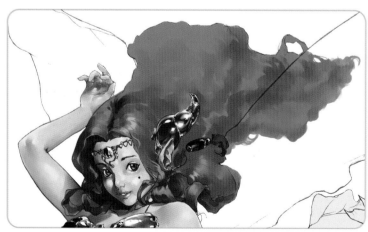

We continue with the hair, which should have a vaporous quality with blended and blurred contours.

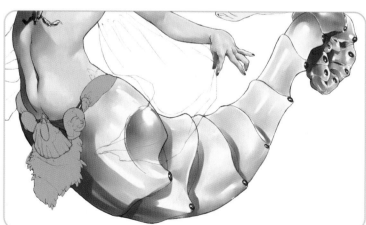

In order to color the shell, we looked at pictures of crustaceans and conches. We apply some broad, faded-color brushstrokes to give it a lacquered appearance.

The coloring process for the metal parts consists in applying vigorous brushstrokes to produce shadows and reflections, and to blend the colors and strokes nicely. We repeat this step until we reach the desired degree of realism and detail.

Using different color tones, we draw strong reflections on the coat of mail so that they look somewhat like underwater reflections.

The scaly skin of these goldfish is similar to that of the of coat of mail, the only difference being that we use orange and yellow tones for the fish.

WARLORD

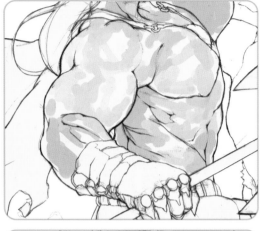

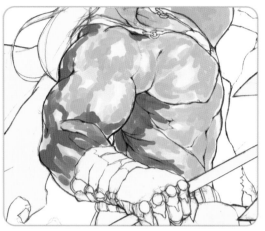

We begin by applying some brushstrokes in gray tones all over the skin of the figure, on top of which we add some color marks in a darker gray to produce the shadings. We then model the volume of the muscles and lighting by blending the color brushstrokes carefully.

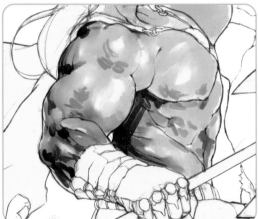

We add some thicker color brushstrokes over this first layer and blend them to cover up the various layers because this helps define a more detailed kind of lighting.

The brushstrokes over the helmet should be more marked and have greater contrast. Over the color layer that delineates the volume of this feature, we apply some looser brushstrokes to produce the scratches and other textures of the helmet.

To color the cape, we apply a very dark color base and gradually draw the pleats by adding reflections in white tones. We then carefully blend the brushstrokes and the colors, marking the contours of the pleats and folds.

The boots should be colored in a similar way as the helmet, with the difference that at the end of the process we have to add some reflections, blending them in larger circles as if they were on a curved, smooth surface.

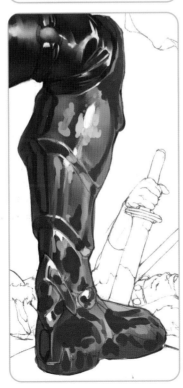
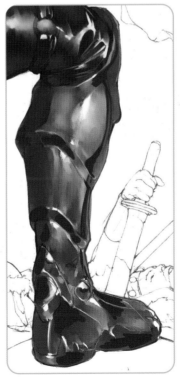
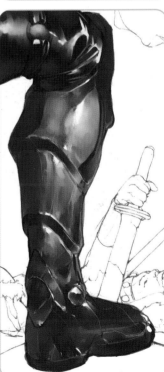

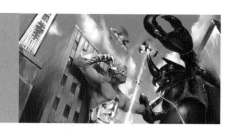

COLOSSI'S FIGHT

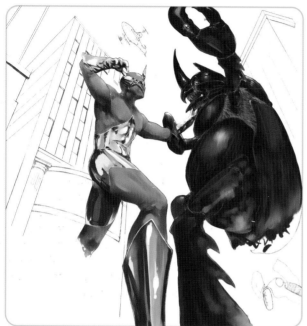

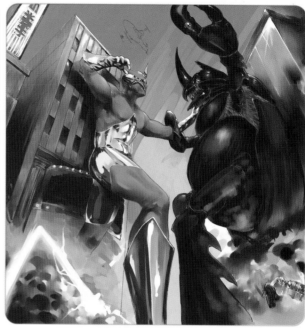

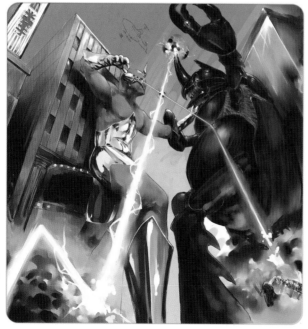

Because there are so many elements in this image, we have to organize them first, then apply the color in different layers. We start by coloring the figures, then proceed to the buildings in the foreground and the background elements. We don't pay too much attention to detail at this stage. Once we have a clearer idea of what the finished work will look like, we move on to defining the farthest background elements. We add the special effects, such as the laser beams and flames, and the background details and smaller elements.

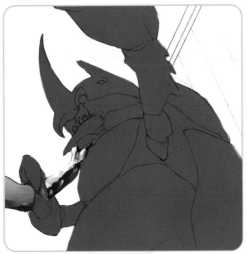
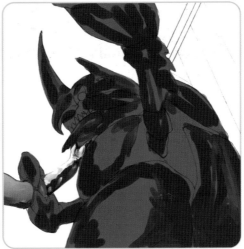
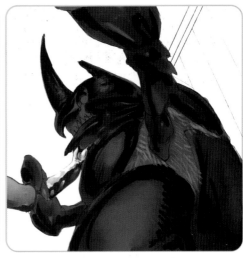

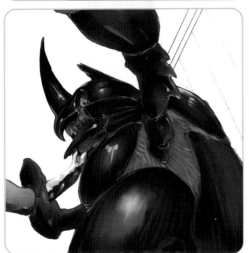
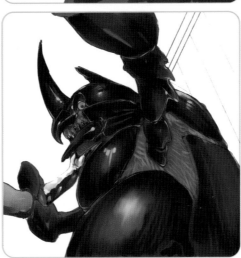

In order to color the figures, we first apply some thick brushstrokes, which help model the volume, and then we add the lighting and little by little the textural effects with smaller and more controlled brushstrokes. At the end, we draw the details on the figures by applying more defined and more opaque brushstrokes.

The various elements of the clothing have different textures, but the coloring process is the same as with the figures.

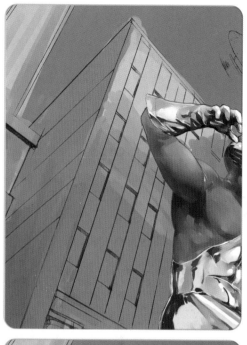

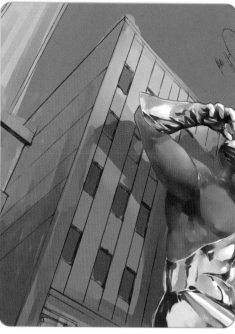

To color the building, we apply some thick brushstrokes by following the plane and the vanishing line of the wall. Then we add the shadows and textures by applying different color layers.

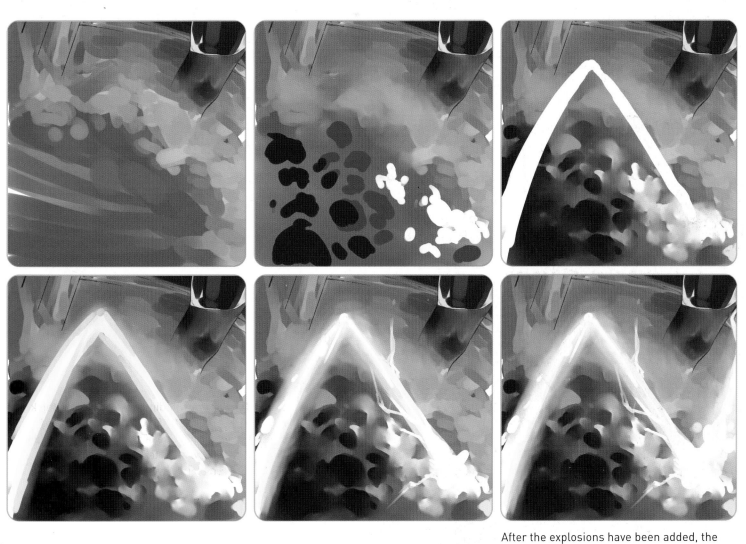

After the explosions have been added, the rays are drawn directly on top of the color. The explosions look more realistic when drawn with amoeba-like points of color that overlap and mix.